NEVER MET A MAN I DIDN'T LIKE

THE LIFE *and* WRITINGS *of* WILL ROGERS

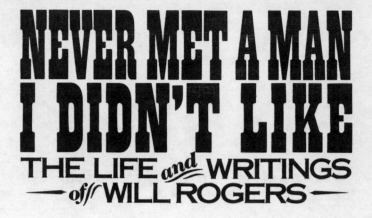

NEVER MET A MAN I DIDN'T LIKE

THE LIFE and WRITINGS

of WILL ROGERS

JOSEPH H. CARTER

Introduction by Jim Rogers

AVON BOOKS NEW YORK

NEVER MET A MAN I DIDN'T LIKE: THE LIFE AND WRITINGS OF WILL ROGERS is an original publication of Avon Books. This work has never before appeared in book form.

AVON BOOKS
A division of
The Hearst Corporation
1350 Avenue of the Americas
New York, New York 10019

First Avon Books Trade Printing: December 1991

NEVER MET A MAN I DIDN'T LIKE

THE LIFE *and* WRITINGS *of* WILL ROGERS

INTRODUCTION

WHEN JOE CARTER TOLD ME HE WAS WRITING A BOOK about Will Rogers, I was very pleased. Joe is the director of The Will Rogers Memorial in Claremore, Oklahoma, a long-time reader of Dad's material, a member of the press, and of a strong political background. I know of few people who have his knowledge of Dad's life and history, and this, coupled with his years of experience in the press and political fields, gives him a keen insight into Dad's material. Dad, after all, was a columnist, and his writings and speeches were a running commentary on world events through most of the 1920s and first half of the 1930s and were most generally of a political nature.

Dad was basically a humorist, but he was also a shrewd observer of people and events and had an ability to cut through propaganda and doubletalk and, in a few words, get to the meat and potatoes of

the various issues and come up with a humorous twist. He joked and kidded most all of the prominent people of his times, but never with malice. He might disagree with a man's policy or stand on an issue, but his criticism was of the issue and not of the man personally.

I think that when he wrote "This old countryboy is doin' pretty good and that's because he's still an old countryboy" he told a lot about who he was, for regardless of where he was, he was always himself. Oh, he always had a bag of jokes and gags he could come up with when the situation warranted or his professional image called for a joke or a quotable quote, but other than that he was just plain Will Rogers.

One of the truest things Dad ever said was "The day I roped Betty was the greatest performance of my life." My brother Bill, sister Mary, and I all agree that if it had not been for Betty Blake from Rogers, Arkansas, there never would have been the Will Rogers much of the world knew and loved. Mother, like so many of those other unsung heroines who were the wives of great and famous men, knew when to push, encourage, criticize, sympathize, praise, mother, and when not to do anything. Although in public Mother was never in the limelight, Dad always knew she was there, in his corner, one he could count on. When I think of Mother I'm reminded of an old cowboy song, "My Mother Was a Lady." As the cowboys who drove the cattle up from Texas used to say, "She was one to cross the river with."

I hope you like this book, learn a bit about what Will Rogers did and perhaps a bit about why and

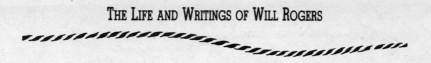

how a mixed-blood Cherokee cowboy, actor, comedian, columnist, radio personality, speaker, and humorist was taken into the hearts of the American people as no other private citizen before or since has been. Of course I'm a bit prejudiced, for he was my Pop.

—Jim Rogers
August 1991

PART ONE

THE MAN AND HIS TIMES

AN OKLAHOMA BOY

At First Brush, Will Rogers Seemed Breezy. He was, indeed, humorous. Then some people recognized him as informed. Visionary. Maybe even prophetic. Certainly uncanny. What he said made sense. Common sense to common people. Will Rogers reduced life's riddles to understandable terms, impressing even the mighty.

Adolph S. Ochs, publisher of the *New York Times*, described Will Rogers as a scholar and a philosopher because he could unscramble complex ideas. In an April 26, 1928, letter, Ochs called him one of the most popular writers and entertainers in the United States, with the marked support of the public, who had confidence in his views in the 1920s and 1930s.

Author-journalist Damon Runyon said Will Rogers was "America's most accomplished human document. One-third humor. One-third humanitarian. One-third heart."

Poet Carl Sandburg said that "there is a curious parallel between Will Rogers and Abraham Lincoln. They were rare figures whom we could call beloved without embarrassment."

O.O. McIntyre, a contemporary newspaper columnist and friend wrote: "If Will Rogers were not one of the most talented men of his time, he should have achieved greatness for this simple statement in a world swollen and angrily red with hate: 'I never met a man I did not like.'"

Will Rogers was jocular, self-effacing, and slapstick without sacrificing his integrity. His stance reflected a birthright that was simple and without apology. He strode across all parts of the earth and penetrated many levels of humanity. He showed little preference for rich or poor. He was irreverent without rancor. He wore no bridle.

Will Rogers was born in Indian Territory in 1879 when horses were the fastest mode of transportation. He was killed nearly fifty-six years later in Alaska Territory when an experimental airplane crashed.

He was born and he perished in primitive, rugged environments where the fit survived, prospered, and multiplied, but where an error or weakness could be fatal. With his adventuresome lifestyle, living fifty-five years defied odds. After his death he has remained widely known for a period even longer than he lived.

Will Rogers was many things: an important writer, a philosopher, a wit, an actor, a skilled horseman and roper, and a reflection of the common America of the first third of the twentieth century.

Will Rogers was the renaissance man of the American West. He used to say: "My ancestors didn't come over on the *Mayflower*, but they met the boat." He was a Cherokee by heritage but Irish and Scottish by higher percentages of pedigree. His father, Clement Vann Rogers, was born January 11, 1839, to Robert Rogers of the Blind Savannah Clan of the Cherokee Nation and Sallie Vann Rogers of the Wolf Clan of the Cherokee. Under Cherokee law, Clem adopted his mother's Wolf Clan. Will Rogers's grandparents at an early age had migrated to Westville, Indian Territory, and built a two-story house overlooking the lands they cleared and farmed in the Going Snake District. In 1840, in an ambush blamed on tribal rivalry, Robert Rogers was fatally shot, and his dying words to his wife were: "See that Clem rides his own horse." The words became a dogma as Will Rogers's father, Clem Rogers, lived to be fiercely independent.

An unwilling student in structured classrooms, Clem Rogers nonetheless was educated in the discipline of the Old Baptist or Ju-da-ye-tlu Mission in math and the writing of both the English and Cherokee languages. Stubbornly yielding to parental demands, he studied three years in the national male seminary at Tahlequah, Indian Territory, the capital of the Cherokee Nation. At the nearby Cherokee school for young ladies, he met the lady who would become Will Rogers's mother.

Mary America Schrimsher was born October 9, 1839, in Alabama. Her father was Dutch; her mother was equally Welsh and Cherokee. The Schrimshers had assumed their hereditary position in the Paint Clan of the Cherokee Nation and, as Indians by

choice, had migrated westward for opportunity in Indian Territory.

While attending the Cherokee Female Seminary at Tahlequah, Mary Schrimsher met her husband-to-be.

Clem Rogers was a robust, methodical, business-like man attracted to the warmth, charm, and bright humor of Mary Schrimsher. She excelled in song, dance, and performance. Clem knew cattle, land, and commerce. Mary was spiritual and faithful to her Methodist Episcopal Church. Clem was shrewd, ambitious, and strongly bound to his earthly heritage.

When Clem Rogers's temper flared, Mary America Schrimsher would bring peace with a warm, funny story. She would eventually give her last born, Will, his place in the Paint Clan of the Cherokee Nation.

At age seventeen, Clem Rogers quit the seminary and "rode his own horse" into the life of a cattle drover. On dusty trails, he herded cattle to the rail-head at St. Louis from the rich grasses of Indian Territory. In short time, the calculating Clem Rogers discovered the unexploited bluestem grass of the Cooweescoowee District of the Cherokee Nation two days' ride from Westville.

Returning home, Clem Rogers claimed his inheritance of twenty-five longhorn cows, a bull, four horses, and two black slaves, Rab and Houston Walker. They became a three-cowboy team with Clem Rogers the leader. Slavery dissolved without formality on the Wild West frontier. The black men moved from employees of Clem Rogers to self-employed farmers. Their children would become Will Rogers's dearest childhood friends.

When Clement Vann Rogers and Mary America

6

Grandma Schrimsher (left) and Mary America Schrimsher Rogers, Will Rogers's maternal grandmother and mother, respectively.

Schrimsher were married in 1859, both were twenty years old. With their firstborn, Elizabeth, the couple moved westward and established a home on the ranch and a trading post Clem had established at Rabs Creek, a tributary of the Caney River named in honor of the freed man.

Clem Rogers bred and fattened cattle on the blue-stem grass and the waters of the Caney River. His enterprise bought rangy longhorn cattle of Texas to the south and primed them for the markets of Kansas and Missouri to the north. His was a midpoint of famous trails for the lusty nineteenth century cattle drives that made western cattlemen rich and nourished people of the East.

Although forty years earlier, renegade whites and invading Cherokees had massacred native Osages in

7

their village of Claremont, Clem Rogers made peace and traded with surviving, forgiving Osages.

Clem Rogers's intricate business enterprises boomed a half dozen years until Civil War struck the United States in 1861.

Pro-Union Kansas Jayhawkers overran and ravaged the Rabs Creek ranch as they rushed to join with Creek Indians to battle the Cherokee Confederates in Indian Territory. Indians, whites and blacks fought side by side for the forces of both the North and the South as Civil War battles flared.

For safety, with the black man Rab as a guard, Clem Rogers rushed Mary and Elizabeth to Westville. There, the baby died of natural causes. Mary Rogers, again pregnant, fled to Bonham, Texas, for greater safety.

Clem Rogers became a scout, then was elected a captain in the Confederate forces of Stand Watie. The war was a hate-filled conflict pitting cousins against cousins both across the nation and in Arkansas and Indian Territory. For four years, Confederate forces fought Union followers of Cherokee Chief John Ross. Watie forces were the last of the Confederates to surrender—two months after the war ended in defeat for the South.

Even when the war formally ended, both sides within the Cherokee Nation hung blankets over lighted windows after nightfall to prevent assassinations.

Because most Indians had supported the Confederacy, the victorious Union contended that the Five Civilized Tribes had forfeited their land rights. In compromises, the Indians agreed to free their slaves, forfeit large areas of land, and agreed to form a gov-

ernment among the several tribes that eventually would become a state, borrowing its name from the Choctaw language: "Okla Homa," or land of red people.

Clem Rogers talked little about his role in the war, but he was left impoverished. Rabs Creek was devastated. Horses and cattle were gone, and improvements were burned.

To establish a new stake, the undaunted Clem planted crops and began driving a six-mule-team freight wagon from Kansas City to Indian Territory. It was hard, dangerous work, but he earned money and saved.

But always his thoughts were on the bluestem grass country. For $25, Clem purchased a cabin that full-blood Cherokee Tom Boot had built seven miles east of the old Rabs Creek spread. Under Cherokee code, from that point Clem Rogers could take all the vacant land that he could manage and occupy. The unbroken, bluestem grass was perfect pasture for cattle herds. The Verdigris River bottom was rich for wheat, feed grains, and hay farming. The Verdigris riverbank was his new homesite.

Over a two-year period, Clem Rogers built a new one-room cabin and corrals, then fenced gardens. Across a narrow vacant area called a dog run, he later added a second cabin, then enclosed the space between the two sturdy structures. In 1870, he moved his wife and three children, ages seven, four and one, onto what would someday become the Dog Iron Ranch.

Clem Rogers's domain grew to sixty thousand acres, with thousands of beef cattle wearing the CV—for Clement Vann—brand.

Within five years, Clem Rogers had directed expansion of the log cabins into a solid, two-story home with the massive log walls covered with plaster inside and white siding on the outside. The home was called the White House on the Verdigris.

Clem Rogers was rapidly becoming one of the wealthiest ranchers of Indian Territory. He wore a business suit daily. He was a rancher, not a cowboy. To the business world, he was C.V. Rogers, who hired cowboys. He bought cattle for $1 in Texas, drove them to be fattened on his Oklahoma bluestem grass that grew from the limestone-rich soil, then herded them to St. Louis to be sold for $40. Costs were low, profits high. Businessman C.V. Rogers mastered the opportunity and succeeded handsomely.

Mary and Clem Rogers begat five daughters and three sons, but only four reached adulthood.

In the log cabin portion of their house, Mary America Schrimsher and Clement Vann Rogers's eighth child, William Penn Adair Rogers, was born November 4, 1879, and was named in honor of his father's wartime friend. A member of the Paint Clan, Will Rogers was nine thirty-seconds Cherokee Indian and became number 11,384 on the Cherokee Nation rolls.

Elizabeth, Zoe, and Homer Rogers had died in infancy. When Will was born, surviving siblings were Sallie, sixteen; Robert, twelve; Maude, ten; and May, six.

Robert would swoop his young brother into the saddle and gallop across the prairies, giving Will Rogers his first taste of freedom on the plains. Then,

Will Rogers as an infant.

at age seventeen, Robert died of typhoid, and Will
Rogers swallowed his first bitter loss.

On the frontier, life was a gamble. Mourning for
the dead quickly gave way to hope. Demands of sur-
vival required optimism and a clear understanding
about life. Will Rogers later said it this way:

"If you live your life right, death is a joke as far as
fear is concerned. Live your life so that when you
lose it you are ahead."

He grew from examples. His first decade, with tra-
gedies along the way, was mostly idyllic in his
memory. When he was born, the worst hardships of
frontier life had been conquered, and his family was
affluent by standards of the primitive environment.
His mother was loving and entertaining. His father,
tough in business but gentle at home, was content
to work hard and was influential.

In the Cooweescoowee District, Clem Rogers was a judge and a five-term senator in the Cherokee Nation, a government and a country unto itself, but located within the boundaries of the United States.

In a primitive land with few meeting places, the White House on the Verdigris became a place of government, private and business meetings, and of regional social life. Preachers, tribal officials, friends, and strangers were welcome to eat and spend the night unless their "horses had cockleburs in their tails."

Mary Rogers would play the piano and everyone would sing, or they would roll back the parlor rug for a dance. Worship services and weddings were performed at the parlor hearth.

Clem Rogers, besides serving in the Cherokee senate and as a judge, owned large herds, and up to fourteen binders cut his wheat. Visitors were welcome and continually brought information and conversation into the household. Great issues of the day and particularly the business of governing the Cherokee Nation were debated in the household while Will Rogers listened.

Doting sisters coddled Will with tenderness, love, and iron lifelong support. His mother, assisted in housework by a cook and maids, lavished time and attention on her children.

After Robert Rogers died, caring black field workers and cowboys rushed to fill Will's need. As a tot, he would be taken to the wheat fields and placed on the back of a tall, gentle gray horse named Lummox, the lead draft animal on the harvesting machine. For hours, boy atop animal would circle the fields.

Delegates from the Cherokee Nation to the Dawes Commission 1898–99. Clement Vann Rogers stands far left.

At home, his mother read aloud history and humanities books. She taught him manners and helped him learn to read and write long before he entered school. She taught him to teach himself.

Although it was a frontier rarity, Clem Rogers subscribed to the *New York Times*, which arrived by train, bringing news of the greater world.

From his neighbors, Will Rogers learned Indian history. Others communicated the African heritage that slavery had delivered to America. Will Rogers's early mentor was Rab Rogers, the freed slave who had taken Clem Rogers's name and built a home on Rabs Creek. While managing his own farm, Rab helped Clem Rogers as an occasional farmhand and cowboy. The 265-pound man had eleven children. Will Rogers would spend entire days playing at their home and called Mrs. Rab Rogers Aunt Rody.

Clem Rogers's best cowboy and full-time employee was Dan Walker, also a black, whose wife, Agnes, was called Aunt Babe. The Walkers' five children joined Will fishing, riding the range, and enjoying picnics. Will was reared largely with black and Indian children, as whites were excluded from Indian Territory.

Dan Walker was a skilled horseman and bronc rider, and was adept in animal husbandry. He was keenly interested in the staple livestock cattle and horses, but, most important to young Will Rogers, Dan Walker was the best roper in the Cooweescoowee District.

Dan Walker could form a perfect spinning loop. He could rope a cow with precision: around the neck, one leg, or all four legs. It was practical expertise he used to rescue cattle down in a bog or to capture the burly wild animals to be branded, doctored, or castrated. It was also fun. He developed his trade into an art form.

Young Will Rogers was fascinated by the lariat. He imitated. He begged for lessons. He practiced. He learned. Dan Walker taught Willie how to form a honda, the looped knot where a rope would curl to form a lasso. He taught his own children how to knot the honda, build a noose, shake loose the loop, and make the throw. But Willie was the one most interested and he practiced hardest.

Some cowboys would whirl the loop high over their heads. Dan Walker spread the rope at his side, then, with artistry, flipped it onto the target. The rope was an extension of his reach.

Other children longed for a cane pole and fishing

line; Will Rogers kept a lariat in his hands. He began by roping goats.

In 1887, at the age of seven, Will Rogers was packed off to a school called Drumgoole operated by the Cherokee Nation. Since it was seven miles from the Dog Iron, Will spent weekdays with his married older sister, Sallie McSpadden, who lived only a three-mile horseback ride from school. On Fridays, he would gallop to the Dog Iron for a weekend of ranching.

Drumgoole was largely for full-blood or mixed-blood Cherokees. While non-Indians could attend for $1 monthly tuition, most students were Indians who spoke, read, and wrote in Cherokee. English was a linguistic challenge.

"I was just enough white that they suspected my honesty," Will Rogers said.

Throughout his life, a period when Indians often were objects of discrimination, Will Rogers remained proud of his Cherokee heritage.

"My father was one-eighth Cherokee Indian and my mother was a quarter-blood Cherokee. I never got far enough in arithmetic to figure out how much injun that made me, but there's nothing of which I am more proud than my Cherokee blood."

The range had perils. Riding alongside Dan Walker chasing a cow, Willie's pony stepped into a hole and fell. The boy was knocked unconscious and delivered home by horseback in Walker's arms. Full recovery took days.

At age ten, Will Rogers was attending a church-operated boarding school, Harrell Institute at Muskogee, Oklahoma. After the first semester, he was stricken with measles and returned home. At the

15

same time, his sisters Sallie and Maude were bed-fast with typhoid fever. Clem McSpadden, Sallie's four-year-old son, also contracted measles. With guidance from Dr. A. J. Lane, a country physician, Mary Rogers became personal nurse to her ailing children.

Then Mary fell ill with typhoid. Clem Rogers raced sixty miles overnight in a buggy to assist. Dr. Lane was not available, so a second physician was summoned. Dr. Oliver Bagley crossed the thirty-six miles of rugged prairie from Vinita in four hours, only to oversee Mary Rogers's death on May 28, 1890.

Mary America Schrimsher Rogers was fifty-one years old when she was committed to the ranch graveyard. While friends carried the frail body of his mother to her grave, Will Rogers lay sick with mea-sles and torn with grief in the home of "Aunt" Gra-cey Greenleaf, a black woman who was the cook for the Rogers family. Four decades later, Will Rogers wrote:

"My own mother died when I was ten years old. My folks have told me that what little humor I have comes from her. I can't remember her humor, but I can remember her love and understanding of me."

Historians called C.V. Rogers and other Indian Territory cattlemen lean, brown, hard-bitten men. That was the image of settlers of the West. The other personality was the kindly "Uncle Clem" Rogers, whose son needed comfort beyond reassuring words.

A horse named Comanche, was led into Will Rog-ers's life. A five-year-old dun or cream-colored horse with black markings, the horse stood a modest four-teen hands tall and weighed 950 pounds. Save an AR brand on the shoulder, the pony was without

blemish. Clem Rogers bought him from a sympathetic Houston Rogers, who had asked $65 for his mount. Clem Rogers countered with a CV branded pony and a $10 cash bonus. The trade was closed. Will Rogers had a new pal for comfort.

The summer of 1890 was a healing time for Will Rogers, meandering across the prairies with his pals Doc Payne and Bright Drake. Jim, a spotted greyhound dog, would perk his nose at the whiff of a coyote and open a chase, and Rogers would lasso the coyote while riding Comanche. Wild turkeys and goats were other lariat targets.

Offering important labor, the boys would join in trail drives of short distances when cattle were delivered to markets. But their profitable venture was care for motherless calves, called dogies. It was Will Rogers's challenge to convince the calf that a boy's finger was a teat, then to dunk the animal's sucking mouth into a pail of milk for nourishment. Or, if a surrogate mother cow was available, the boys negotiated an adoption. If Will succeeded and the dogie survived, his father awarded him the calf as the start of his own herd.

By summer's end, Will boasted a small herd that would mix with his father's cattle. On the open range, hot branding irons seared individual marks on the rumps of cattle. These were especially designed to be applied in a specific location by an individual rancher. Then the brands were registered in a legal manner that could be enforced by neck hangings for cattle thieves or rustlers.

Willie, in consultation with his father, designed a marking iron that would be his for life and later assumed by his grandson. It was an O with the bot-

tom opening to two feet. Since it would be applied to Will's dogies, he called the brand Dog Iron, the name tabbed to the Rogers ranch.

Will Rogers reluctantly spent a year at the Presbyterian Mission School in Tahlequah, followed by his four happiest years at Willie Halsell College, a Methodist-supported institution at Vinita, some thirty-six miles from Oologah.

Throughout life, Will Rogers's powers of memory and recall of names and events were important assets. So was his humor.

Roommates John McCracken, Charley Mehlin, and Tom Lane recounted a time when Willie was precluded from joining their fun because of a required piano lesson from "Aunt" Eugenia Thompson.

Will Rogers had neglected to practice and had dreaded the inevitable admonishment. However, moments later he joined his pals.

"How did you get out of your lessons?" they asked.

"Aunt Eugenia kept pointing her finger at the notes on the music page and saying 'What's that?'

"I said: 'That's your finger.'

"She slapped me off the stool and told me to go to school. Here I am!"

In 1893, Will Rogers attended the World's Fair at Chicago. Clem Rogers had timed a railroad shipment of cattle to arrive during the storied event, and father and son joined the excursion. With livestock in cars ahead, they rode, ate, and slept in the caboose with railroaders.

After unloading cattle at the Chicago stockyards, the Rogerses were greeted by the two-block-wide, mile-long "Plaisance" of the fair.

International exhibits exposed thirteen-year-old Will to foreign foods, his first camel ride, and the joy of a three-hundred-foot Ferris wheel that almost was like flying. Sheer numbers of people in Chicago impressed the boy from the sparsely settled plains.

The greatest occasion was when Clem and Will Rogers, in classy box seats, joined twenty-two thousand other patrons to watch the Buffalo Bill Wild West Show, fresh from four years of touring Europe.

On fourteen acres near the fair entrance, William F. "Buffalo Bill" Cody built his own sets and played to six million people. The grandstands were canvas covered, but the central arena was in open air. The cast of four hundred included American cowboys and Indian warriors, Russian Cossacks, Irish Lancers, British Hussards, French Chasseurs, and Japanese soldiers. U.S. Calvary galloped to the rescue of a wagon train. A lithe Pony Express rider, mail sack in hand, leaped from mount to mount to open the show. But not ahead of Buffalo Bill.

Cody, astride a huge sorrel named Old Duke, thundered into the arena and bellowed: "Permit me to introduce the Congress of Rough Riders of the World."

The show was on and Will Rogers was its captive.

Vincente Oropeza, the accomplished Mexican roping artist, splashed a new world into the thirteen-year-old's vista. Like his accompanying troop of vaqueros, Oropeza wore a dazzling embroidered jacket, red sash, gold braided hat, and buckskin trousers.

He twirled his lariat with artistry and danced through the flying loops. He was Dan Walker with flair. Oropeza would snare a charging horse by select feet or even the tail. In the finale, one letter at a time,

the Mexican's twirling rope wrote "O-R-O-P-E-Z-A" in the air and spelled a career for Will Rogers.

When he got back home, Will Rogers plunged into a renewed phase of perfecting his trick roping, coupled with increased academic neglect.

After Halsell, at his father's urging, Will Rogers enrolled at Scarritt College at Neosho, Missouri, but only briefly.

One day on campus, he spied a young horse and tossed a lariat around its neck. Unexpectedly, the animal jerked the rope from Will's hand and bolted. It plunged through the tennis court net, jumped a fence, and vanished. Unfortunately, the animal belonged to the headmaster. Will Rogers was expelled.

Back home, Clem Rogers had remarried, moved twelve miles into Claremore, and diversified his business interests into banking, a livery stable, and other enterprises. Will Rogers's three sisters, Sallie, Maude, and May, were married and had started their own families away from the old home place.

If discipline came to Will Rogers, the busy father raved as the sisters nodded in agreement, it would happen at a military school. Clem Rogers dispatched his still-reluctant seventeen-year-old son to Kemper Military Academy in Missouri, a disciplined training ground where sons of the affluent paraded in starched uniforms with pomp and poise.

Willie arrived wearing spurs on high-heeled, red-topped boots; a bright vest; a flannel shirt; a short Stetson hat; and a kerchief around his neck. Lariats were coiled to his luggage.

Will Rogers accepted the uniform and even excelled

Will Rogers in his Kemper Military uniform, circa 1898.

in elocution as he recited the classics. In an era when students were called before the class to recite their lessons, Will Rogers inevitably reached for laughs from classmates instead of high marks from the teachers. Instructors recalled his ability to easily commit to memory difficult volumes of history charts. Instead of capitalizing on the knowledge, he often would invoke gestures and twist emphasis to gain a laugh. While his overall grades were only sporadically good, he consistently scored best in elocution, letter writing, and political economy.

He adopted the Kemper military uniform easily and wore it proudly but with just enough carelessness to maintain his individuality.

During visits home, Will Rogers would wear the uniform and demonstrate his military prowess.

Quickly borrowing a cowboy's rifle that he didn't know was loaded, he began executing the manual of arms. Strutting, bellowing commands, and counting cadence, he properly slammed the rifle butt to the ground.

The weapon fired.

The slug burned up the side of his face, flipped his hat into the air, and left a faint white scar that was visible for life.

Throughout his movie career, when pals like Tom Mix were filming lucrative Western shootouts, Will Rogers never was cast as the cowboy with a gun. His talking roles in movies were hits without gunfire.

Will Rogers enjoyed the absurd even as a Kemper cadet. When an inexperienced corporal barked a wrong command, Will seized the opportunity and followed the order precisely by marching into a lake, breaking cadence only with his whooping laughter.

THE LONESOME COW HERDING YEARS

WITHOUT NOTICE ONE NIGHT AND CLAIMING HE DIDN'T know if he jumped or was shoved, Will Rogers caught a train and, in his own words, he "quit the entire school business for life. I spent two years at Kemper. One in the guardhouse and one in the fourth grade. I spent ten years in the fourth grade and knew more about McGuffey's Fourth Reader

than McGuffey did," he would joke about his formal education. Violations had earned him 150 demerits—150 hours of penalty marching time that was never settled.

The eighteen-year-old cowboy arrived in west Texas seeking travel and adventure but needing money and a job. Because of his tender age, recruiters rejected him for Colonel Theodore Roosevelt's cavalry of Rough Riders. He heard a trail boss was seeking to hire a drover and arrived at the camp in time to overhear a young applicant be rejected because he bragged profusely of his abilities.

In contrast, Will Rogers modestly cited his experience and was hired as a horse wrangler—the bottom job. Hard, steady work got him promoted to a regular cowhand. He drifted between $30-a-month jobs in Oklahoma, Texas, and New Mexico. The duties were riding the range and overseeing the herds; he worked his rope in roundups or driving cattle to railroads in Kansas for shipment to eastern markets. The cowboys' sport was steer roping in timed competition.

Cowboying was solitary work on the high dry plains that he said "was the prettiest country I ever saw in my life, flat as a beauty contest winner's stomach, and prairie lakes scattered all over. And mirages! You could see anything in the world just ahead of you."

At the physical size he would maintain lifelong, five-feet-ten and 170 pounds, Will Rogers was lithe and strong. From childhood training at home, he was an able, seasoned cowboy with excellent skills as both horseman and roper. He understood cattle and seemed to enjoy sleeping on the ground with his

saddle as a pillow and eating meals from chuck wagons that featured mostly his favorite food: beans. He was not boisterous, but good-natured, laughing at other's jokes and working hard.

In riding the cattle herds, Will Rogers preferred spurring his horse in pursuit of a wild dogie, roping the critter, then dragging it to the branding iron fire where other cowboys tackled, downed, and seared the wildly kicking calf's rump with identifying marks. It was spirited, physical exertion.

Will Rogers said there was no greater or happier life in the world than that of a cattleman. He loved ranching and said he regretted that he had not lived thirty or forty years earlier in Indian Territory ahead of the nesters, farmers, cities, barbed wire fences, and so-called civilization. He wished he had taken all his drinks from a carved-out gourd instead of a paper cup. He lived in the tail end of a passing era.

Hired to manage a trainload shipment of cattle to the William Randolph Hearst ranch in California, Will Rogers finished the job in San Luis Obispo. With a fellow cowboy, he visited bustling, modern San Francisco and shared a room that sparkled with the light of a gas lamp. Accustomed to kerosene lamps that fed on liquids, Will Rogers's pal "blew out" the hotel light. Natural gas flowed from the jet unlighted. Both men were found unconscious from asphyxiation.

The emergency room doctor abandoned Rogers for dead, but experimenting medical students resuscitated him. After traveling home, he spent a period of recuperation at Hot Springs, Arkansas, taking curative baths.

Clem Rogers's sprawling ranch had been bisected

by the railroad, and in 1898 the U.S. Congress passed the Curtis Act, effectively whittling the sixty-thousand-acre spread to a 148-acre allotment of Indian land shared by Clem and Will Rogers.

Tenant farmers from Illinois lived in the old home place and Clem Rogers had become a banker when Will returned from the western ranges in January 1899. He wanted to settle down on the old ranch with his pal Spi Trent and to restock the holdings.

The Rogers family furnishings were gone from the two-story house that stood in disrepair. Worse, the tenant farmer's wife failed to understand that a cowboy needed gravy, beans, and biscuits three times a day.

The two cowboys retreated to a private site, built a twelve-foot square cabin with no windows, and hauled in a double bed, a cookstove, and some boxes. They kept a kettle of beans cooking at all times, and visitors had a standing invitation to "just grab a tin plate and help yourself."

A stray steer rambled into the cabin, became disoriented, and bucked around until the building collapsed. By then the Illinois couple had abandoned the frontier, and the two men moved into the old home place.

Will Rogers was dispirited by the dull routine of the management side of being a rancher. Between dances and steer roping contests, he neglected serious ranching duties but was an avid, accomplished cowboy who competed hotly and won prizes.

Later, together with three other underwriters including Colonel Zack Mulhall, Will Rogers promoted a roping contest during the Confederate veterans' reunion in Memphis, Tennessee. Well

attended but poorly managed, it lost money. The good luck was that Will launched a powerful friendship with Mulhall, who would become a major promoter of Wild West shows.

With sixty musicians who, Rogers said, "could not ride in a wagon unless their shirt tails was nailed to the floor," Mulhall organized a cowboy band to play state fairs but added Rogers and another genuine cowboy to rope steers. After one show, during a barbecue, Will Rogers was asked to speak.

"This is a mighty fine dinner." He paused. "What there is of it."

The crowd laughed. Will Rogers tried to cover up: "Well, there is plenty of it." Pause. "Such as it is."

Laughter again, and the embarrassed cowboy sat down. In a sense, he had blurted out what would become a trademark monologue.

With the opening of the railroad, Will Rogers's mode of travel changed to trains and involved either renting a cattle car stall for his horse or leaving the animal at the livery stable in Oologah.

In the autumn of 1900, Will Rogers disembarked at Oologah from the eight P.M. passenger train from Kansas City. Seeking a banjo he had checked as baggage, the twenty-one-year-old cowboy entered the station and encountered a strange, slight woman with short-cropped hair. He couldn't speak. He just looked at her. She remained mute. She stared. Seconds ticked away. Then the cowboy wheeled and without a word, left behind the station and Betty Blake.

She was the seventh child of James and Amelia Blake, who operated a mill near their log and frame house at Silver Springs, Arkansas. Two years before

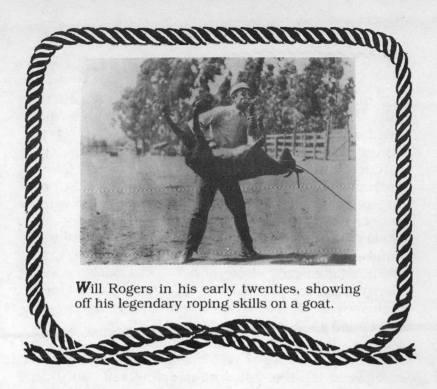

Will Rogers in his early twenties, showing off his legendary roping skills on a goat.

the railroad came to western Arkansas and two months before the birth of Will Rogers, Betty had been born on September 9, 1879. Her slight seniority to Will apparently was somewhat of an embarrassment or concern that led to her date of birth being listed as September 9, 1880—even on her tomb marker in the family sarcophagus at Claremore, Oklahoma.

The Blake family grew to nine children: boys John and James Jr. and girls Cora, Anna, Waite (in honor of the Cherokee Confederate general, although the Blakes used a different spelling), Theda, Betty, Virginia, and Zulika.

Their grandfather, Dr. Larkin H. Blake, had been a physician in Alabama who moved his practice to Greene County, Missouri, where his son, James, was

born on October 7, 1845. The doctor practiced for a while in the Arkansas village of Silver Springs but ended his career in Bentonville.

On the other branch of the family tree, Betty's maternal grandparents, M. Chris and Emeline Crowder, had been drawn to Arkansas from North Carolina six years after their daughter, Amelia Crowder, was born on October 25, 1846.

Asked of their ancestry, the nine Blake children would say English. Or Southern. Love for the Confederacy faded only slowly.

Betty was not yet three years old and her eldest brother was fifteen when their thirty-six-year-old father died in June 1882. Faced with rearing nine children, the widow Amelia Blake sold the mill and farm and purchased a house she necessarily enlarged to ten rooms in the fledgling railroad town of Rogers. Her skill as a seamstress provided income, and the busy mother was able to work at the cheerful home on East Walnut Street, which became a social factor in Rogers, Arkansas.

Her children would be guided in their first years by the secular and religious teachings of the Reverend J.L. Dickens in the new Congregational church. In 1893, the Rogers Academy opened, and church and education were separated. The nine Blake children managed to capture two graduation certificates from the academy, but Betty never graduated.

The economics of the single-parent family simply required that each child, at the earliest possible age, find employment.

As a teenager, Betty Blake became a typesetter at the *Rogers Democrat* newspaper. Later she was a store clerk in the H.L. Stroud Mercantile Company,

and she traveled to the tiny town of Jenny Lind, Arkansas, near Fort Smith, for a job as a railroad billing clerk. Betty Blake played mandolin in the twenty-one-member Bentonville Young Ladies Orchestra, rode bicycles, sang in plays at the town theater, and helped establish the library.

At age twenty, Betty Blake was stricken with typhoid during an epidemic. For a while she was gravely ill. Then, in a listless, rundown condition, she boarded a train to recuperate with the care of her eldest sister, Cora, whose husband, Will Marshall, was station agent for the Missouri Pacific Railroad at Oologah, Indian Territory.

The typhoid had cost Betty her long, light brown hair. To improve her appearance, she had trimmed her remaining locks into a boyish bob. Cora Marshall had written that the only young people in the town were the daughters of the hotel keeper and a boy, Will Rogers, who lived on a ranch a few miles outside Oologah.

Oologah in 1900 sported the depot, a frame hotel, a livery stable, one church that also served as a school, and livestock pens. Other scattered buildings were connected by sagging boardwalks. The street was unpaved, and trees were far less numerous than in Arkansas.

The Missouri Pacific depot had three rooms added for the agent's family. When trains passed, the wooden building rattled. Two passenger trains—one northbound and the other southbound from Kansas City—whizzed by daily. They were the town's entertainment, and everyone would run to watch their passing. They stopped only when signaled about a

*B*etty Blake, who later became Mrs. Will Rogers.

waiting passenger or to discharge an incoming traveler.

When the eight P.M. train from Kansas City defied custom and stopped on a wintry evening, Betty searched from the bay window as a figure alighted.

It was Will Rogers, who couldn't even state his business. A moment or so later, Betty's brother-in-law came in with the express packages. One was a banjo addressed to Will, who spent the night at the hotel across the road.

Early the next morning, Betty heard the sound of a horse's hooves. In her nightgown, she watched through a window as Will Rogers rode eastward from town toward the Dog Iron. His coat collar was turned up to protect against the cold. One hand held the reins, and the other clutched a valise. He wore a derby hat. He had abandoned his banjo.

A few nights later, both Betty and Will were invited to supper at the hotel. He was quiet during the meal but afterward produced a roll of music he had purchased in Kansas City and began singing popular songs in a high tenor voice. His shyness vanished.

Through the music, a magic grew between Betty and Will. His singing led to popcorn popping and a taffy candy pull. Before departing, Will gave Betty the sheet music with instructions that she should practice the numbers on her sister's piano for a later party. The evening was a social success, but no special words were spoken. The cowboy simply appeared at the train station the next day to claim his banjo, which like other musical instruments he never really learned to play.

Until Betty returned to Arkansas for Christmas, the couple attended parties and became fast friends. Back home, she told Arkansas friends, "I've got me a cowboy,"

The first letter Betty received was signed "Injun Cowboy W.P. Rogers." It requested her "kodak picture" for "a lonely Indian Wigwam" and complained that "we were just getting acquainted when you left. Hoping you will take pity on this poor heart broken cow pealer and having him rejoicing over these bald prairies in receipt of a few words from you, I remain your true friend."

As a genteel young lady of Arkansas, Betty allowed a proper lapse of time before replying. Will Rogers's second letter offered her a choice of his ponies if she would return to Oologah and proclaim: "I am yours with love." He asked her to burn the letter and never mention the suggestions if

she rejected the ideas. Betty kept the letter, and the couple met twice over the next few months, with Will acting subdued, shy, and offended because he had learned from others that Betty's friends had ridiculed her friendship with a "Wild West Indian Cowboy."

One meeting was at Springfield, Missouri, where Will Rogers, wearing a small Stetson hat, rode Comanche while performing in Colonel Mulhall's Wild West Show. They only made small talk, and any romance seemingly had cooled. Betty believed the relationship was hopeless.

For Will Rogers, other things were depressing. Sodbusting farmers had invaded the Cooweescoowee District and were dividing the range. Clem Rogers had built the first fences, and now they were everywhere. Will Rogers liked the wide open spaces. Farm management was not his forte. Tales of Argentina, gauchos, and limitless opportunity lured the restless cowboy. He promised his pal Dick Paris a guaranteed round-trip ticket for company on a visit to South America.

With $3,000 from the sale of his livestock to Clem Rogers, and some harsh words between father and son, twenty-three-year-old Will left Oologah by train for the port of New Orleans, but found no southbound boat. The two pals sailed to New York but just missed the ship to Buenos Aires.

Advised to try London, they found that their arrival in England meshed with the coronation of King Edward VII, and Will Rogers wrote he had seen "his big Nibs at a distance. Don't think he recognized us."

Finally the two travelers found a ship sailing for Buenos Aires, where they arrived ten months after leaving Oologah. The aspiring ranchers traveled eight hundred miles into "the interior" and across the countryside, studying the cattle industry.

"It's no place to make money unless you have $10,000 to invest," Will Rogers wrote home, saying cowboy wages were only $5 to $8 a month, and his inability to speak Spanish was a barrier.

"I think I can say 6 words," he wrote; "did know 7 and forgot one."

Paris grew homesick and, true to his promise, Will Rogers purchased his pal's homebound ticket. The $3,000 from the cattle sale to his father was depleted, and Will Rogers was penniless. For a while, he slept on a park bench until he found work roping mules for 25 cents a head.

Will Rogers remained a faithful son and often wrote letters to his father and his sisters, and occasionally sent endearing notes to Betty Blake. In 1902, mail traveled slowly by steamship and train. The messages, spiced with humor and small talk, concerned care for his pony, Comanche; payments on his life insurance policy; and defense of his financial dealings as respectable. Will Rogers expressed concern over gossip about him frittering away his father's money. He admitted having small regard for wealth, but said he was "as happy as if I had a million."

Will Rogers learned that a boat loaded with livestock was looking for a cattle tender. In South Africa, forty-five hundred miles distant, the Boer War had decimated herds. Aboard the feculent livestock boat were cattle, sheep, horses, and ponies for the estate of a British subject named Piccione, who

had purchased them. Will Rogers suffered motion sickness and welcomed both dry land and the sound of English-speaking voices when the cargo arrived in Africa. After delivering the stock that included fifty thoroughbred horses, Will Rogers worked as stable boy and steeplechase jockey for two months on the estate he described as a "veritable palace heated by steam and lighted by electricity."

THE ROPING ARTIST AND SHOW BUSINESS

CLAIMING PICCIONE COULD "HOLLER LOUDER AND MORE at a person than Papa," Will Rogers welcomed a chance to drive a herd of mules to the market at Ladysmith, South Africa, where he discovered Texas Jack's Wild West Show.

Will Rogers, twenty-three, signed on as "The Cherokee Kid: Fancy Lasso Artist and Rough Rider" but doubled as a singer of tunes such as "Just Because She Made Dem Goo-Goo Eyes." Beyond deft roping displays, Rogers played black parts and was an Indian who staged "blood curling scenes of western life in America." Texas Jack, the "world's greatest sharpshooter," liked Will Rogers and groomed his act as "the man who can lasso the tail off a Blowfly."

"One of the smartest showmen I ever met," is how Will Rogers described Texas Jack. "He gave me the

TEXAS JACK'S CIRCUS.

THE

CHEROKEE KID

THE WORLD'S

CHAMPION LASSOER.

He will perform the following feats with the Lasso:

Catching a Horse by One Leg, Two Legs and Four Legs.

Throwing the Rope with his Foot and Catching the Horse.

Forming a Loop in front of his body, carrying this behind him and catching the Horse.

Holding the Lasso by one end, jerking the rope through the air and tying single and double knots during its flight

Several Varieties of the "Crinoline," making it on Horseback, forming a circle round the Horse with a Lasso 65 feet long,

THE MOST WONDERFUL FEAT KNOWN.

Holding a Lasso in each hand, throwing both at the same time and catching Horse and Rider, each by the neck, while going at full gallop.

The South African bill that featured Will Rogers as "The Cherokee Kid."

idea for my original stage act with my pony. He could do a bum act with a rope that an ordinary man couldn't get away with and make the audience think it was great.

"I used to study him by the hour and from him I learned the great secret of show business:

"Knowing when to get off."

Texas Jack had raised the Cherokee Kid's wages from $20 to $25 a week, allowing Will Rogers to send money home. He quit the show after nine months with a letter of recommendation describing him as sober, industrious, reliable, and hardworking.

Explaining in a missive to his father that he was "heading around this old globe to see if it really is round," Rogers traveled east from Africa to Australia, touring the cattle and sheep industries before moving to New Zealand, where he used Texas Jack's letter to land temporary work with the Wirth Brothers Circus, billed as "The Cherokee Kid, the Mexican Rope Artist."

Since Mexicans had developed lariat artistry and had been Will Rogers's inspiration, the circus owner's wife, Mrs. George Wirth, sewed a gold-braided skin-tight red velvet suit that the swarthy Will Rogers proudly wore instead of the customary American cowboy gear: chaps, bandanna, and bright shirt.

"The Cherokee Kid is a gentleman with a large American accent and a splendid skill that fairly dazzled the crowd," a reviewer wrote in the *Auckland Herald*. "He seems to be able to lasso anything from a wildly galloping steed or the business end of a flash of lightning."

The local newspaper called the act "highly origi-

nal" and "the best performance of the kind we have seen."

With cash savings in a money belt, Will Rogers had planned only a short run before going home. Then, in a moment of levity, with no experience as a card player, he joined a poker game with seasoned cheats. He lost the money in his belt. It required eight months working the tour across New Zealand and Australia with Wirth Brothers before he finally had sufficient money for passage home.

"I started out first class, dropped to second class, and come home third class," he wrote, "when I was companion to those cows on that perfumed voyage to Africa it might be called no class at all."

It was spring 1904 when third-class passenger Will Rogers passed under the Golden Gate Bridge, landed at San Francisco, and headed toward the Indian Territory he had left behind two years and fifty thousand miles ago. Teddy Roosevelt had been elected President of the United States. Oil had been struck at Red Fork some forty miles south of the Oologah ranch, and the territory sizzled with oil boom fever. Automobiles had come to the country.

With its dazzling electric light bulb pavilion, St. Louis, Missouri, was preparing for the centennial celebration of the Louisiana Purchase—that eventful transfer of land from France to the United States that had given the American West its European morality, English language, and common law.

Located on the west bank of the Mississippi River where Clem Rogers, riding a mule, had ended a trail drive to sell cattle, St. Louis now was the gateway to the West. The self-proclaimed capital of this new

civilization was saluting progress by staging a World's Fair.

At age twenty-five, Will Rogers was ready to claim the "poet lariat" crown. Within a week after returning from the world tour and reunited with his favorite horse, Comanche, the trick roper joined his old employer, Colonel Mulhall, in a new Wild West show. Mulhall's cowboys included his skilled cowgirl daughter Lucille and aspiring cowboy Tom Mix.

Mulhall's cowboys teamed with the Cummins Indian Congress for a combined cast of hundreds. Will Rogers devised intricate acts. Laying two ropes on the ground, holding the ends in both hands, he would snap them upward as a horseman rode past, draping the rider's and horse's necks simultaneously.

Will Rogers could throw three ropes at once. One rope would fly through the air over the horse's head. The second lariat encompassed the rider. The third rope captured all four of the horse's legs, coming up from the ground under the running equine. Gently, as the horse and rider halted, Will Rogers would draw taut all three lariats.

For World's Fair crowds, Will Rogers worked two Wild West shows during the day. For nighttime employment, he discovered a new outlet for his artistry—the indoor stage.

Hometown pal Ted McSpadden and Will Rogers teamed in special twenty-minute roping demonstrations at a burlesque house while backstage the striptease queens wiggled back into their layers of clothing so they could start peeling again. Trick ropers simply relaxed the audience between the serious acts, but these were Will Rogers's first perfor-

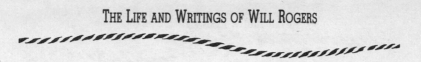

mances indoors, on a wooden stage and under bright lights.

Back on the midway, the impeccable Betty Blake, who would only reluctantly remove her hat in front of a man, had traveled from Rogers, Arkansas, to St. Louis to visit her sister and to see the World's Fair. While in the Oklahoma pavilion, she was surprised to hear the name Will Rogers. She hadn't known he was back in the United States or was playing in the show.

In an act that normally would be considered outrageous for a proper lady from Rogers, Arkansas, Betty Blake sent Will Rogers a note that was answered with a return invitation to watch the matinee and then join him for dinner.

At the matinee with her sister and cousin, Mary Quisenberry, Betty Blake heard a high-pitched cowboy yell as Will Rogers galloped into the arena. He was not in chaps and modest Stetson. No, there was Will Rogers in his made-in-Australia Mexican outfit: tight, gold-braided red velvet and flash!

As her sister and cousin gave Betty sidelong glances and smiled at the gaudy costume, the lady from Arkansas sat in horror. She was too stunned by Will Rogers's attire to hear the applause or to appreciate Will's increased expertise with the rope.

Afterward, Will Rogers changed out of the velvet costume and the couple toured the fair while he cooled Betty's distress by explaining the history of the Mexican garb. He said he had worn it especially for her instead of his traditional cowboy clothing. She glared. Will Rogers never wore red velvet again.

The Arkansas lady made clear her reservations about show business. She shared Clem Rogers's

opposition to his career direction and wanted Will to come to his senses, move home, and take over the family businesses, which had expanded into the First National Bank of Claremore.

Will Rogers quietly disagreed. With help from friends of other dispositions, he would continue in show business. The owner of the Standard Burlesque Theatre of St. Louis wrote a Chicago friend, J.J. Murdock, and got Will Rogers a $30-a-week booking in a vaudeville show. Neglecting to send the customary confirmation telegram or advance publicity, the roper arrived in Chicago to learn his act had been replaced when no word of confirmation had come.

Will Rogers stalked the theatrical circuit and overheard a house manager urgently trying to book an act. Interrupting, Will said he would be ready to go on in as "long as it would take me to go to my hotel and get my ropes."

Within minutes, Will Rogers was mounting the stage of the Cleveland Theatre on Wabash Avenue for a week's engagement, interrupted only when a trained dog from another act escaped onto the stage and Will roped him. The crowd laughed and clapped. It became a clue for a change: The public liked live targets. A pony named Teddy in honor of President Roosevelt would later join the act and be roped on stage. It would require custom-made boots for Teddy to keep the horse's hooves from sliding, but Will Rogers was undaunted.

Colonel Mulhall had booked his Wild West exhibition at the National Horse Show at Madison Square Garden in New York City, and Will Rogers won a spot in the cast.

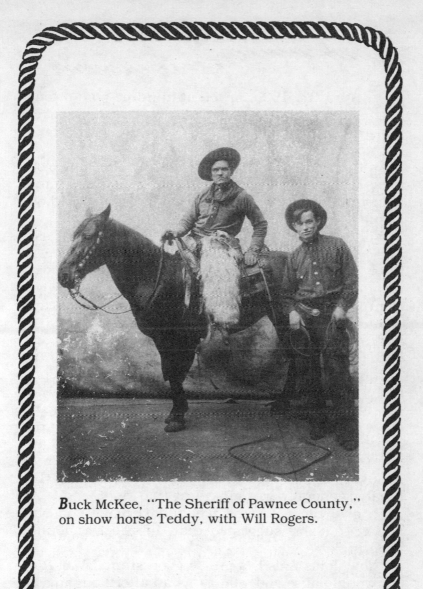

*B*uck McKee, "The Sheriff of Pawnee County," on show horse Teddy, with Will Rogers.

On April 27, 1905, an eight-hundred-pound long-horn steer broke free, defied cowboys and police, jumped a rail, and climbed into the grandstand. Patrons fled in panic.

As the story was fully reported by the New York press, the steer climbed three flights of stairs into a balcony with a half dozen lariat-swinging cowboys in pursuit.

Will Rogers ran up the Twenty-seventh Street side and headed the steer off. As it passed from the corridor again into view of the spectators, who recounted events to reporters, the Indian cowboy from Oklahoma roped the steer's horns. Alone and afoot, he countered the enraged animal's strength and swerved it down the steps on the Twenty-seventh Street side, where it jumped back into the ring.

Publicity about his heroics led vaudeville promoters to sign him to open at six-thirty P.M., June 11, at Keith's Union Square Theatre in a supper show that featured him roping Teddy, who was ridden by Buck McKee, billed as "The Sheriff of Pawnee County." It was a silent act without music or dialogue. It also was a bad time slot, because the theater generally was empty at that hour.

To give the act some life and perhaps add suspense, someone suggested that the roper announce each trick.

"Now, folks, this is a pretty good stunt." Will Rogers would pause and, almost as an afterthought, say, "If I can do it."

The naive wit and the slow Will Rogers drawl struck the crowd as intended humor. They laughed. Will Rogers was offended. Was his special art being ridiculed? No. He was funny.

Accustomed to laughs while spinning yarns with friends, Will Rogers was slow to realize that his stage ad libs were greater treasures than his rope tricks.

Moving from silence to talk pleased audiences, and the quips came easily. Will warmed to the new format.

He purposely would loop only three of Teddy's legs, then quip with a grin: "Got 'em all but one that time."

"I'm going to throw two ropes at once and get the horse with one and the rider with the other," he said, paused, grinned, then added, "I don't have any idea if I'll get it, but here it goes."

After a spectacular exhibit, Will Rogers would turn to the footlights with an aside:

"Out west, where I come from, they won't let me play with this rope. Think I might hurt myself."

Or, in jumping back and forth through the lariat in the Texas skip, he would purposely hook the rope with his toe and the rope would fall to the floor. In mock disappointment, he would stick his chewing gum on a prop and try again with flawless rope skipping. Afterward, he would retrieve the gum and pop it into his mouth. Crowds roared.

"Swinging a rope isn't bad," he would say, grinning, "as long as your neck's not in it."

Spontaneous humor and skill as a trick roper meant popularity at Keith's and good newspaper reviews, and led Will Rogers to vaudeville's finest, Hammerstein's Paradise Roof.

William Hammerstein argued that the smallness of his stage would enhance the act. Taking the horse Teddy by elevator to the roof was the behind-the-scenes feat.

After Paradise Roof, Will Rogers moved to Hammerstein's Victoria Theatre. The graceful, finely timed roping feats involved catching both Teddy and Buck McKee or playing out a hundred-foot loop in the physically grueling rope trick called the crinoline. The quip-filled act won curtain calls and $125 a week.

"The greatest catch in Vaudeville," his calling card read as Will Rogers began touring the nation's theatrical circuit.

A gold-bordered blue saddle blanket embroidered with "Will Rogers" was added to Teddy's back. When the man-horse team traveled to a new town, Will Rogers would ride the pony to a main intersection, dismount, drop the reins, and walk to the stage door with unbridled Teddy following faithfully. Trailing children loved the scene, and the press covered the spectacle.

Europe's most important theater, the Winter Garden in Berlin, booked the act for four weeks. Rogers then moved to the Palace in London, which led to a special showing at the Ranelagh Club, with King Edward VII in attendance, where Rogers was presented with a silver cup trophy. All this less than a year after the Madison Square Garden steer-roping incident.

In anticipation of her brother's visit home, Will's sister, Maude Lane, invited Betty Blake to a house party at Chelsea. Her train from Arkansas stopped twenty miles before the destination, and Betty was jolted to see Will Rogers board the train. Since the seat next to her was taken, they quietly shook hands and he walked to a vacant seat in the rear of the car. At Chelsea, Will Rogers went forward, took Betty's

baggage, and stepped down from the train at her side. The apparently nonchalant scenario required planning and coordination.

Yet, during the visit, Will Rogers was elusive and saw Betty Blake only for group horseback rides and during parties. Betty returned home baffled about the relationship. A week later, Will Rogers unexpectedly arrived at her home in Rogers and proposed an immediate marriage. Betty Blake refused.

"I simply could not see a life of trooping the country in vaudeville," she said. "Will could not understand my attitude. Our parting was a sad one, but we promised to write."

Will Rogers returned to the $200-a-week vaudeville circuit and sent a note from Syracuse to Arkansas with a lace handkerchief. He said he had carried it since he was in Africa, intending to give it to the lady he would marry, but now, "there's nothing doing for me. I will just give it to you as I kinda prize it."

Will Rogers enlarged his act with two new cowboys and three additional horses for a Wild West show and was booked in Europe. Bucking horses and the crowded act failed to excite audiences. To escape financial disaster, Will Rogers scaled back to his traditional act with Buck and Teddy and earned sufficient funds to send the extras home. The proven trio returned to America to earn $250 weekly in vaudeville.

In 1911, Will Rogers spent the equivalent of a year's salary, $10,000, to buy a twenty-acre hillside in Claremore, Oklahoma, for a home site. He was earning big money and, in flashy show business grandeur, Will Rogers also bought a big diamond

ring and an alligator bag. During his travels both the warted bag and gaudy ring were stolen.

"So it took two thieves to at least try to give me the appearance of a gentleman," he said. "Now when I see a man wearing either a diamond ring or an alligator valise, I offer up thanks to the two men who robbed me."

He also used his funds to shower Betty Blake with gifts. During an open week in 1908, he again arrived unexpectedly at her home and announced that after a final tour, he would quit show business. Would she marry him?

For several weeks, on his private booking schedule, large capital letters across the week of November 23 stated: "GETTING MARRIED."

The wedding occurred in the Blake home at 307 East Walnut, Rogers, Arkansas, eight years after the couple had met at the Oologah train station. Both bride and groom were age twenty-nine.

The wedding was fully reported by the local press, and the newlyweds took the northbound evening train for St. Louis en route to New York City. Then, after a run in Europe, the Arkansas newspaper claimed, they would return to the farm in Oklahoma.

With his pony Teddy and faithful Buck McKee, Will Rogers played twenty-minute acts twice daily, giving plenty of time for Betty's honeymoon along the Orpheum vaudeville circuit, moving from town to town. Betty had long carefree hours with an impulsive, energetic new husband. For Will, it was a rediscovery of the America he had previously visited alone. Now he lovingly shared old haunts with his wife, who said that "he hated to lose a moment

of his life; he wanted to do everything right now. He nearly ran me ragged."

When it was time to return to Claremore, a lucrative offer to play the Percy Williams theaters on the eastern seaboard interrupted. His promise to quit show business would never materialize; in fact, Will Rogers expanded the act to include a women's bucking horse championship and trick riders.

Standing in the wings watching the gala at the Keith's in Philadelphia, theater manager Harry Jordan whispered to Betty: "I would rather have Will Rogers alone than that whole bunch out there."

FROM ROPES TO JOKES

When Betty Told Will What the Theater Manager had said, he faced a critical career decision. Show business people understand being hired and fired. But after six years together, it was agony for Will to retire Teddy to the range at Oologah. Then Buck McGee quietly left for a new life in California. The three-member act was abandoned. Alone, Will Rogers and his lariat would face audiences for $300 a week with a new routine and a new challenge. He would talk.

The challenge, he said, was "to make jokes and tricks come out even. I've got to either practice roping or learn more jokes." What he imparted really

were not jokes, simply well-timed comments with a funny twist, delivered in a slow drawl.

Will Rogers became acquainted with Fred Stone, a celebrated song-and-dance actor from Kansas. At first, Stone taught Rogers to dance while Rogers taught Stone trick roping. A lifelong friendship between kindred professionals grew. Stone called Will Rogers "the greatest 'one man show' the world has ever known. I've heard him on one of his concert tours talk three hours without stopping and then say to his audience who was clamoring for more, 'Aw, go home. We're going to turn out the lights.' People knew him as humorous. He had a brilliant mind but the softest heart in the world."

Stone and Rogers became neighbors, played polo, roped, and rode horses together. If one was discouraged, the other was nearby with a helping hand.

In 1911, Clem Rogers brought his daughters to Washington, D.C., to watch his son perform at Chase's Opera House. While he had grumbled earlier that his son's earnings were so high that it "looks like something is wrong," Clem Rogers counted seats in the theater, multiplied the ticket price, and announced to his daughters: "Girls, that manager sure is making a lot of money off Willie."

Proudly, the man who wanted Will Rogers to run the family business would inform theater patrons that he was the star's father. Clem Rogers would lead a crowd of admirers to the stage door for a personal introduction to his son.

Back in Claremore, knowing that Betty was pregnant, Clem Rogers mailed some baby socks and a pair of small beaded Indian moccasins for the new Will Rogers Jr., who arrived October 29, 1911, in

*E*ddie Cantor, Will Rogers, and friend Fred
Stone (left to right).

New York City. Five days later, Clem Rogers, seventy-two, died in his sleep at his daughter's home at Chelsea, Oklahoma.

The *Claremore Progress* obituary read: "Mr. Rogers was one of the most prominent citizens of the Cherokee people and was noted far and wide as the most philanthropic and public spirited citizen. He was a friend of school children and every person in distress could find a ready helper in Uncle Clem Rogers. He amassed a fortune in his time but a large portion of it had been devoted to charity before he died."

The family legacy and the Cherokee flame had been passed to a new generation by a father who died at peace with his son.

The following spring, Will Rogers's specialty act

was featured in *The Wall Street Girl*, starring Blanche Ring. During the opening performance, a whisper swept the audience, and patrons began to depart quietly. Backstage, Will Rogers learned the cause of the patrons' unrest and impulsively walked to the footlights and announced that on its maiden voyage, the ocean liner *Titanic* had struck an iceberg and had sunk. The death toll eventually rose to fifteen hundred.

The musical continued with a solemn audience that night and nonetheless enjoyed a long, successful Broadway run. Will Rogers afterward mixed vaudeville engagements with appearances with *The Wall Street Girl* touring company while Betty Rogers and Will Jr. visited Rogers, Arkansas.

Will Rogers was on the stage in Texas when a telegram arrived announcing that Mary Amelia Rogers had been born in Arkansas on May 18, 1913. Joyously, Will Rogers read the telegram to the audience, then continued the act.

After a subsequent $400-a-week tour in London cut short by rumblings of war, the showman moved his family to Amityville, New York, across the street from Fred Stone's home.

Bookings slowed, and Will Rogers pondered his future. Fred Stone encouraged him to stay in New York, "stick it out here. A part in a show is all you need."

James Blake Rogers, called Jim, was born on July 25, 1915. Will Rogers had purchased an Overland touring car and kept a stable of horses, including a solid black pony named Dopey, who rambled through the house freely but was called to duty

when one of the children turned age two and began riding lessons.

Such household expenses were onerous when work was slow. To survive in New York, Will Rogers would play suburban theaters for as little as $75 a week or accept one-night jobs to pay bills. To hide his financial difficulties, he asked that his name be changed in billings. Theater owners cooperated and pals in the newspaper business never told the public that the performer was the rising star, Will Rogers. Along the way, Will Rogers placed on sale a diamond ring he had acquired but never wore. A friend brought a potential buyer, who took the ring with a promise to pay $1,000, but gave no receipt. Betty was shocked by her husband's trust. A few weeks later, a check arrived. Will Rogers was not surprised. Betty was.

Will Rogers said: "I'd rather pay too much than charge too much. I would rather be the guy who bought the Brooklyn Bridge than the one who sold it."

"I'm just an old country boy in a big town trying to get along. I have been eating pretty regular and the reason I have is because I have stayed an old country boy."

Just when his professional prospects appeared most dim, *Hands Up*, a Shubert musical, at the last minute added him to its opening night playbill, hoping to strengthen the show. His surprise appearance on the stage brought applause. His jokes brought laughs. His rope tricks worked. Fred Stone was in the audience leading the cheers. Will Rogers won an encore, and the applause strengthened. Then the lights were cut off. Thinking that management had doused the floodlights to end his performance, Will

Rogers retired testily to his dressing room. The applauding crowd would not let the musical continue. They wanted Will Rogers, hands down. Shubert himself rushed to the dressing room, explained the lighting fiasco was an accident, and dragged the roper back to the stage. Grinning, Will Rogers gave a second encore and played *Hands Up* until his one-man show was booked into the imposing Palace Theatre on Forty-seventh and Broadway. Will Rogers was back in the big time.

Then came an offer from Florenz Ziegfeld's vaunted *Midnight Frolic*, which opened at the strike of twelve and featured dancing beauties who played early mornings on the roof of the New Amsterdam Theatre in a nightclub setting.

While the women changed costumes, Will Rogers's routine was a slow commentary mixed with rope tricks to fill time. Gene Buck, Ziegfeld's informed lyricist and a savvy producer, felt Will Rogers gave the show balance. Ziegfeld, a creator of pageantry, beauty, and glitter, was skeptical about a homespun cowboy humorist. Buck argued that paying audiences liked Will Rogers but reluctantly agreed to the boss's order to fire the comic. Ziegfeld left town, and Buck sauntered into Will Rogers's dressing room to relay the owner's ultimatum.

Before he could speak, Will Rogers asked for a $50-a-week raise and announced that he would follow his wife's suggestion and comment on the daily news. Buck overlooked the request for a raise but postponed the firing while Will Rogers began delivering a new act as a commentator on timely topics.

Over the next four years, Will Rogers's six- to ten-

minute appearances each featured new material fresh from the latest editions of the newspapers. There were no jokes, simply humorous comments about current events. He said the way to make a joke effective was to "make it look like it was not a joke." His dry, ironic, catchy observations were quoted in offices the next day or mentioned in news columns. Often a newsmaker would plant himself in the audience. Will Rogers would spy him and call him to the stage, or toss a lasso across the room and drag the celebrity into the limelight. The "victim" feigned reluctance but felt honored.

Long after his death, for more years than he lived, Will Rogers's recorded, wry comments for Ziegfeld stage monologues were repeated and quoted. On the other hand, insightful sayings were often attributed to the departed comic without proof he said them. "Will Rogers said" became a launching pad for one-liners of apocryphal origin.

Will Rogers's delivery was unique. For impact and because it succeeded, he continued to use faulty grammar. The wise country philosopher claimed his "ravings ain't liable to throw any jealous scare into literary circles."

Will Rogers capitalized on his natural Oklahoma drawl. Comments that otherwise would have sounded caustic and insulting seemed acceptable when drawled. He paused for long periods pondering his next statement. His rope was handy or danced in his hands, but the crowds wanted his thoughts. Important people waited.

"All I know is what I read in the papers" was his kickoff point, but he was well read, well traveled, and well informed. He made his point, then traipsed

off the stage before the audience was bored. Just as Texas Jack had taught him.

Besides reading newspapers, Will Rogers kept on the prowl to witness events or experience happenings firsthand. In 1915, he was offered a ride in a flying boat built by Glenn Curtis. Nervous but pleased, he was carried piggyback style across shallow water to the plane and waved to Betty as the plane soared aloft. Will Rogers became an instant champion of aviation.

Through the years, he would fly at every chance even if it meant pasting postage stamps on his flight suit to be delivered as air mail. He took two dozen coast-to-coast flights in the United States and flew into Russia and across Southeast Asia. His enthusiasm led to friendships with the father of the American Air Force, Billy Mitchell, and with famed aviators Charles Lindbergh and Wiley Post.

Will Rogers survived crash landings and near-crashes. He accepted risks. While swimming in the ocean during 1915, Will Rogers dived into a rock and was knocked unconscious. Somehow the blow impaired his right hand. To conceal the disability, he spent tough hours learning to twirl a rope with his left hand. Slowly his right arm healed, and Will Rogers had gained the ability to rope with both hands.

In 1916, Ziegfeld launched his famous *Follies*. Continued success of Ziegfeld's *Midnight Frolic* prompted Gene Buck to offer Will Rogers an additional role in the early evening gala. Betty and Will Rogers determined the pay offer was too low and refused the engagement. Opening night of the *Ziegfeld Follies*, with Will and Betty Rogers in the audi-

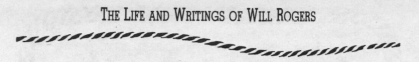

ence, the stage was filled with glittering dance and pink flesh—and dullness.

A few days passed, and Ziegfeld personally called Will Rogers asking for help to enliven the show. There was no discussion of salary and no change in pay. Will Rogers simply joined the cast that evening, then would move later in the evening to the *Midnight Frolic*.

When Ziegfeld's tradition decreed that the *Follies* would move to Pittsburgh for Thanksgiving and to Chicago for Christmas—despite overwhelming spring and summer success in New York—Ziegfeld appeared in Will Rogers's dressing room offering a $600 weekly contract for one year, followed by $750 a week the second year. Betty and Will had expected $500.

Will Rogers declined a written contract, but Ziegfeld called for a witness to the handshake. When the show moved from New York, Ziegfeld added space in a railcar for the black roping pony Dopey and another horse. At home or away, Will Rogers could ride every day. By 1918, his salary was $1,000 a week.

While dress rehearsals were disciplined exercises and entire wardrobes would be discarded by Ziegfeld's decree, Will Rogers never practiced. When his fifteen-minute slot opened, he walked on and performed spontaneously. He cracked personal jokes about the cast, director, and stagehands. But he always called the producer "Mr. Ziegfeld."

To play in a benefit called *Friar's Frolic*, Will Rogers traveled to Baltimore. Shortly before curtain time, President Woodrow Wilson joined the audience unannounced. Will Rogers always was tense

Will Rogers (standing center) with the cast of
Ziegfeld's *Midnight Frolic.*

before an appearance anyway, but there sat the
twenty-eighth President of the United States, whose
handling of world affairs happened to be the butt of
Will Rogers's jokes. Wilson was embattled by his
reluctance to abandon failed diplomacy and to assist
the Allies in World War I. That was Will Rogers's
material for puns.

Fellow performer George M. Cohan encouraged
Will Rogers to leave his act unchanged.

Drawing laughter by admitting he was "kinder
nervous," the Oklahoma cowboy said: "President
Wilson is getting along fine now. Do you realize,
people, that at one time in our negotiations with
Germany that he was five diplomatic notes behind.

"There is some talk of getting a machine gun if we
can borrow one. The one we have now, they are

using to train our Army. If we go to war, we will just about have to go to the trouble of getting another gun."

Woodrow Wilson joined the audience in laughter, and after the show, the President went backstage to congratulate Will Rogers.

Wilson shortly asked Congress to enter the three-year-old World War I, which lasted an additional nineteen months.

Even more than the President, Will Rogers nipped at Congress: "They are funnier 365 days a year than anything I ever heard of."

In 1918, Will Rogers was thirty-eight years old, and by midsummer, his family had grown to four children with the birth of Fred Stone Rogers on July 15. Age and dependents made him ineligible for military service. To support the cause, Will Rogers bought the government's Liberty Bonds to help finance the war and donated 10 percent of his $1,000 weekly paycheck from Flo Ziegfeld to the Red Cross to help comfort the fighting men.

He observed that the more serious the situation, the more Americans would laugh at his satire if the angle was right. The public responded well to Will Rogers's explanation that the reason the United States was able to mobilize two million soldiers so quickly was that "in our training manual there's nothing about retreat. When you only have to teach an army to go one way, you can do it in half the time."

As World War I raged, automobile tycoon Henry Ford, a pacifist, chartered a boat to send protestors to Scandinavia to seek peace through mediation. Will Rogers told his Ziegfeld audience: "If Mr. Ford

had taken this bunch of girls, in this show, and let 'em wear the same costumes they wear there, and marched them down the trenches, believe me, the boys would have been out before Christmas.''

WILL ROGERS THE WRITER

WILL ROGERS FIRST MADE THE BIG TIME AS AN AUTHOR when his *Ziegfeld Follies* quotes were published by Harper & Brothers in 1919 as *Rogers-isms: The Cowboy Philosopher on the Peace Conference*. It was the first of six books that carried the Will Rogers byline.

His stage success as a funnyman and commentator was drawing many favorable media reviews, and Will Rogers quotes often appeared in news columns. Printing stage quips in a book proved profitable.

Will Rogers's books, like his other writings, contained misspelled words, long sentences, poor if any punctuation, but strong views. The public bought his thoughts and ideas both in the bookstore and at Ziegfeld's theater.

The foreword of the peace conference book explained that Will Rogers had played before President Wilson five times using the same jokes, which, Rogers said, proved his theory that "you can always joke about a big man that is really big. But don't ever kid about the little fellow that thinks he is

something, cause he will get sore. That's why he's little."

Will Rogers said he had planned to write a book on the war, but had heard some other fellow had already done it. Because there were so many books on the war, he predicted that no two people will have to read the same one.

Will Rogers summarized the peace treaty and Wilson's Fourteen Points as: "If you birds start anything again, we will give you the other barrel."

The peace treaty, he opined, would have been signed earlier but "the German generals whom they sent out to sign up had never been to the front and didn't know where it was. The Kaiser was on the verge at one time of visiting the western front then he said, 'No, I will just wait a few days until it comes to me.'"

Will Rogers was no less a critic of President Wilson at the negotiations table:

"Pres Wilson and England compromised on Freedom of the Seas. England got it.

"Pres Wilson and Japan compromised on the Chow Chow Place. Japan got it.

"Pres and Italy compromised on that town down there. Italy got it.

"America went in for nothing and expects nothing. They are unanimous WE GET IT."

As history unraveled and Germany struggled from depression and harsh reparations to launch World War II, a Rogers quote pointed toward the fatal weakness of President Wilson's work:

"The Armistice terms read like a second mortgage," and the final treaty "reads like a foreclosure."

Good sales prompted Harper & Brothers to produce a second slender book in 1919 based on more stage quips: *Rogers-isms: The Cowboy Philosopher on Prohibition*, in which he claimed "you won't find the country any drier than this book" as he lambasted the Volstead Act, Prohibition, bootleggers, and moonshine whiskey:

"Statistics have proved that listening to prohibition lectures has driven more people to drink than any other cause.

"If you think this country ain't dry, you just watch 'em vote. If you think this country ain't wet, you just watch 'em drink.

"The South is dry and will vote dry. That is— everybody sober enough to stagger to the polls will."

During his early travels around the Southern Hemisphere, Will Rogers's letters to folks back home and his commentary had made their way into type at weekly newspapers in Oklahoma. He was an inveterate communicator and letter writer who developed a habit of reading the *New York Times* as a child and never kicked it.

At age thirty-nine, when he joined Fred Stone in promoting a rodeo on Long Island, he was asked to write a special newspaper article for the *New York American*, which he accepted on a pledge to "lay my chips down a little different." He said, "I want it to go as she lays, even if the guy that has to set up the type has to get drunk to do it."

As a writer, Will Rogers did lay his chips different; often they were sobering. It was a clue to future editors that Will Rogers would expect his own spelling, grammar, and punctuation to be printed as he wrote things.

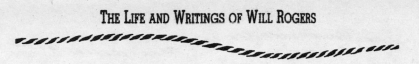

Once admonished about using "ain't," he said, "I know a lot of people who don't say 'ain't,' ain't eating."

In 1922, V.V. McNitt, president of the McNaught Syndicate, sensing the marketplace, after watching Will Rogers in the *Ziegfeld Follies*, asked him to write a weekly column to be sold to newspapers around the country.

"The famous cowboy monologist, Will Rogers, has undertaken to write for this paper a weekly article of humorous comment on contemporary affairs," the subscribing newspapers reported. "The *Literary Digest* recently quoted an editorial from the *New York Times* thus: 'Not unworthily is Will Rogers carrying on the tradition of Aristophanes on our comic stage.' "

The first column appeared in the December 24, 1922 *New York Times* as the flagship outlet, and a week later the column went into general syndication for publication by papers that would pay the fee.

He began: "I want to apologize and set the many readers of the *Times* straight as to why I am blossoming out as a weekly infliction on you all.

"It seems the *Times* had [British Prime Minister] Lloyd George signed up for a pack of his memoirs. Well, after the late election Lloyd couldn't seem to remember anything, so they sent for me to fill in the space where he would have had his junk.

"You see, they wanted me in the first place, but George came along and offered to work cheaper, and also to give his to charity. That benevolence on his part was of course before England gave him his two-weeks notice.

"Now I am also not to be outdone by an ex-Prime

Minister donating my receipts from my prolific tongue to a needy charity. The total share of this goes to the civilization of three young heathens, Rogers by name [his fourth child had died in 1920], and part Cherokee Indians by breeding.

"Now, by wasting seven minutes, if you are a good reader—and ten to twelve if you read slow—on me every Sunday, you are really doing a charitable act by preventing these three miniature bandits from growing up in ignorance.

"A great many people may think that this is the first venture of such a conservative paper as the *Times* in using something of a semi-humorous nature, but that is by no means the case."

Wilhelm II, the Kaiser until Germany's defeat in 1918, had just published his memoirs while exiled in Holland. Will Rogers wrote: "I am following the Kaiser, who rewrote his life after it was too late. I realize what a tough job I have, succeeding a man who to be funny only had to relate the facts."

Over the next thirteen years, Will Rogers wrote 665 Sunday columns, expanding his audience from two thousand *Follies* patrons nightly to forty million readers weekly.

Asked why the columns succeeded, he said: "When I first started out to write and misspelled a few words, people said I was plain ignorant. But when I got all the words wrong, they declared I was a humorist."

The weekly articles were long and rambling reports on his own activities and commentary on public happenings, especially politics. Within them were short sentences or paragraphs that capsulized ideas and coagulated public opinion.

Will Jr., age six; Mary, age four; and Jim, age two.

December 28, 1924: "It's getting so Christmas kills more people than it makes happy."

April 6, 1926: "This is an age of progress. Live fast and die quick. The human side of anything can't compare with so-called progress."

April 5, 1931: "Art ain't put-on when you are paying for it out of your own pocket."

July 15, 1934: "Retroactive means as you were before you got like you are."

August 11, 1935: "The banker, the lawyer and the politician are still our best bets for a laugh. Audiences haven't changed at all and neither has the three above professions."

After Rogers had been writing the weekly epistles for four years, *New York Times* publisher Adolph S. Ochs suggested that Will Rogers cable any interest-

ing items during a trip to Europe. Will Rogers sent the telegrams and the *Times* published them as "Will Rogers Says" daily telegrams. They were pithy, terse commentary on page one of the second section for the next nine years.

In just a few words, Will Rogers commented on news of the day in a humorous vein that impressed not only Ochs but also Lawrence Winship, feature editor of the *Boston Globe*, who sought but was refused the right of republication. The *Times* articles were under copyright protection even though Will Rogers was not being paid for their content.

The *Times* published thirty-six daily columns with a London dateline:

"You can pick an American bootlegger out of a crowd of Americans every time. He will be the one that is sober. Yours temperately, Will Rogers."

"It is the open season now in Europe for grouse and Americans. They shoot the grouse and put them out of their misery. Yours truly, Will Rogers."

"Parliament met today. One member was thrown out. It seemed like Washington."

Will Rogers had supplied forty-seven succinct columns exclusively to the *Times* before the McNaught Syndicate was able to catch up with the author and make the deal to sell his product. Will Rogers's daily telegrams went into syndication October 10, 1926, appearing immediately in ninety-two newspapers that paid—including, finally, the *New York Times*. At times, six hundred newspapers carried Will Rogers's columns.

From movie sets or during far-flung travels, Will Rogers wrote 2,817 daily columns under a seven P.M. Eastern Standard Time deadline that often meant a

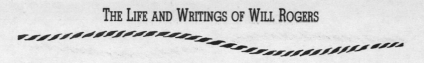

fast race to the nearest Western Union office with "Will Rogers Says" copy.

The wire arrived at the syndicate headquarters in New York and was simultaneously telegraphed to subscribing newspapers for publication in the following morning's editions.

Will Rogers's writer's royalties rose from $1,700 a week from McNaught to a guaranteed $130,000 a year. This income was in addition to fees for special writings, lucrative movie contracts, speech honorariums, and radio commentaries sponsored by E.R. Squibb and Sons or Gulf Oil.

Newspapers were important to Will Rogers, and "all I know is what I read in the papers" was a common opening line both for speeches and for columns.

"Will Rogers Says" telegrams and the weekly newspaper columns were the backbone of some two million words that he wrote between the ages of forty-two and fifty-five. His six books were based either on his shorter writings or on his stage commentary.

The columns were best during conflict, but Will Rogers never seemed to be devoid of subject matter. If the news of the day was dull, he would recount his own activities. In effect, the columns were simply Will Rogers—a breathing institution. His family, active life, frequent trips, and brushes with interesting people sufficed when news was dull. Accustomed to his unique, humorous style, perhaps forty million persons, or about one-third of the population of the United States, read Will Rogers.

His book *Illiterate Digest* compiled syndicated newspaper columns written in 1923 and 1924, but

the title was a spin-off of some movie shorts of the same name.

Will Rogers had appeared in these satirical movie shorts that had spoofed film shorts called *Topics of the Day*. The subjects were based on scholarly items from the *Literary Digest*. An outraged lawyer wrote Will Rogers a letter warning that the prestige of *Literary Digest* was being lowered by the subject matter of Will Rogers's movie shorts and title. The lawyer cited copyright laws, implied legal action, and called on Will Rogers to "withdraw the use of the objectionable title."

Feigning pride, Will Rogers wrote back volunteering to withdraw the series "if *Literary Digest* feels that the competition is too keen." He threatened retaliation, however, if the magazine ever took up rope throwing or chewing gum. Months later, he met the lawyer, who said he had been bemused by the reply, passed copies to attorney friends, and dropped the matter.

Will Rogers then dedicated his book *Illiterate Digest* to the lawyer and thanked the magazine for allowing him to announce his illiteracy publicly.

Will Rogers examined baths and bathtubs. He said twenty-five bathtubs were sold for every Bible, fifty for every dictionary, and 389 for every encyclopedia. "We may be neglecting the interior, but we are looking after the exterior." He predicted that if George Washington were aroused from his tomb and told Americans were spending $2 billion a year on bathing, the father of the country would have asked: "What got them so dirty?"

In the 1925–27 period, Rogers experimented with a new McNaught newspaper column format called

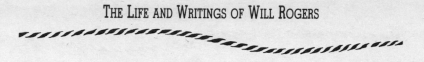

"The Worst Story I Heard Today," featuring jokes—but the idea sputtered. Will Rogers was not a joke teller; he was a humorous commentator on real happenings, trends, and people.

Often, he wrote special reports at $2,000 each for the popular *Saturday Evening Post*, including the family's European tour series in 1926, called "Letters of a Self-Made Diplomat to His President," which also became a book.

The *Post*'s spoof assignment, in the form of open letters to President Calvin Coolidge was "so antiseptic" that the writer had not bothered to call the White House in advance.

A typical story was Will Rogers's confrontation with the passport office because he had no birth certificate: "In the early days of the Indian Territory where I was born there was no such thing as birth certificates. Being there was certificate enough. We generally took for granted if you were there you must have at some time been born."

As he did with many of his ideas, Will Rogers also used the passport scene in the 1930 movie, *So This Is London*. It was not unusual for him to take an idea from his newspaper column or magazine article, use it in a book, and then ad lib it in a movie or radio broadcast. Many remarks originated on the stage, where spontaneity and timeliness were Will Rogers's trademarks.

While in Europe, on June 3, 1926, Will Rogers obtained an unusual visa to visit the Soviet Union despite the fact that he was on a family vacation and had no official diplomatic purpose. The *Saturday Evening Post* added a three-part serial on Will Rog-

ers's observations about Russia and its experiment with communism.

Almost incidentally, Will Rogers saw naked men and women bathing together in a river. That begat the book title: *There's Not a Bathing Suit in Russia and Other Bare Facts.*

Besides bare bodies, Will Rogers told about drinking Russian vodka: "It was the most innocent-looking thing I ever saw . . . drink it all down in one swig; nobody can sip Vodka.

"I had no idea what the stuff was and for a second I thought somebody had loaded me up with molten lead, and I hollered for water."

He was mistakenly given a second glass of vodka and reported "quick results that stuff delivers!

"Where do they get this white iodine? Corn down South would be branch water compared to this stuff. So much insensibility into one prescription is almost a chemical wonder.

"They informed me then that that was Russia's national dissipation," Will Rogers wrote, then reported the recipe:

"One half bushel of old potato peelings; fourteen ears of Russian corn, or maize, cob and stalk included; four top and soles of worn Russian boots; five grams of Giant Powder; three bombs chopped up fine. Mix all this in a washtub full of Vulgar River water, add two Revolutions and serve."

Will Rogers concluded that nobody knew anything about Russia. If a composite article couldn't be written on America, certainly one couldn't be written on Russia, because it was a "country that is so much bigger than us that we would rattle around in it like an idea in Congress."

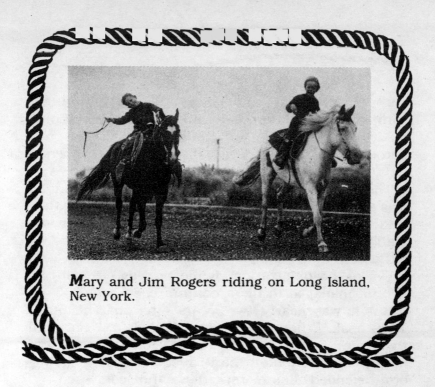

Mary and Jim Rogers riding on Long Island, New York.

After explaining that men and women bathed nude in the Moscow River, Rogers informed his readers: "I did not get to see all of Russia, I got to see all of some Russians."

The summer 1926 European excursion that began as a family pleasure trip resulted in Will Rogers launching the daily telegrams column, writing six magazine feature articles, and publishing two hardcover books.

Will Rogers's writings often were reports on personal experiences. During a speech in West Virginia, he suffered severe abdominal pains that struck again a few days later while he relaxed at the ranch in Oklahoma. Back in California, gall stones were diagnosed and surgery ordered. His June 19, 1927, telegram from a Hollywood hospital was terse: "Relax—

lay perfectly still, just relax." Four days earlier, complaining of abdominal pain, he had told national readers that "one doctor thought I had had a prosperous enough season to call a bellyache appendicitis."

The next day he reported that "doctors found it was not appendicitis, knowing me personal, they said it must be gall or cholelithiasis . . . they are going to relieve me of surplus gall . . . let the stones fall where they will."

During hospitalization, while he was critically ill, he still managed to file a column each day.

But it was nearly two years later that his April 1929 book, *Ether and Me or "Just Relax"* narrated the event in first-person detail. Although modern medicine undoubtedly had saved his life, Will Rogers defended home remedies and confessed: "I always felt that the best doctor in the world is the veterinarian. He can't ask his patients what is the matter—he's just got to know." The book, fewer than ten thousand words long, was a hospital gift shop best-seller and Will Rogers's final book.

THE MOVIE STAR

BY 1918, THE PUBLIC WAS WELL AWARE OF WILL ROGERS. He had graduated from Wild West shows to vaudeville and then to the *Ziegfeld Follies*. Noto-

riety came his way as he was reviewed and quoted in newspaper columns and began making speeches.

"Will, you are going into flickering photos," he quoted Mrs. Rex Beach, the wife of a screenplay writer, who had arrived early one morning at his Long Island home.

That is how Will Rogers said he "horned into" moving pictures, which was a growing industry even before sound was added to the film. The Rex Beach screenplay, *Laughing Bill Hyde*, starred Will Rogers in the title role of a good-at-heart escaped convict wearing black and white prison garb. The melodrama was filmed at Samuel Goldwyn's studio at Fort Lee, New Jersey, during the summer of 1918 while the *Follies* was in recess. It was the same summer that Betty gave birth to Fred Stone Rogers.

When the hour-long six-reeler premiered September 30, 1918, reviews were excellent. Critics said it proved that Will Rogers's talents exceeded his gift of conversation. They left open the question of whether Will Rogers really could act or only was himself before the camera. Then he was on the road with the *Ziegfeld Follies*. The financial success of the silent movie inspired Goldwyn to travel to Cleveland with a movie contract that doubled Will Rogers's $1,000 weekly Ziegfeld salary and pledged $150,000 the following year.

It was the start of a career in cinema. Will Rogers starred in forty-six silent and twenty-one sound pictures and often reigned as the leading male box office favorite.

While Will Rogers enjoyed the live stage and missed the audience reaction, he said cinema was "the grandest show business I know. The only place

where an actor can act and at the same time sit down in front and clap for himself."

To Sam Goldwyn's surprise, Will Rogers had arrived at the studio two weeks earlier than expected after sending a telegram that he was "rearin' to go." Because the contract went into effect and the paychecks started when Will Rogers arrived at the studio, Goldwyn sprung into action. Victor Schertzinger had been designated as director of the Will Rogers movies, but had not completed the project he was working on at the time.

Clarence G. Badger was summoned by Goldwyn and temporarily assigned as Will Rogers's director for *Almost a Husband*, the story of a schoolteacher in a small Southern town. The four-reeler inspired a European reviewer to proclaim Rogers "the finest comedian in the world."

Without consulting Badger, Will Rogers approached Goldwyn and asked that Badger be assigned as his permanent director. Goldwyn confronted the unsuspecting Badger, accused him of "monkey business" with Will Rogers, and denounced him for trying to "dictate to me how I shall run my business."

"What gave you that idea?" Badger responded earnestly. Goldwyn realized the Rogers-Badger team was Will Rogers's idea. He apologized to the director and made the assignment permanent. Cameraman Marcel Le Picard was added to the team.

Jubilo, an eighty-minute six-reeler based on a *Saturday Evening Post* story by Ben Ames Williams, became the Rogers–Badger–Le Picard team's next project. The story centered around a tramp who sang a gospel song entitled "Land of Jubilo." The

film was shot both at the Culver City studio in California and on location in New Orleans.

Goldwyn wanted to change the name of the movie to *A Poor But Honest Tramp*, but Will Rogers protested: If Hollywood filmed the Lord's Supper, that would have been released under the title *A Red Hot Meal*.

Before 1920 ended, Will Rogers had starred in eight feature movies and had written a list of suggested improvements and observations about the fledgling motion picture industry:

"Use your audience for a press agent instead of hiring one," he suggested. "What is the salvation of movies? I say run 'em backwards. It can't hurt 'em and it's worth a trial."

"The average life of the movie is until it reaches the critic," he wrote. "The average life of the movie hero is until he is found out. What the entire industry needs is a sense of humor."

Will Rogers described himself before the cameras: "Straight on I didn't look so good and even sideways I wasn't so terrific. But a cross between a back and three-quarters view was hot." He refused to wear makeup and protested he wasn't an actor but a rope thrower who played only himself.

When Will Rogers's two-year contract expired with the release of *A Poor Relation* in December 1921, no new offer was made. With no idea of the force that the newly created MGM would exert on the industry, Will Rogers saw an industry in turmoil and sensed opportunity as stars were starting their own companies, such as United Artists.

With a dozen titles to his credit, Will Rogers decided to become a movie producer. He used his

savings and money from mortgaging the family home to finance the venture, then enticed director Badger and cameraman Le Picard to join his enterprise.

An agreement was reached with Pathe Exchange to refund Rogers's money when a film was produced; Pathe would release and distribute the feature and pay a royalty. Through complexities of an industry in disarray, the agreement was short-lived.

The Ropin' Fool, a two-reel silent, black-and-white classic, was the first money loser for the Rogers family. The film featured Le Picard's innovative photography. He sped up the camera during filming, so that when projected at regular speed the action was slowed; the film preserved for posterity the unmatched lariat skills of Will Rogers. He threw a figure eight around a galloping horse and lassoed a rat with a piece of string. But the film's highlight was undoubtedly as the camera showed Will Rogers simultaneously throwing three ropes, one catching the horse Dopey around the neck, the second lassoing the rider around the body, and the third bouncing up under the horse and roping all four legs.

Plentiful use of slow motion photography showed how it was done and dispelled any possible belief that the stunts were faked, a period reviewer said.

Will Rogers at age forty-two realized that the fine edge he had on some of the more difficult tricks was fading and that slow motion film was a method of fixing in time an art form that was critical in both his vaudeville days and the practical work of a cowboy.

Irene Rich, who played his "reel wife" in nine

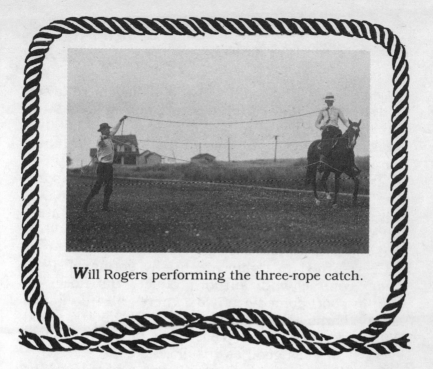

Will Rogers performing the three-rope catch.

films, joined Rogers in his 1923 three-reeler called
Fruits of Faith, where a likeable tramp took on a
wife and responsibility when they found an aban-
doned seven-year-old boy, played by Rogers's son,
Jim. Reviewers said the silent movie was "a story
made human and humorous by the humanness and
humor of Will Rogers."

One Day in 365, featuring a typical day in the
Rogers family life, was a charming episode that
never was released by Pathe. It marked the end of
Will Rogers's career as a movie producer.

The Pathe agreement in shambles, Will Rogers
had banked his life insurance, bonds, savings, and
real estate, and had finally deposited the films them-
selves at the bank for security. After years of pros-
perity, by the summer of 1921 he was deep in debt.

Determined to pay all bills, Will Rogers returned to New York and, after a short stint playing the Shubert, rejoined the *Follies*, earning $2,500 a week. For $1,000, he began making after-dinner speeches.

"It was poverty that drove me out of this paradise," Will Rogers wrote about leaving California. "I was living fine on the climate but those kids of mine have no sense of value of climate and beauty. They demanded meat and bread."

He returned to California in the spring of 1923 under contract with author-producer Hal Roach to play in short comedy movies where "all I do is run around barns and lose my pants" for $2,500 a week. Will Rogers appeared pleased to be back "where every man is as good as his close up."

Two Wagons, Both Covered was a parody of the very serious ten-reel Paramount Studios epic *The Covered Wagon*, which told the drama of settlers of the West. Hal Roach cast Will Rogers as leading man in the satire where "escrow" Indians attack settlers moving West and try to sign mortgages for housing developments.

Other Roach films likewise were parodies. In *Big Moments From Little Pictures*, Will Rogers impersonated Rudolph Valentino in a bullfight scene, Douglas Fairbanks, and Ford Sterling and his Keystone Cops.

In *Uncensored Movies*, Will Rogers was unmerciful in his parody of Tom Mix, who had become a $20,000-a-week cowboy matinee idol and was Will Rogers's old friend from Oklahoma and Colonel Mulhall's Wild West shows.

As young cowboys, Tom Mix and Will Rogers once

had only $5 between them; Tom was carrying the money in his pants pocket. When evening came, they settled down for the night in a barn. Will hung his hat on the same stall where Tom Mix hung his pants. During the night, the Missouri mule in the stall ate the hat, pants, and $5.

The next day, Rogers was hatless. Tom Mix wore only chaps over his long underwear. Both were broke and the mule was content. It was on sound foundation that Will Rogers built his Tom Mix satire in *Uncensored Movies*.

While Hal Roach and Will Rogers remained close friends, the slapstick comedy acting wore thin, and after fifteen features their contract went unrenewed in late 1924.

During the next three years, Will Rogers starred in a half dozen feature films, then in 1927 starred in and wrote titles for twelve travelogue single-reel featurettes in places like Dublin, Paris, Holland, Ireland, Switzerland, London, and Berlin.

The technology of sound on motion picture films revolutionized Hollywood during 1927. Will Rogers called them the "noisies," but they quickly were proven loud favorites by patrons. Many silent movie stars lost their glamour as they lacked suitable voices for audio tracks.

"My old friend, Tom Mix, had a little local upheaval. Some actor said Tony, the horse, would be good in the 'talkies.' He could at least snort." Sound ended Tom Mix's cinema career as a Saturday matinee cowboy idol. For his talkative fellow steer wrestler, Will Rogers, it was the opening of a new phase for performance.

Will Rogers would play a judge, doctor, pharma-

Will Rogers, honorary mayor of Beverly Hills, flanked by Douglas Fairbanks (left) and Tom Mix (right).

cist, oilman, politician, editor, sausage manufacturer, steamboat skipper, race horse trainer, banker, hog farmer, hobo, razor blade manufacturer, radio station owner, cotton ginner, war veteran, meat packer, and diplomat.

Silent pictures never seemed to capture the full essence of Will Rogers's screen appeal. Adding his voice was a clincher.

Fox Film Corporation signed a $600,000 contract on June 1, 1929, for Will Rogers to play and assist in four talking movies. The second pact was $1.12 million in October 1930 for six pictures. New deals were made and the filming continued through twenty-one feature films that earned the studio more than $1 million each. The contracts gave Will Rogers a free editorial rein, which he exercised. "Get-

ting stories is more of a job than making them. They talk about a lot of money wasted in the movies. It's wasted in the paper that scenarios are written on. I don't mean that there is not maybe some good ones, but they are mighty scarce. You just can't become a dramatist overnight." On the set, most writers simply watched their scripts drop to the ground as Will Rogers ad-libbed his part. One of his directors, Frank Borzage, said Will Rogers would change his lines as he saw fit, and "his version was usually better than the original script."

Over the six-and-a-half year period under contract with Fox that ended with his death, Will Rogers reigned three years as moviedom's top male box office star and was Hollywood's highest-paid actor.

During this same sixty-six-month period while starring, advising and ad-libbing his way through twenty-one feature films, Will Rogers wrote 2,612 daily newspaper columns and 285 expansive weekly syndicated articles and became a major network radio commentator. He made two trips around the world and another into South America. He conducted a drought relief tour, covered political conventions, and made speeches while playing polo and roping calves with his family.

They Had to See Paris was Will Rogers's first movie with sound. Fox Movietone Productions was so nervous about the sound technology that it made a simultaneous silent version. The ninety-six-minute feature, billed as a musical comedy, drew large crowds and rave reviews.

The plot revolved around a poor Oklahoma family who got rich by striking oil. Irene Rich as the wife wanted the family to go to Paris to find a French

nobleman to marry their daughter—against the better judgment of her husband, played by Will Rogers. His homilies and shrewd actions included a ploy where he sized up a French lady. That brought the family back to their good senses.

The movie had its premiere in Los Angeles, but Will Rogers's column that day had a dateline of Wichita, Kansas: "They was opening my first talking picture tonight in Los Angeles and charging those poor people five dollars and I just couldn't stand to be a party to such brigandage. First night audiences pay their money to look at each other, so if they get stuck they can't blame me. It will be because they don't look good to each other."

In his column Will Rogers reported that he had "announced that Father for perhaps the first time in his life was just out for travel, sun and amusement." He flew to Wichita, then Tulsa, where he was met by his sister, and "for the next few days I did nothing but just visit around with my folks and old cronies, made no dates, just get in the car and go see 'em."

He visited the Indian hospital in Claremore to see a friend who couldn't listen to the radio, so Will said he would get him some headphones. Then, quietly, he bought headphones for everybody in the hospital.

The sojourn ended abruptly as Will Rogers reported: "I received a wire from my wife from California saying the picture had opened and I could come home. That's all the wire said. So you see, we got two comedians in the family."

Rested and back home ten days after he left, Will Rogers said he was just "bumming. High class bumming. But it was bumming nonetheless."

A still from Will Rogers's first talkie, *They Had to See Paris.*

Each of his twenty-one sound movies was wholesome and carried an underlying message of moral goodness. Will Rogers, playing mostly himself, emerged as an ordinary, upright, good fellow. His secret, on screen and off, was that he acted naturally, as himself.

Will Rogers spent days on the movie lot unpretentiously. He didn't change into costumes in his dressing room. He disdained makeup. He enjoyed simplicity. His dressing room, as director David Butler explained, "wasn't really his dressing room, just the place he came when he couldn't think of any other place to go."

Fox Studios, with many stars, provided its celebrities with bungalows on the lot. Will Rogers had a special three-room dressing facility built like a ranch house. It had southwestern flair, with cactus, sand, and desert rock for the lawn.

There were cedar-lined wardrobe closets, two baths with showers, a dressing table with mirrors outlined in makeup lights, and a luxurious living room.

Will Rogers seldom went near it. From time to time, he would deposit some neckties, a slouch hat, or other unused clothing in the bungalow. They would be carelessly tossed on the top of a lamp or the back of a chair or laid on the sofa's cushioned seat. A few extra neckties, a shirt, a suit, and a couple of pairs of shoes were Will Rogers's complete movie wardrobe.

Closets were left empty, and the only indications of human use were Will's few garments parked on the table and chairs. The only clue that it was Will

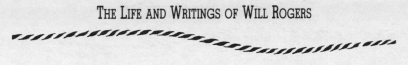

Rogers's exclusive area was a spare portable typewriter on the edge of one of the tables.

Will Rogers's real dressing room and makeup table was the rumble seat of his car. Although he was the best-paid actor in Hollywood, he seldom was driven by a chauffeur. An employee with that title was more of a friend of the family. Driving a bit too fast, Rogers would race his roadster up beside the stage or the location where he was working.

Usually a few minutes late, he would yell, "Hold on there, boys, I'm coming." Then he would open up the back of the rumble seat, pull out a pair of pants and his shirt, and shortly would be ready for work. He would rush to his director or anyone handy to find out what was to be done. When he understood the idea of the scene, he would position himself in front of the camera and mold the action as he saw fit. Still his movies were hits that made millions.

There was no bed in his bungalow, but it didn't matter. When Will Rogers wasn't on the set, he would push his old spectacles on the end of his nose, slide way down in a chair, pretend to be reading a newspaper, and nap.

Even in the middle of a filming session, when hunger pangs struck, Will Rogers would issue a curdling yell: "Lunch-ee." The session recessed until the meal was ended.

He appeared unimpressed with being the king bee on the Fox lot but laughed with pride when a hotel in Claremore, Oklahoma was named in his honor. He played it down by saying: "Now I know how Columbus must have felt when they named that town in Ohio in his honor."

He was ingenious on the set as well. He shot a jail

scene for *Handy Andy* during the summer of 1934 and was ready to end the day's work when he remarked to director David Butler: "Y'know, Dave, I could git out of this jail any time I wanted to. I already got my wooden gun whittled out." Butler reassembled the crew and shot four takes of Rogers repeating the remark.

During production of *A Connecticut Yankee* in 1931, Will Rogers had a bad day that required many shots. In disgust, Butler called it quits and was stalking off the set when Will Rogers caught his arm. Tears were in his eyes as the star apologized to his director.

A Connecticut Yankee was based on Mark Twain's fantasy. In the film version, Will Rogers played Hank Martin, a New England radio technician, who is hurled to King Arthur's A.D. 528 court when knocked unconscious in a freak accident in an eerie mansion.

It was a rollicking absurdity based on an equally ludicrous plot. But Will Rogers was right at home. With cowboy resources he dueled armored knights with adept horsemanship.

At one point, actress Myrna Loy, playing Morgan Le Fay, touched Will Rogers with a faint kiss. Fox technicians painstakingly, reel by reel, hand-tinted pink on the frames to show Will Rogers blushing. It was the only color added to the black-and-white cinema career of Will Rogers and was an innovation of the industry.

After the light kiss, Will Rogers said earnestly, "I feel like I've cheated on my wife."

The show won Will Rogers *Photoplay Magazine*'s "Actor of the Month" Award in April 1931, and was

one of the year's best films. Fox studio had origi-
nally bought the script with Tom Mix in mind as the
silent star but Harry Myers played the lead in the
earlier 1920s version.

A 1930 film, *So This is London*, featured Will
Rogers singing, which pundits said was "positive
proof that Will's ancestors were Cherokee Indians
. . . his song is more of a whoop and whoopee than
a lilting melody."

In the trade, Will Rogers was known as a good
trouper. If the script called for a song, he sang. If a
dance was needed, he danced. Will Rogers was Hol-
lywood's most untemperamental leading man, who
fished for laughs. Viewers understood, appreciated,
and expected his humor and clean good fun in the
service of comedy. He was a comedian generally
without being a clown.

If in the middle of a scene, Will Rogers had an
idea, he would walk to the director and begin talk-
ing. An expensive array of cameramen, electricians,
and other assistants sat grouped around on the floor
and on props, mouths wide open, listening to and
laughing at the dialogue.

John Ford was director of *Dr. Bull*, *Steamboat
'Round the Bend*, and *Judge Priest*, his favorite of
Will Rogers movies.

Irvin S. Cobb, who wrote scripts and played in the
features, related an episode between director John
Ford and star Will Rogers at the start of filming
Steamboat 'Round the Bend:

Ford: "Do either of you two gentlemen by any
chance happen to have the faintest idea of what this
story is about?"

Rogers: "I don't for one. Something about a river,

ain't it? I was raised at Claremore, Oklahoma, where we don't have rivers to speak of, so you might say I'm a stranger here myself."

Ford: "I thought so. And, I don't suppose Mr. Rogers, you have gone so far as to glance at the script?"

Rogers: "Been ropin' calves. Tell you what, John, you sort of generally break the news to us what this sequence is about and I'll think up a line for Cobb to speak, and then Cobb'll think up a line for me to speak, and that way there won't be no ill feelin's or heart burnin's and the feller that kin remember after it's all over what the plot was about—if there is any plot by then—gets first prize which will be a kiss on the forehead from Mr. John Ford."

Cobb said: "That is how we did the scene with Ford sitting by as solemn as a hoot-owl."

Booth Tarkington's novel, *The Plutocrat*, was adapted for the 1932 movie *Business and Pleasure*, starring Will Rogers as Earl Tinker, an Oklahoma razor blade mogul who sailed to Syria to buy the secret of Damascus steel. Wearing an elaborate beard and disguised as an ancient mystic, Will Rogers exposes a sultry lady industrial saboteur's scheme to foil his trip.

Bemused critics exposed the Earl Tinker character as a parody of Edward Tinker, president of Fox Film Corporation. One even claimed it would be libelous to suggest that Edward Tinker had mobile lips like a mule's, a wiggling weather-beaten nose, and so little knowledge of how to behave that he would annoy his fellow passengers on a transatlantic liner by hooting low ballads in the ship's bar.

The critic denied that Edward R. Tinker would allow a treacherous female adventurer to pat his

shoulder even to strengthen the financial structure of Fox Film Corporation. The critic feigned disbelief that a movie mogul would impersonate a radio voice to astonish a sandpile millionaire in Asia Minor as a preliminary to smoking imitation hashish through a gasoline pipe.

Resigned, the critic said: "Only a low grade buffoon with small respect for his calling" would pull such shenanigans. Tinker and Rogers both were cleared of chicanery, and the reviewer said the movie was "amusing."

AFTER-DINNER AND RADIO TALKS

As A SEVEN-YEAR-OLD, WILL ROGERS RECITED "I AM A Little Star" for the audience at Drumgoole school. Decades later, he discovered people would pay money—big money—to hear him talk.

After the stage became his forum, a demand arose for Will Rogers as a speaker, largely at banquets. Thirty-five years after Guglielmo Marconi's wireless invention, as radio was being harnessed for entertainment and advertising, Will Rogers said: "Radio is too big a thing to be out of."

To quickly recoup from his financial fiasco as a movie mogul, Will Rogers hired an agent and made the $1,000 after-dinner speech a major income source. For convention planners, his name meant attendance: Will Rogers filled lecture halls.

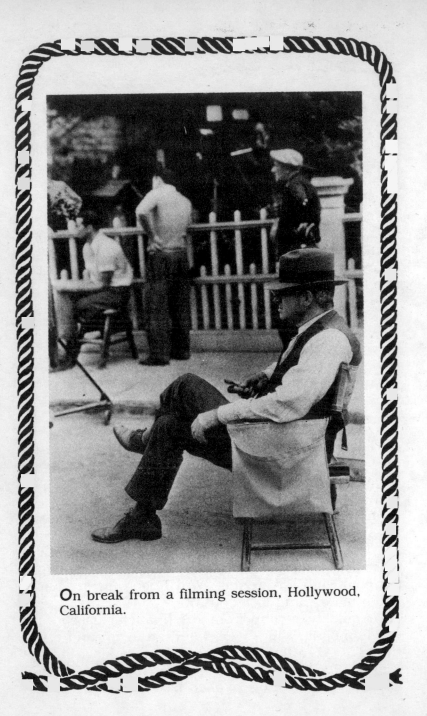

On break from a filming session, Hollywood, California.

He personalized his talks, scouting the local community or convention for distinctive tidbits and insights that spiced his down-home humor. He took notes, sketched out thoughts on his typewriter, reviewed the material, then nervously approached the podium. He sputtered, gained confidence, relaxed, then launched into ad-lib talk. On stage, screen, radio, or at the podium, his delivery was spontaneous. Mostly he was humorous. Sometimes he was cutting.

Paid to address a bankers' convention, he said that borrowing money was a "sucker game" evidenced by the banker being the richest man in town. He suggested that lending should be outlawed and that bankers should "go to work if there is any job any of you could earn a living at." Then, taking a swipe at himself, he said banking and after-dinner speaking were the most nonessential industries.

In San Antonio at the Old Trail Drivers Association barbecue of 1926, honored guest speaker Will Rogers speculated that Texas herdsmen "did all right. You'd start out down here with nothing and after stealing our cattle in the Indian Territory, you'd wind up in Abilene with 2,000 head."

Outraged, a portly Texas matron shouted, "My husband was no cattle thief!"

Radio was a more protected but lonelier environment. Will Rogers complained that the microphone looked like an automobile radiator cap, but it didn't talk back. Working without the audience reaction in the stillness of a studio was stifling—so he imported an audience. He learned early in radio that the programs started and ended promptly—on the hour or half hour. Will Rogers brought along an alarm clock

that rang shortly before his time expired. One alarm clock failed, so he brought two. The alarm clock became his trademark in radio, as his gum chewing was a trademark when he performed before live audiences.

Will Rogers first appeared on radio in Pittsburgh in 1922 on KDKA when the medium was in its infancy. That broadcast signal was picked up only by crystal sets and earphones, the forerunners of radios with loudspeakers. A widely circulated publicity photograph recorded the historic event with a grinning Will Rogers, hands in pockets, squarely before a microphone with his wife, Betty, seated at a piano and Ziegfeld girls around the studio.

After-dinner remarks in New York sometimes would be broadcast live. Newark's station carried a 1923 speech by Will Rogers at the Newspaper Publishers Association banquet at the Waldorf Astoria.

During the 1924 presidential campaign, Will Rogers was on the "Eveready Hour" when the National Broadcasting Company launched operations. His segment was called "Fifteen Minutes With a Diplomat," and he chatted about his world travels and about politics.

Sometimes, in historic efforts, the broadcasts were live and special networks were formed. An association of twelve independent stations called the "Radio Industries" joined together to broadcast their own special banquet speech. Because of a discovered exclusive agreement clause in a speaking tour engagement contract, the star withdrew just hours before the appearance.

Broadcast promoters were distressed until Will Rogers said he would appear and explain why he

could not speak. The apology was broadcast live. "I have been forbidden to make a speech to you over the radio by my manager who I am soon to start a concert tour for. He figures if you ever hear me once you would never want to hear me again," Rogers told both the radio audience and the laughing crowd at the banquet.

"It is a bigger disappointment to me than you. You make an actor keep his mouth shut—he's in pain."

The manager never complained about a breach of contract.

On January 4, 1928, Will Rogers's Beverly Hills den was anchor studio for an unprecedented radio show with Al Jolson in New Orleans, Fred Stone in Chicago, and the Paul Whiteman Orchestra playing in New York. The technology was such a challenge at the time that engineers needed ten days to wire the four studios together. The "Dodge Victory Hour" spent $67,000 for the historic innovation to announce a new $600 automobile over forty-five stations simultaneously.

"I was nervous as I ever was on a first night," Will Rogers said. "Radio is a tough thing, especially for a comedian. It's made to order for a singer and a person making a straightforward speech or explaining something. To try to get some laughs, it's the toughest test. That little microphone is not going to laugh."

Will Rogers unexpectedly said: "I want to introduce a friend of mine who is here and wishes to speak to you." Will Rogers puckered his lips, shifted to a high pitch, and began imitating President Calvin Coolidge, who had just met with belligerent farmers:

"Farmers, I am proud to report that the country as a whole is prosperous. That is prosperous for a hole. A hole is not supposed to be prosperous and you are certainly in a hole. There is not a whole lot of doubt about that."

Reporters wrote that dull-witted listeners switched off their radios believing the President had endorsed Dodge automobiles. The President's staff was miffed, and Will Rogers wrote an apology to the White House.

"I thought the matter of rather small consequence myself although the office was informed from several sources that I had been on the air," President Coolidge replied.

Wall Street's crash of 1929 and the Great Depression that followed emptied many nightclubs and left people broke and at home with the radio.

When a pharmaceutical sponsor paid $77,000 for Will Rogers to make twelve nationwide radio broadcasts in 1930, he donated all the money to help Depression victims.

The Sunday show generally was used to tell a bootstrap success story about someone Rogers admired: automobile magnate Henry Ford, the prince of Wales, America's ambassador to Mexico Dwight Morrow, aviator Charles Lindbergh, President Herbert Hoover, and New York Governor Alfred E. Smith. Will Rogers editorialized on self-reliance and the virtues of rural life. Six months into the Great Depression, the broadcasts, spiced with anecdotes, were a tonic to listeners.

His May 11, 1930, broadcast focused exclusively on Mother's Day and was widely quoted. He came

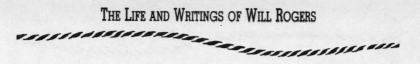

back later and jabbed at florists for commercializing it, suggesting a pork chop commemoration because mothers don't eat flowers.

The Depression deepened. Hoping to restore confidence in the economy, an industrialist booked Will Rogers and President Hoover together in a special broadcast on October 18, 1931. "We're the first nation in the history of the world to go to the poorhouse in an automobile," Will Rogers said in remarks that became known as the "bacon and beans and limousines" speech.

He said the nation had become so engrossed in getting bathtubs, facial creams and "straight eight" cylinder automobiles that it had forgotten to see if we had any bacon or beans.

Will Rogers's solution to the unemployed was work: Cut weeds, fix fences, mow lawns. He then added that there were "filling stations to be robbed, gangsters to be catered to. There is a million little odds and ends" that paid no money, but the activity would keep people in the practice of work "in case something does show."

The "Good Gulf Radio Hour" in two years became a nine P.M. Sunday institution at a time when some six hundred radio stations dotted the nation and even impoverished families had one radio. Typical programming included music and variety acts, then fifteen minutes of Will Rogers.

He divided the $50,000 he received for the first seven shows between the Salvation Army and the Red Cross. In the transaction Will Rogers said he had "nothing to lose but his voice."

The oil company continued adding Will Rogers to

the lineup for a total of fifty-three Sunday night shows, into an uncompleted contract for 1935. The show, switching between CBS and NBC networks, was not without a downside. Preachers complained that parishioners were missing Sunday night services to hear Will Rogers.

Will Rogers used the medium extensively to bolster the Roosevelt administration early in its fight against unemployment and the Depression: "Mr. Roosevelt—somebody told me was listening in—we've turned everything over to you. We've given you more power than we have ever given any man in the history of the world. We've gummed it. You take it and run it. Do anything so long as you get us a dollar or two every now and then."

On radio, Will Rogers said if the Roosevelt administration died its epitaph would be that it "perished through trying to give the little fellow a fair deal."

Later Will Rogers became disenchanted with giant government programs that loaned millions to build projects that employed only a few men with levers or steering wheels. He said the difference between employment and unemployment was trading the wheelbarrow for a ten-ton truck at the same time Ma traded the old skillet for a bridge deck and Pa his ax for a putter.

Finally, disgusted with the failure of government plans, Will Rogers announced his plan to eliminate all plans. He said the country had been planned to death. In concert with ideas he was conveying in newspaper columns, movies, and magazine articles, Will Rogers's radio addresses were the principal opinion molders during the first half of the 1930s.

LIFE AND STYLE OF WILL ROGERS: MOVIE STAR

In a Personal and Career Sense, 1918 was a watershed year for Will Rogers.

Professionally, he had starred in his first motion picture, *Laughing Bill Hyde*. Although it lacked sound, it was a box office smash and opened a new phase in his life.

For the family man, the movie contract meant moving his family from New York to California.

In New York the family lived in a house rented from Fred Stone. Though it was a convenient subway ride from Broadway and Will Rogers could easily commute to his nighttime job at the *Follies*, then the *Frolic*, it was not their own home.

A high-dollar, long-term movie contract with Sam Goldwyn meant they could purchase their own property in the mild climate of Los Angeles. The Goldwyn contract required him to work at the studio in Culver City, and the Rogers family rejoiced about moving to California. When the *Follies* closed in the spring of 1919, Will Rogers went to California, and Betty Rogers, four children, horses, and dogs followed on the train a few weeks later.

When the family arrived in Los Angeles, Will Rogers met them with a chauffeured limousine that drove them to the home he had rented on Wilshire Boulevard.

Sam Goldwyn had ordered a corral built on the studio lot where Will Jr., seven, and Mary, five, rode horses each afternoon. Jimmy, three, would start

riding regularly later, although he had started training at age two. Fred was an infant.

The *Ziegfeld Follies* and *Midnight Frolic* had been nocturnal events, but Will Rogers faced a different schedule in the motion picture industry, where action started early in the morning and ended in time for the actor to spend evenings with his family.

"Out in Hollywood," Will Rogers wrote, "they say you're not a success unless you owe fifty thousand dollars to somebody, have five cars, can develop temperament without notice or reason at all, and have been mixed up in four divorce cases and two breach of promise cases.

"As a success in Hollywood, I'm a rank failure and I guess I am too old to be taught new tricks. Besides, I'm pretty well off domestically speaking and ain't yearning for a change. I hold only two distinctions in the movie business: ugliest fellow in 'em and I still have the same wife I started out with."

Jim Rogers, the son of the star, often was cast in juvenile roles, and Will Rogers would use his own horses in films. Life was a family affair with Father working long hours and Mother running the household.

During their second year in California, the three boys were stricken with diphtheria. Mary and the parents somehow escaped the disease. Serum could not immediately be found. Will Rogers was on location in San Francisco and drove ten hours down the six-hundred-mile coastline in a relay of automobiles. It was too late.

On June 17, 1920, Fred Stone Rogers died.

After a simple funeral, the family returned to active lives, and the dead child was never men-

tioned to the surviving children. Years later, his body was quietly exhumed from a California grave and moved along with his father's to a final resting place in Claremore, Oklahoma, a few feet from where his parents reposed.

To help ease the loss, the family purchased a fine home in Beverly Hills, a fashionable city that was filling with moviedom figures. At the time, Rogers said, Beverly Hills was "real exclusive. Mine was the only house."

The city grew, and for a while crowned Will Rogers as honorary mayor. Land values soared and Will Rogers's real estate investments were highly profitable. A national financial magazine reported: "If someone hears of an investment Will Rogers has made, the sales are sure to be boosted the next day."

Success in movies had given Will Rogers financial resources not only for speculation, but for an expansive lifestyle. Rather than swimming pools and private airplanes, the Rogers family life centered around pets, horses, and livestock.

During school months, the family lived in growing Beverly Hills, but they soon bought some farmland in Santa Monica and began developing. At first, they would retreat a short drive to a cabin for quiet weekends.

The Santa Monica ranch soon represented an investment of $500,000, and included a polo field, a tan bark ring, a roping corral, horses, and steers. The original 150 acres was purchased for $300,000 with a down payment and regular payments. Through gradual acquisition, the ranch was enlarged to three hundred acres.

The rolling foothills of the Santa Monica Moun-

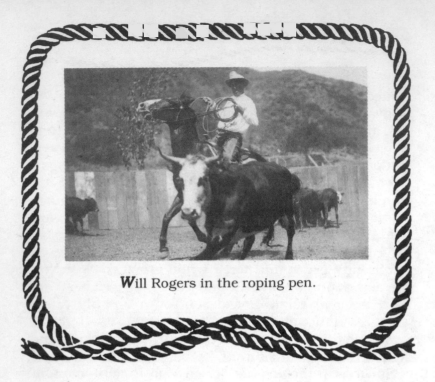

Will Rogers in the roping pen.

tains offered a view of Catalina Island, Santa Monica
Bay, and the Pacific Ocean. But when the family
bought the land, only a small patch had been
cleared by a Japanese truck farmer, and wild scrub
brush predominated. The road was almost impass-
able until Will Rogers brought in work crews.

Roads were built down to a path that met what
would become Sunset Boulevard. Under Will Rog-
ers's direction, a barnlike home rose and was con-
stantly modified and expanded on the hillside
overlooking the polo field. Often a calf or pony would
stroll into the living quarters. A brahma named
Sarah was an indoor companion.

The friendly, rambling Santa Monica home called
"the house that jokes built" included a shower with
a series of water spouts for gushing water from head

to toe. Everything was fixed the way Betty and Will Rogers wanted.

A longhorn steer head hung over the fireplace, and Navajo rugs were tossed alongside a rare saddle collection, tiger and leopard skins, and even a cigar-store wooden Indian.

In his travels, Will Rogers over the years had made friends with Western artists Charles Russell, Ed Borein, and Charlie Beil. Their paintings, plaster castings, and bronze sculptures were commissioned or purchased to adorn the walls and shelves.

His special friend was Charles Russell, the Montana cowboy turned artist. Russell molded a twelve-inch statue of Will Rogers on an unidentified horse. There was no discussion between the artist and the subject about the figure of Rogers, but the two quarreled about the horse. Will Rogers wasn't content with the brand. Russell changed it from a wineglass to the Dog Iron of Will Rogers's own childhood design. At Rogers's urging, Russell finally modified the animal's hind legs and tail. The version that pleased Will Rogers had just four castings. Russell's original was widely sold at premium prices in bronze.

Figures like Russell would join at an open barbecue area with an elaborate movable canopy, built for informal feasts. Guests like the three Western artists, actors, and writers were invited for dinners of beef cooked over open charcoal fires. Recreating the happy, informal conversation sessions from his boyhood back in Oklahoma, Will Rogers often filled his home with leading opinion molders of the era for loose, frank discussions.

On one such occasion, Will Rogers Jr. took issue

with Will Durant, the famed historian. It was a level field where all views were considered.

The parties were not glitzy Hollywood events. Lusty polo games, roping contests, and hearty meals were featured. Close understandings and strong friendships grew, as reflected in the introduction Will Rogers wrote for Charles Russell's posthumously published book, *Good Medicine*.

"If it wasn't for a book like this, Charlie Russell would just go down in history as an artist, 'The Great Cowboy Painter.' There was more buried than just a painter.

"He wasn't just 'another artist,' he wasn't 'just another' anything. In nothing he ever did was he 'just another.'

"That painting gag was just sort of a sideline with Charlie. If he had quit talking to you and started painting, you woulda got sore. It wasn't what you wanted. What you wanted was to hear him talk, or read what he said. He could paint you a picture and send you a letter with it and you would value the letter more than you would the picture.

"He could think twice as straight as he could draw a line with a brush. He was a philosopher. He was a great humorist. He had a great underlying spiritual feeling, not the ordinary customs and habits that are supposed to mark 'what the well-dressed Christian is wearing this season' but a great sympathy and understanding for the world be he 'Injun' or White.

"I don't know what religious outfit he sorter leaned to, if any of the present organized and chartered ones. But he sure had one, and that was a belief in somebody or something, and that some-

body or something was the one he was going to leave to judge his fellow man."

In what many would agree was a self-reflection, Will Rogers continued to write about common values he shared with Russell regarding life, peace, contentment, humility, nature, and the spirit of the Indian that non-Indian Russell seemed to penetrate so dramatically with paint and canvas.

"He not only left us great living pictures of what our West was, but he left us an example of how to live in friendship with all mankind."

Betty Rogers was a quiet force in the background of Will's life. She never told jokes, but her eyes sparkled in response to humor. She was unabashed about her love for her husband and children and radiated appreciation at any mention of her family.

She had few interests outside the family, although she took some trips abroad both alone and with her husband. She was a member of the Woman's Club in Beverly Hills, where she assisted in charity work but seldom attended meetings. She helped to establish the First Church in Beverly Hills. While sophisticated beyond normal Arkansas standards, she was not the Broadway type or California breezy. She dressed smartly but simply. Her hair was soft, wavy, and pushed slightly toward the back of her head. Her hazel eyes needed no enhancement, and her clear skin radiated without paint or rouge. She had an easy, graceful walk and a resonant, low-pitched voice. Her enunciation, grammar, and manner were precise but she maintained a motherly air.

While considered charming, she seemed most interested in her husband, in family life, and in instilling into her children "old-fashioned" values of

the frontier shared from both her and Will Rogers's origins.

"We all like animals and outdoor life," Betty Rogers said. "I frequently ride horseback with the children but I never attempt any of the stunts."

The three youngsters were taught trick riding, trick roping, polo, and steer roping by their father. Riding horses as a foursome, they would thunder across the fields standing upright on their saddles.

When adolescent Mary quit the team, her father announced that "she went social on us."

At age nineteen, Mary received a birthday letter from her father that said: "Sometimes we old ones don't see eye to eye with you kids. But it's us that don't stop to see your modern viewpoint. Times change. But human nature don't." She was leaving for Paris, so he sent her money, saying: "You being a woman will think Paris is the clothes place. You can get better ones at home."

Will Rogers had another way of communicating with his children. A 1931 newspaper column read:

"Early in the autumn, Mrs. Rogers and I sent two sons away supposedly to schools. (We got tired trying to get 'em up in the morning.) One went north, here in this State; another to New Mexico. Since then we have received no word or letter.

"We have looked in every football team over the country. Guess they couldn't make the teams, knew their education was a failure and kept right on going."

On November 8, 1931, he reported the boys had "arrived at their school O.K. If their remittance is in proportion to their grades, I am not going to have such a tough year at that."

In his movie producer friend Hal Roach's plane, Will Rogers went to Mexico City for a polo match. With a three-goal handicap, he played the game with skill and courage. A famous photograph shows him in a cluster, his horse falling as he hit the ground hard.

For polo, Will Rogers's favorite mount was a horse named Bootlegger. For trick riding, dangerous scenes, and movie stunts, Will Rogers chose a horse named Chapel. Movie lot people believed Chapel had almost human intelligence and communicated totally with Will Rogers.

Dopey was the coal-black mount purchased in New York but moved to California with Mary's pony, Dodo. Dopey was the family pet used to teach children to ride. Champion calf roper Fay Adams used a horse named Cowboy that Will Rogers acquired. Spirited and unpredictable, Cowboy was used for roping until Soapsuds edged him out with both high performance and great predictability.

A one-eyed steer was kept on the ranch for roping. Young Jim Rogers, as a joke, tied a string of firecrackers to its tail while his father awaited the animal's release into the roping pen.

The fireworks exploded when the steer charged from the gate, and "Dad didn't catch the steer and I didn't go near the house for days when he was there," Jim said.

Will Rogers never punished the children. Discipline was left to Betty Rogers, who said her only hope was that they mature "clean-minded and good which is a lot to expect."

Will Rogers's professional life was not a family

topic. The children were left to find their own persuasive interests and careers.

Through the years in Hollywood, there were vague and unfulfilled plans to move back to the ranch near Oologah "next year." But the specter was not threatening.

When a reporter asked about being married to Will Rogers, Betty said: "He is never cross. He has a smooth, even, easy-going disposition. He is the softest-hearted man that ever lived. He is intensely sentimental whether over people, places or things and equally loyal."

One reporter said Betty pleased her husband by:

"ONE: Feed him. (Mr. Rogers's favorite dish is beans. As a cowboy he learned to like beans. Does Mrs. Rogers say, 'My goodness, Will, I do wish you would eat something else'? She does not. She serves beans twice a week.)

"TWO: Laugh at his jokes. (Even if they're old ones, she adds.)

"THREE: Encourage his hobbies. (Mr. Rogers's hobby is music. He plays the ukelele. Mrs. Rogers never groans.)

"FOUR: Let him wear his old clothes if he wants to."

About his wife, Will Rogers said: "I try and get a few laughs and get some money in and then let Mrs. Rogers do the rest. She is the financial end of the firm.

"This acting thing don't last long. People are get-

ting so they get wise to you mighty quick and you never know what morning you might wake up without an audience," Will Rogers said. "I realize that in order to retain your humor in your old age, you got to have plenty to eat and a comfortable ranch to eat it on."

WILL ROGERS'S WORLD BEYOND HOLLYWOOD

Newsman O.O. McIntyre Described Will Rogers as a fighter on edge, never fatigued or slowed. He was agape at the work Will Rogers did, the things he accomplished, the furious pace he set. During informal "yarning and repartee" at McIntyre's New York apartment with novelist Irvin Cobb and Texas publisher Amon Carter lounging in easy chairs, Will Rogers was walking up and down, twisting, turning, and jiggling things on the desk, peeking into the kitchen, tearing up match flaps.

Nearly fifty years old, Will Rogers was still on the prowl hunting causes.

Heavy rains during spring 1927, flooded the Mississippi Valley. Will Rogers enlisted popular singer John McCormack—"those two nifty boys in funny songs and sentimental jokes"—for a benefit show that raised $17,950. Then they went to New Orleans where they raised $48,000. His great appeal for homeless thousands was through his column:

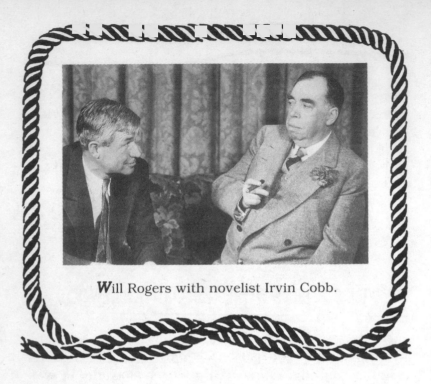

Will Rogers with novelist Irvin Cobb.

"The poorest class of people in this country is the renter farmer or the ones that tend the little patch of ground on shares. He is in debt from one crop to the other to the store keeper or the little local bank. He never has a dollar that he can call his own. City people don't realize the poverty of poor country folks.

"They can talk all they want about country people being out in the air and the open, but I want to tell you as a diet and nothing to go with it, I don't think there is a scientist living that can show any more calories in a few whiffs of country air over air on Hester Street or the Bowery."

Will Rogers pitched for the poor people whose homes and farms were swept away by the flood, including thousands of rural blacks who "never did have much—but now it's washed away."

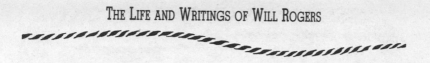

Relief started rolling in for the helpless, and Will Rogers was called to testify before Congress.

CHAIR: "We always accord Congressmen the right of way. We have a new Congressman with us this morning—Congressman at Large Will Rogers. His title was imposed upon him at the Press Club some time ago and of course he had to appear when called upon. He will now testify before the committee. What is your name?"

ROGERS: "Will Rogers."

CHAIR: "What is your post office address?"

ROGERS: "Well, I am waiting for the best offer from California or Oklahoma. Beverly Hills, California, is the latest one."

CHAIR: "What is your business?"

ROGERS: "Well, everybody's."

CHAIR: "You have heard of the recent flood of 1927, I take it, Mr. Rogers, in your travels around the country?"

ROGERS: "Yes sir, I am one of the few Congressmen who have heard of it."

He testified for a public works bill exclusively for flood victims and urged Congress to resist making it a pork barrel bill. He said California's "lawn sprinkling needs should not be compared with the needs of thousands of people on rafts and housetops floating down to join the ocean.

"Every little old one-cylinder Senator, and punctured-tired Congressman from all over the country is

going to try to use the Mississippi Flood Legislation to try to put over his little local scheme," Rogers predicted. "Wonder why our real big men never go into politics?" he asked rhetorically.

Besides congressmen, Will Rogers had other targets. When archaeologists found a huge ancient skull, he said it could have been a golfer who died just after winning his first tournament or a heavyweight champion prizefighter who was told he wasn't required to defend his crown.

Will Rogers joined the nation's serious concern when aviator Charles A. Lindbergh took off in a historic first-ever solo flight from the United States to Europe.

Lindbergh arrived safely. The world rejoiced. Will Rogers wrote: "Lindbergh's great feat demonstrated that a person could still get the entire front pages without murdering somebody."

With Lindbergh, Will Rogers went to Mexico on a goodwill tour and to get some real chili con carne and tamales, see the Mexican ropers, see senoritas dance, and "maybe, if fortunate, see 'em shoot a presidential candidate."

Animal husbandryman Will Rogers seriously explored the breeding and training of fighting bulls, which he said interested him more than any politician.

With Will Rogers in the stands, Mexican President Plutarco Elias Calles grabbed a cape, entered the ring, and took passes at a bull. "Where is your American comedian?" he yelled, challenging Will Rogers to fight a bull. From the highest seat in the arena, Will Rogers explained: "No sir, I had been butted enough in a branding corral by snorty old

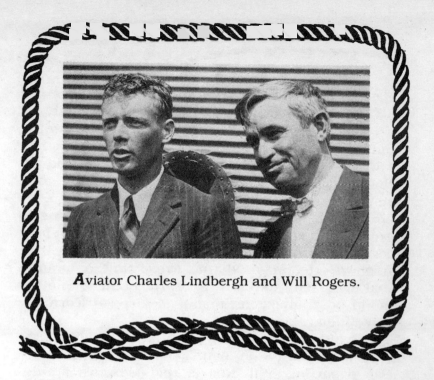

Aviator Charles Lindbergh and Will Rogers.

calves to know that Clem Rogers' boy Willie of Oologah, Oklahoma, wasn't carved out to meet any bull in combat."

Will Rogers reported how celebrities and spectators would leap into the ring to spar with the young, small bulls until as a practical joke, he quietly paid the gate keeper five pesos to release the real thing— a stud bull, a powerful animal imported from Spain for breeding: "When that door opened and he came charging out there, you never saw as many capes, hats and even shoes left in one arena in your life.

"He emptied it like a speech on the tariff will the Senate Gallery. A skunk in a parlor couldn't have more thoroughly disrupted a party than this lone bull did."

Other Will Rogers articles during the trips charged the United States with selfish interests in only oil and coffee: Our calling card to Mexico or Central America, he said, had been a gunboat or a bunch of violets shaped like Marines. Will Rogers said an alternative U.S. policy could be kindness and common sense.

He was critical of wealthy Mexicans for failing to invest in their own country, charging they spent more money on French dresses and perfumes than on plows. He proposed that every time a wealthy child was sent to Paris to learn French, another should be shipped to Sonora, Mexico, to learn the native Indian language.

"The Indians are the ones you have to live and get along with, not the French."

On departing, Will Rogers said Mexico's natural wealth gave the country long-term prospects superior to those of the United States and that "the only trouble with this country is the verbs have too many endings."

Will Rogers posed the question: "Wouldn't it be great if Mexico started electing by the ballot instead of by the bullet? And us electing by the ballot instead of by the bullion."

In Cuba for a Pan-American Conference in 1928, Rogers said delegates "want to vote to make revolutions unlawful. That is, while they are in. But when they are out, they want them declared legal again. It's rather embarrassing for all the delegates are there by grace of a revolution at some time."

In his usual restless fashion, Will Rogers spent the spring of 1928 crisscrossing the United States. He flew down to Oklahoma and landed right on the

ranch where he was born. "First machine ever in here," he said on a grass landing strip beside the house of his birth.

He flew in a compass era, before electronic wizardry, and to assist navigation Will Rogers called on citizens to emblazon their town's name on the tops of their buildings, promising: "I will pay for the paint."

Response was overwhelming. "Mooselookmeguntic, Maine sent me a bill for $79," he said. "They had to put a letter on each house and borrow three houses from Connecticut." By May 18, he wrote that he had "overestimated my resources . . . typographical error . . . I meant I would send brush."

While piloting his own plane, actor Fred Stone crashed and was seriously injured in September 1928 while Will Rogers was in the midst of a lucrative lecture tour. Dropping other commitments and refunding prepayments, Will Rogers flew to New York and took his old friend's role in *Three Cheers*, which opened on Broadway co-starring Will Rogers and Dorothy Stone, Fred's daughter.

Will Rogers stuffed the script in the pocket of his costume and would consult it shamelessly while on stage in front of the audience. *Three Cheers* was a smash hit. Singing songs of the production, Will Rogers said, "was as far as any man has ever gone for a friend."

One columnist said Will Rogers's voice has something of the quality of a water spaniel with a nightmare, the mellow resonance of an eighty-fifth car making the turn onto Madison Avenue.

Another reviewer said a person could see the show at a matinee and return that evening and not know

it was the same musical. *Three Cheers* enjoyed a healthy six-month run on Broadway, then a two-month run on the road, but Will Rogers's diversion from after-dinner speaking cost him an estimated $500,000 in lost income.

Nonetheless, abundance and prosperity served Will Rogers and his family. But across America, drought and Depression gripped the land.

The ill-famed Dust Bowl devastated the environment. The stock market had crashed in 1929, and a general depression gnawed at the world.

During a trip into drought-stricken Arkansas, Will Rogers reported five thousand families, six to the family, were eating in soup lines. "You don't know what hard times are until you go into some of these homes. This is not a plea, it's just a report, but it's the worst need I ever saw."

Working through the Red Cross, Rogers turned the report into a plan of action. He had three weeks open between pictures and wanted to help the downtrodden. Using a plane, he decided to stage his own fund-raising activities. He would pay his own expenses, and money would go half to rural areas and half to the unemployed in cities and towns.

The tour started at Austin, the capital of Texas, in January 1931, before a paid audience in a downtown theater. He had addressed sessions of the legislature before the show, but the lawmakers attended the Austin performance as a body and were the main target.

"The only trouble with your legislature is that it ain't got started yet," Rogers said. "A lot of those boys aren't used to the salary they're getting. Maybe they've never been overpaid before!"

Then he sized up the nation's economic problems: "There's more than a million persons in the country with more money than ever before, but there's ten million people who are poorer than ever. It's up to us to do something about it."

In thirteen Texas cities he raised $82,000 for Red Cross relief and $100,000 during a week in his native Oklahoma. Wealthy Dallas gave only $3,800.

"Dallas laughed at my jokes," he said, "but they like to laugh for nothing."

Back in Hollywood, he took six weeks to film *Young As You Feel*, then left on a two-week flying tour of Central America that included a timely visit at the site of a devastating earthquake that leveled Managua, Nicaragua. His plea for relief assistance was so appreciated that the tiny country issued five postage stamps in his honor.

To his readers in the United States, Will Rogers telegraphed: "You generous folks have been asked until you are ragged, but, honest, if you saw it you would give again." And they did. Will Rogers slept in a tent with Marines and contributed $5,000 of his own money to help people he said were "poorer than a southern cotton renter," then staged relief benefits as he continued his Caribbean tour.

Upon landing in Miami, he said it "must be American territory. I don't see any Marines."

Will Rogers spent a week on the east coast, flew home, and reported he had "traveled 13,000 miles. Fare less than a thousand dollars. Not a forced landing. Not a plane even late. Visited 16 foreign countries including New York City."

A week later, with his wife, he drove some three thousand miles round trip over two-lane roads to

New Mexico and walked seven miles through Carlsbad Caverns, then went home for Mary's 1931 graduation from preparatory school, along with daughters of three other movie figures. Will Rogers said that "all four of us just sat there and purred like old tomcats basking in a little reflected sunshine and secretly congratulating ourselves on choosing a profession where education played no part."

THE WILEY POST CONNECTION

In the latest state-of-the-art Lockheed commercial liner cruising at nine thousand feet at 170 miles an hour, Will Rogers flew home to Oklahoma after his daughter's graduation. Excited as always about flying, he felt this was a doubly important trip because in Tulsa he would meet and fly with the famous world record-setting Oklahoma aviator Wiley Post for the first time.

On July 14, 1931, in the fabled *Winnie Mae* single-engine plane with Wiley Post as pilot, Will Rogers flew twenty miles from Tulsa to his hometown of Claremore.

To attract publicity, in just four days the town had built a special airport to welcome Rogers, Post, and Harold Gatty, Post's Australian navigator who had joined in his 1931 around the world record.

Aviation was a deep interest of Will Rogers in

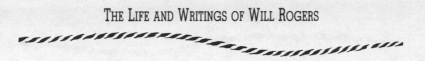

which he had long participated. He battled navy and army traditionalists over the inevitable power of an air force in future wars. When Billy Mitchell was court-martialed in 1925 for criticizing mismanagement of the Aviation Service, Will Rogers stood at his side.

When he traveled, he chose airplanes. If there was a crack-up, he would minimize the event, and the records are fuzzy about how many times he crashed—surely several.

When Post and Gatty set the eight-day, around the world flight record in 1931, Will Rogers wrote: "I would like to go to that Honolulu some time, but I do hate that boat trip. If I could fly over I would go tomorrow. If I could get this Gatty and Post to take me over. Such a navigator. Such a flyer. Just think, clear around the world with one motor."

When Post flew around the world alone in July 1933, Will Rogers wrote: "I would have liked to have been in there with Post instead of the robot. And I could have if I had known as much as it does.

"What did I tell you about that little one-eyed Oklahoma boy. He is a hawk. Nobody would criticize him even if he turned banker or took a seat on the stock exchange."

A decade younger than Will Rogers, Wiley Post was born near Grand Saline on a Texas farm. His only sister was born when he was three, and he felt neglected and showed considerable signs of self-pity: "Nobody seemed to care much what I did as long as I took care of the few simple chores," he said.

When the family bought a new harvester, the lonesome boy learned every component. The family moved to Maysville, Oklahoma, and the mechani-

cally minded boy became the community tinker, repairing anything that moved.

In 1913, he rode fifty miles in a horse-drawn buggy to Lawton, Oklahoma, to see farm equipment at the Comanche County Fair, but what the four-teen-year-old boy discovered was a Curtiss pusher airplane. The pilot became his first hero.

His efforts to touch the plane were thwarted by a special guard, but under cover of darkness Post sneaked into the open cockpit. His imagination had him hurling through space at thirty miles an hour when his brother found him. He pulled Wiley from the flying machine but not from the romance of flying.

Three years later, Post traveled to Kansas City for a seven-month course at Sweeney Auto School, then returned home to help build an air field at Fort Sill, an army field artillery post at Lawton.

With World War I raging, he joined the Students' Army Training Camp at Norman, Oklahoma, and studied radio, mechanical drafting, and some engi-neering. The war ended and his school was dis-missed. Wiley Post became a $7-a-day oil field roughneck—repairing drilling equipment—but soon graduated to an $11-a-day tool dresser, then a driller at $25 a day.

When a barnstorming pilot, Captain Zimmerman, landed in Walters, Oklahoma, Wiley Post, then twenty years old, paid $25 for his first airplane ride. Less thrilling than he expected, it left him squeam-ish. At that point he said he realized aviators did not necessarily have "supernatural powers I had been reading about."

While working as a driller, Post also was speculat-

ing on oil land—missing fortunes each time. At age twenty-four, he walked off a job and joined a flying circus as a parachutist. On his second airplane ride, he leaped from two thousand feet into "one of the biggest thrills of my life. It didn't take more than two minutes, but to me it seemed like a couple of hours."

For fees up to $200, Wiley Post spent two years as a barnstormer parachutist gradually learning to fly the planes, but when oil prices boomed in December 1925, Post returned to the security of the oil fields, resolving to quit when he had earned enough money for his own plane.

When he was fresh on the job, a metal chip flew off a bolt that was being hammered and struck Post's left eyeball. Infection set in, forcing doctors to remove the eye.

While recuperating on an uncle's farm, Post practiced gauging depth and distance by looking at a tree, guessing the distance, then checking his judgment based on walking at a four-mile-an-hour gait.

Workers' Compensation awarded him $1,800 for the eye loss and after he paid medical expenses, he had $1,200. For $240, he bought a slightly crashed Canuck with an OXS-5 engine and spent $300 rebuilding it. After some lessons, he began a flying service for Oklahoma oilmen during the week and worked the aerial circuses on weekends.

While he was eloping from Sweetwater, Texas, with Mae Laine, the rotor in the plane's magneto distributor quit and Post executed his first forced landing in a Graham, Oklahoma, cornfield. He fixed the plane and got married before he took off again.

Post sold the Canuck and became a private pilot

for oil well drilling promoter F.C. Hall, flying a Travelair. In 1928, Hall traded for a Wasp-motored Lockheed Vega that was christened *Winnie Mae*, in honor of Hall's daughter.

At this point, Wiley Post finally got his formal pilot's license despite the loss of an eye because Hall politically interceded on his behalf.

Business reversals forced Hall to reconsider the economics of supporting a plane and pilot. Post delivered the plane to the factory in Los Angeles, then was hired by the manufacturer Lockheed as a test pilot. He learned engineering details that he applied to the design of the second *Winnie Mae* that Hall bought when he became financially able to hire back his old pilot.

After winning $7,500 in a cross-country flight, Post teamed with Frank Gatty in the historic, record-setting around the world flight of eight days, fifteen hours, and fifty-one minutes during the summer of 1931.

The day they took off, Will Rogers said he would have liked to have been "stored away in the tail."

Two years later, reportedly embittered over his failure to become rich, Post took off on his second around the world flight—alone, without even a parachute or a life raft. Seven days, eighteen hours, and forty-nine and a half minutes later, he was back in New York. Aviators the world over agreed it was the greatest individual feat in aviation history.

On that hot July evening in 1931 before the flight to Claremore, at a banquet in Tulsa, Will Rogers glowed with pride about his new personal acquaintance with Wiley Post.

Will Rogers and fellow Oklahoman, record-setting aviator Wiley Post.

ASIAN WAR CORRESPONDENT

By Autumn 1931, Fox Studio Had Finished Will Rogers's filming schedule for the year with *Ambassador Bill*, a spoof of the diplomatic corps, with Will Rogers playing a common sense political appointee thrust into successful public service.

Soon to follow was Will Rogers as an international war correspondent in search of action. Furthermore, he had columns to write and a continuing urge to travel. Japan had used an explosion on September 18, 1931, as an excuse to invade Manchuria, where they fought the Chinese forces of General Chiang Kai-shek.

Like a war correspondent, Will Rogers set out for the front lines.

Rogers disdained public apathy about the aggression, quoting headlines reading: "China Attacks Japanese Troops," and "Japanese Attack Chinese Troops," but then lamenting that the "one lone item that appealed to everyone was that poor fellow with the hiccoughs."

Datelines on Will Rogers's daily cables charted the trip, starting with eleven days from "Aboard S.S. Empress of Russia." He reported that the ship "hit a typhoon . . . crossed with a monsoon and sired by a Hurricane." In Yokohama, Japan, he reported he got run over by a ricksha. "That's a taxicab propelled by a man."

"After drinking about two barrels of tea and wanting to be fair, here is about how Manchuria looks to me: China owns the lot. Japan owns the house that's on it. Now who should have the policeman?

"China is trying to save its country, Japan is trying to save its investments, the League of Nations is trying to save face. Now somebody has got to lose."

He sailed to Korea, then flew to Dairen, China, with Japanese pilots flying close to the tops of the rice fields. He called China the birthplace of Japan and the graveyard of old Russia. He said Siberia looked just like Oklahoma in the midst of great drought, and the farmers are just as bad off. By December, he was in Harbin, China, where the temperature was thirty-two degrees below zero, the horses were wearing snowshoes, and vodka was not a beverage but a necessity.

Instead of war, he found Russian and Chinese actors staging *Abie's Irish Rose*, a sentimental 1922

American comedy about a romance between a Jewish boy and an Irish girl that enjoyed 2,327 performances in New York. Will Rogers asked: "What more cause could there be for a war?"

In a more serious vein, he reported that the League of Nations was sending a commission to examine the Manchurian battlefields and opined it was "like a sheriff examining the stall after the horse has disappeared. For half the money, I will send in the same report . . . only shorter."

"When a country bigger and more fertile than the whole State of Texas changes hands, yet war is not declared on either side and five months later the League sends in a jury to see how it was done, now there is a laugh in there somewhere."

Will Rogers said any investigator would wind up wrong with both sides. But, he said, since the United States had "yet to referee a fight successfully, we will join 'em and get it wrong. It's too big an opportunity to lose. America could hunt all over the world and not find a better fight to keep out of."

He reported there was "plenty of excitement in these countries. Japan's cabinet resigned. China's resigned. We can't ever have any luck like that."

Finally, Will Rogers decided he had been in China too long. "If I had only stayed a couple of days I would have had a better idea of China. The more folks you talk to, the more you see and the less you know. The last man that knew the Chinese was Confucius and he died feeling he was becoming a little confused."

He said the war was "mixed up with treaties, secret agreements and understandings and nobody knows whose claim is any good. The Japanese have a lot of

money invested in China and they want to supervise things their way. Nobody is going to take China. China, even if they never shot a gun for the rest of their lives, is the most powerful country in the world. You could move the whole of Japan's seventy million into the very heart of China and in seventy years there wouldn't be seventy Japanese left. China is the only country in the world that needs no protection. Its principal enemies are the so-called educated ones that come home and try to change it."

Yet Will Rogers warned that the "Japanese take their wars serious. They go in them to win."

Rogers warned readers of dispatches from the Japan-China war to beware of censorship and press agentry about the war, complaining that neither country would send a dispatch "that is not colored in their favor."

As Will Rogers left mainland China for Hong Kong, he wrote: "Another hoax is that a Chinese's word was as good as his bond. Might have been in the old days but not since the missionaries and businessmen come in. Chinese are just as human as anybody now."

He sailed around southeast Asia, then flew across Thailand, India, the Middle East, Egypt, and Athens with the same airplane and crew. At stops, he cabled daily columns and mailed the weekly articles that kept Americans abreast of his traveling adventures. He proposed to set the Philippines free, then have the United States go under their protectorate as the "only chance I see of us getting an improvement in our government."

From Penang, he reported that nations not under the gold standard had cut their prices in Asian marketplaces, and American salesmen with prices tied

to gold were left to smoking their own cigarettes and burning their own gas because of lack of sales.

From Rome, he reported Italy looked like pie and ice cream compared with India, China, and Mesopotamia. He said Mussolini had "done more with less to work with than any man in the world."

From Paris, he said that all that Europe was looking for the United States to do was cancel debts.

In London, the world traveler was met by his wife, and together they doubled back to Paris, then to Geneva to cover the disarmament conference and to meet Dr. Mary Emma Woolley, the former Mount Holyoke College president and peace activist, who was the American delegate.

"Thirty million women of the world have hope and faith in her common sense versus diplomacy. It's no joking matter getting the world to disarm. Maybe a woman can do it. It's a cinch men can't."

He called the meeting a "hash of nations. There is sixty-five nations represented here. You see, this is land disarmament, too, so every nation with railroad fare and a gun is here. The smaller the nation the bigger the delegation. If you disarmed the delegates you would have disarmed over half the countries present. Turkey is here not to disarm but to try and book some wars for the coming season.

"There is lots of nations here willing to throw away two spears and a shield for every battleship we sink."

As he sailed for home, he reported the meetings were delayed because of the war in China: "They have to disarm between shots." He said Japan had asked investigators "not to come until they had captured enough to make the trip worthwhile. If Japan

keeps expanding, the delegation will meet the Japanese army at about Reno or Salt Lake."

The ominous statement was made nine years before the Japanese attacked Pearl Harbor.

On the boat, he cabled: "I am coming home to Cuckooland. God bless it. He hasn't lately, however, but he will when we deserve it." When he landed in New York, Will Rogers said he was "glad to set my old big feet on American soil even if it has got a second mortgage on it. Business is off they say 60 per cent but that still leaves us 30 per cent ahead of anywhere I have seen.

"If we can just let other people alone and let them do their own fighting. When you get into trouble 5,000 miles away from home, you've got to have been looking for it."

Betty and Will Rogers visited the White House to talk with President Hoover in Washington, saw friends in New York, and stopped in Detroit to spend the day with Henry Ford. Three months after leaving Los Angeles, Will Rogers was back home from his second around the world trip.

USHERING IN THE ROOSEVELT ERA

MOVIEMAKING WAS A ROUTINE, AND WILL ROGERS seemed to relax while busy. Without plans, he would awaken on an idle day and call to his wife, "Come on, Blake, let's get going." Then they would motor aimlessly across the back roads of California.

If he faced a deadline for a column, he would pull to the side of the road, grab his portable typewriter, and concentrate on the next day's epistle while Betty Rogers quietly knitted or simply watched. Then they roared off to the nearest Western Union office, where the missive was sent to New York collect.

Or riding Soapsuds, he would meander into the mountains as carefree as the boy who three decades earlier nudged Comanche up the hillsides of Cooweescoowee District or loped across the plains of Oklahoma.

By 1932, the children were seventeen through twenty-one years old, and increasingly independent. Will Jr. was heading toward a political and journalistic career that would diversify into playing the role of his father in later motion pictures. Mary was privately considering a career as an actress and made strides toward success without her father's intervention. Jim would become a rising Saturday matinee cowboy movie star and then settle for the contented life of a California horseman and cattle rancher—a real cowboy.

The year 1932 was economically and politically turbulent. The world Depression was three years old, unemployment raged, and human despair haunted the globe.

For the wealthy, Will Rogers reported that John D. Rockefeller, ninety-four, had set an example by giving away hundreds of millions of dollars, then opined that others might just as well have given away money; they lost it anyway.

As evidence of ill-distributed wealth, Will Rogers reported that while millions were jobless, broke, and hungry, a $2 billion federal liberty bond issue was

With millionaire John D. Rockefeller.

oversubscribed by previously idle money. He said
there was so much excess wealth that the entire
issue "was spoken for by sundown . . . they could
have loaned twice that much." Then he turned on
Congress as the "'loaningest' and 'appropriationist'
Congress that ever was." At the same time, impov-
erished, almost starving World War I veterans
unsuccessfully marched on Washington and were
denied bonus payments.

The celebrated bonus marchers' pilgrimage "was
ill-advised and no doubt did their cause harm, but
they have their side of it too. They have the same
right there as any other 'lobbyist.'"

He called the demonstrators "the best behaved of
any 15,000 hungry men ever assembled anywhere
in the world," then rhetorically questioned whether

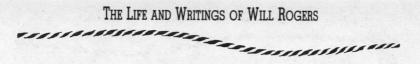

fifteen thousand hungry bankers, farmers, preachers or club women would have acted so civilly. Will Rogers was critical when President Hoover ordered soldiers to set fire to their tent city and mounted troops drove the veterans from Washington.

The Hoover administration was in disarray, and Will Rogers saw a need for change.

Acting in the thin capacity of being former honorary mayor of Beverly Hills, Will Rogers introduced Franklin Roosevelt during a rally attended by a hundred thousand at Olympic Stadium in Los Angeles: "If this introduction lacks enthusiasm or floweriness, you must remember you're only a candidate. Come back as President I will do right by you. I'm wasting no oratory on a prospect."

Roosevelt could not have had a more effective endorsement.

One Will Rogers column charged Republican investors were buying and selling stocks during 1932 to give an impression of economic recovery "just in time to knock the poor inoffensive Democrats out of their hard-earned votes."

During the Democratic National Convention, Will Rogers spoke for an hour to the delegates and predicted a general election victory over incumbent Republican Herbert Hoover.

By autumn 1932, Will Rogers was off to do personal fact-finding in Central and South America. In Mexico he reported there had just been a change of presidents. "Not a shot fired, not a speech made, not even a radio address. Country not all divided against itself. This is the most civilized country in the world."

He noted that the United States wouldn't recog-

nize the government of El Salvador because it was formed after a revolution, "something like Washington did in America."

He visited Honduras, Costa Rica, Panama, and Peru before he found a war in the works. He reported from Santiago, Chile, that "Peru and Columbia are going to war over a boundary so isolated that neither nation can get to it. So they are arranging to have the army meet in a convenient place and fight over a piece of ground that the winner can't get after they have won."

In Brazil he found the streets being swept up after a revolution two weeks earlier: "The President stayed in. The Democrats couldn't dislodge him. That might be the first consolation the Republicans at home have had."

Flying in a Ford Tri-Motor plane, he returned to his California ranch after three weeks, having traveled twenty-one thousand miles through twenty countries. Airfare was $1,600, and he wrote, "It's got any trip to Europe skinned a mile."

He predicted that Latin America was where the United States could expect to build commerce, and his column argued for a strong Pan American alliance. Will Rogers showed increasing distrust of the Soviet Union, the warlords in Japan, Hitler in Germany, and Mussolini in Italy.

Long before World War II started, Will Rogers's visits to the future battle scenes and his talks with major participants gave insight to the average person who read his columns.

He wrote that more land deals than good will was accomplished at peace conferences. In wars, he said, the slogan is honor but the object is land. The fights

are for independence, but at the finish winners snatch defeated opponents' land on which to be independent.

He chided Big Brother nations for claiming to help Weak Sister when, regardless of how poor and inefficient, small countries deserved independence to run their own business. "Japan, America and England can run countries better than China, Korea, India or the Philippines, but that don't mean they ought to."

His travels and reading gave him insight that he tempered with humor and passed along in magazine articles, newspaper columns, and radio shows.

He questioned why the papers got excited because Japan was buying ammunition, guns, cotton, nitrates, and scrap iron: "These Japanese run their wars just like they do their trains—right on time. War is a business with these folks. When a war shows up, they don't have to stop and put in a draft and sing songs and make three-minute speeches and appoint dollar-a-year men. All that has been attended to long before the war ever broke out. All their soldiers are trained between wars—not after one starts. You think that's kidding? You are just another Senator if you do."

While he had met General Jiro Minami, the Japanese war minister, Will Rogers had failed in an attempt to interview Adolf Hitler, but had compared the German leader with gangster Al Capone eight years before Nazi forces invaded Poland.

He even compared Hitler's tactics with those of the Ku Klux Klan, but then gave the German leader encouragement when he had apparently toned down his racial and religious hatreds.

After Franklin Roosevelt took office, Will Rogers championed his New Deal program and praised the new President's international postures in simple words: "Roosevelt made this tough guy Hitler promise to bring sticks out of the water."

Will Rogers warned against believing Europeans. "They will agree to anything until it comes time to sign up."

He said the depths of the Depression "might just be the ideal time to stop a war. Nobody has anything to fight with. Like disarmament, it's not done for humanitarian reasons. Wars are only done for economic reasons."

When France and Germany quarreled, he advised that "for once in our lives, that we just let those two old tomcats, whose tails are tied over the fence, alone and try to cure the scratches we got from the last time we tried to untie 'em."

President Roosevelt seemed to listen to Will Rogers.

THE THIRD TRIP AROUND THE WORLD

Fox STUDIOS BY 1934 HAD SCHEDULED WILL ROGERS for three motion pictures each year, just what the market consistently was accepting profitably. As quickly as possible, he would complete his acting responsibilities and seek new adventures.

Besides his other obligations, Will Rogers had starred in *Ah, Wilderness*, playing the lead Nat Miller in Eugene O'Neill's stage play. Old friend Fred Stone had coached him in the first straight role of his career in which he memorized lines.

The show opened for three weeks in San Francisco April 30, 1934, with performer Eddie Cantor claiming "his performance had the audience throwing their hats in the air and the critics their adjectives even higher." It then ran six weeks in Los Angeles to sell-out audiences. The show grossed $190,000, and the producers wanted to continue the run. Will Rogers had other plans.

On July 22, 1934, Will and Betty Rogers taking their two sons but leaving daughter Mary behind, set sail for Hawaii on Will Rogers's third hasty around-the-world trip. Coincidentally, President Roosevelt was in Honolulu when the Rogerses arrived.

While their sons roamed the beaches, the Rogerses joined a dinner party of a dozen in the President's apartment. The President was, Will Rogers reported, "in great humor and told us many diplomatic things and many that wasn't. He was simply overjoyed at the spirit and prosperity of the Islands and the way the various nationalities all got along."

In general, Will Rogers kept the President's confidence, preferring to report on the islands' surfboard action and allowing: "I couldn't ride one of those ironing boards with my stirrups hobbled. My kids tried it, but they come in a new way—they had the board riding them."

The family sailed for Japan and China, and then, trapped in a railway car for seven days, they rode the Trans-Siberian slow train behind a wood-burn-

ing locomotive. "Wish I had Wiley Post here," Will Rogers telegraphed from Novosibirsk, longing for an airplane.

A year later, Rogers would be lured by the prospects of seeing Siberia from the air and would fly to Alaska with Post, intending to explore a trans-Arctic air route to Russia.

Staring out the train window, Rogers saw women harvesting wheat while the men loafed at the depot and quipped: "You know these folks got some good ideas at that.

"Equality of sex in Russia is not so. The women are doing the work. They are digging a subway. I never saw as many buildings going up in my life," he reported from Moscow.

Leaving his family for short periods, Will Rogers took numerous side trips flying through the Ukraine and the Caucasuses to the Black Sea, and complimenting Russian pilots. He wondered why the government had moved the nation's capital to Moscow from the beautiful city of Leningrad.

He flew to Finland, which he called "integrity's last stand. Most stable government of any of them." His telegraphed columns back home were running geography lessons with social observations: "When Finns aren't running a 25-mile race, they are scrubbing on something." He praised Finland for having the "finest Capitol, House of Parliament, in the world. Brand new. They vote by electric buttons."

In Stockholm, he complimented Sweden for avoiding war so long that "they haven't got a word for repudiation." He said Denmark, Norway, Sweden, and Finland, who had avoided war for fifty years,

were examples to the world on "how to live neighborly and tend to your own business."

Flying with his family into London, he called it a "place where fascism, communism, Hitlerism or nudism will never get anywhere" because of the Speakers Corner in Hyde Park where poor people customarily vented their rage, then went home. He said: "Nobody wants his cause near as bad as he wants to talk about his cause. England has solved the talking problem."

Will Rogers warned his readers that Vienna was "Europe's hot box" and where war could start. Being a leading critic of Adolf Hitler, he did not visit Germany, instead leading his family into placid Scotland, then sailing for the United States.

In Detroit, he visited an optimistic Henry Ford, whom he described as the richest man in the world. "He believes the country is improving. He would vote for Roosevelt. His endorsement is not only verbal, he is spending millions on new plants. I attribute his success to selling motor cars exclusively and not selling stock," Will Rogers wrote.

Will Rogers's hobnobbing with the elite brought him to comical cross swords with a fellow syndicated columnist, Arthur Brisbane, who twitted the Oklahoman's "cowboy style" and hinted that Will Rogers in reality may have attended Eton and Oxford.

"No part of a person's private life is free from the eagle eye of Brisbane," Will Rogers responded in his column, pretending that he had been caught with lofty academic credentials, "if we can conceal it and get away with it, give us credit."

Brisbane was a close friend who enjoyed heckling

Will Rogers's success. Another pal Rogers first met on the circuit in Africa, comedian W.C. Fields, said of the drawling Will Rogers: "I'll bet a hundred dollars he talks just like everybody else when he gets home."

Will Rogers's real reason for completing his trip around the globe in less than six weeks and flying to Detroit was to watch the World Series. The hottest topics of October were his fellow Oklahomans, brothers Dizzy and Daffy Dean, both pitchers for the St. Louis Cardinals baseball team. Dizzy Dean pitched a six-hit shutout in the final game of the 1934 World Series, giving the Cardinals an 11–0 victory over the Detroit Tigers and baseball's crown. Will Rogers spent a week in Detroit to watch as many games as possible.

The Dean brothers shared the media spotlight with another Oklahoman. In December 1934, Will Rogers wrote: "Our own Wiley Post went up to break the altitude record. He drifted from Bartlesville to Muskogee, Oklahoma. He was ten miles up." The following February, Rogers rode in a chase plane behind Post, who was wearing a pressure suit of his own invention on a long-distance endurance flight in jet streams at thirty-five thousand feet. Post carried oxygen sufficient to last eight hours. Problems developed aloft, and Post's experiment was aborted.

By summertime, Soviet fliers were discussing a sixty-hour nonstop Moscow to San Francisco flight over the North Pole that Wiley Post had talked about with Rogers as an alternative to longer transoceanic trips.

In late July 1935, Wiley Post and Will Rogers teamed up for a three-day flight to New Mexico and

Baseball star "Dizzy" Dean (Jay Hanna) and Will Rogers during the 1934 World Series.

visited the Waite Phillips ranch where Post fished and Rogers looked at cattle. They flew over Brice Canyon, Zion Canyon, Grand Canyon, and Hoover Dam, as was graphically reported in Will Rogers's news column.

They were flying Post's newly acquired red single-engine Lockheed Orion that, with Rogers's financial assistance, was being customized with Post's experimental features. The plane was a true hybrid. Quietly, since Fox studios, Mrs. Rogers, and caring friends were concerned about Rogers's flying adventures, Post and Rogers were planning a late summer trip to Alaska that could lead to a polar jump into Siberia. Wiley Post dropped off Will Rogers in Los Angeles and flew to Seattle to fit special pontoons onto the craft.

While Post was in Seattle adapting the plane, Will Rogers was completing two movies, *Steamboat 'Round the Bend* and *In Old Kentucky.*

The screen version of *Ah, Wilderness*, Will Rogers's stage success of 1934, was due to be filmed during the summer of 1935. Eddie Cantor blamed a letter dispatched by a disgruntled minister for Will Rogers's refusal to play the male lead for cinema.

The preacher had taken his fourteen-year-old daughter to the play, not knowing that, in his role, Will Rogers lectured his stage son about having relations with an immoral woman. These lines were offensive to the minister. Ever careful of his clean image and reputation for smut-free living, Will Rogers gave up the part, and Lionel Barrymore was cast in the role. Will Rogers had time to fly with Wiley Post. His column said: "When my wife knew it was with Wiley, it didn't matter where we was going. She was mighty fine about it." Betty Rogers said her husband was tired and had looked forward to a vacation with the eagerness of a young boy.

Even as he packed for the flight to join Post in Seattle, he flipped a coin about going. With Will Jr., Rogers attended the 1935 World Championship Cowboy Contest at Gilmore stadium in Hollywood, then took a late flight to San Francisco to get passport credentials necessary to fly into Russia. However, when he last talked with Betty Rogers at noon, August 8, from Seattle, he said plans beyond Alaska were tentative.

Betty Rogers then left for Skowhegan, Maine, where their daughter, Mary, a twenty-two-year-old rising actress, was playing summer stock theater with the Lakewood Players.

The show, *Ceiling Zero*, would be the rising star Mary Rogers's last theatrical appearance.

Will Jr., almost twenty-four, was preparing for a trip on a tanker to the Philippines.

Jim, twenty, with a cousin, was driving his car from a ranch in Texas enroute to New England to watch his sister perform.

If Will Rogers and Post continued into Russia, the agreement was that Betty would fly back to California, then journey to Europe—possibly Moscow—for a rendezvous with her husband.

Together they would hurry back to California to keep radio show commitments.

If Rogers and Post nixed the Russia idea, Will Rogers would return to Maine to watch his daughter perform.

In Seattle, Will Rogers took a look at the first B-17, the famed Flying Fortress of World War II, that had just taken its maiden flight. Will Rogers called it "the world's greatest bombing plane."

After they had played a healthy game of polo the day before, the Post-Rogers flight took off on the thousand-mile flight to Juneau at nine-twenty A.M., August 6. Five of Will Rogers's lengthy weekly newspaper stories were written about Alaska. He wrote about the Lockheed's big Sirus wings, Lockheed body, three-bladed pitch propeller, and big Wasp engine. The plane's weight was so front heavy that Will Rogers would climb to the extreme rear of the cockpit to give proper balance during takeoff.

He maintained in his columns that their destination was uncertain and compared their travels with a carefree family drive in an automobile.

Will Rogers revealed that, at the last moment, Mrs.

Post had decided against the trip although the plane could carry six passengers. The plane hauled sleeping bags, small grips filled with clothing, a rubber boat, a canoe paddle, life vests, a gun, fishing gear, coils of rope to tie up at docks, and two cases of chili.

In Juneau he purchased and mailed a red fox fur to his wife. Then they flew to Aklavik, Northwest Territory, where Will Rogers saw a horse that ate fish and traveled on snowshoes. They visited Fairbanks, then Anchorage, where Joe Crosson, a savvy Alaskan bush pilot, circled Mount McKinley in a Lockheed Electra so they could see the highest American mountain, wild sheep, moose, and bear.

They flew to Matanuska Valley, where an experimental farming community had been established. In his newspaper column, Will Rogers made a plea for housing for the settlers and concluded that "there is a lot of difference in pioneering for gold and pioneering for spinach." The column was filed August 15 with a Fairbanks dateline. It was daily telegram number 2,817—his last.

As the pair prepared to fly to Point Barrow, Will Rogers handed Crosson a telegram to be sent to his daughter, Mary:

"Great trip. Wish you were all along. How's your acting. You and Mama wire me all the news to Nome. Going to Point Barrow today. Furthest point of land on whole American continent. Lots of love. Don't worry. Dad."

The reference to Nome was a tip-off to Betty that the two adventurers had decided to try the Russian undertaking. She said the telegram was disappointing and made her a little unhappy because she had

Will Rogers (on wing) and Wiley Post preparing to take off on the ill-fated flight to Point Barrow, Alaska.

hoped the two would curtail their voyage in Alaska and return home instead of facing the wide expanse of Siberia.

On Friday, August 16, a second telegram arrived in Maine telling Betty Rogers of her husband's death.

At eleven A.M. on Thursday, the Lockheed Orion had soared northward from Fairbanks toward Point Barrow, where Will Rogers wanted to meet Charles Brower, a whaler-trader for fifty years. Another whaler in an open motorboat along the five-hundred-mile route reported hearing an airplane flying in dense fog.

About fifteen miles from Point Barrow, Wiley Post spotted an inlet, landed, and asked an Eskimo hunting party for directions. The adventurers shared food with the natives, who spoke only broken English.

Eskimo Clare Okpeaha pointed their direction to Barrow, then watched the plane taxi into position and roar into the air. The engine spit, sputtered, and stopped. The plane banked right, then nosedived into the shallow inlet.

The Eskimo man ran out on a sandspit and yelled. There was no answer. Just steam from the hot engine, wreckage, and silent death.

For three hours, across the lonely tundra, Okpeaha ran the fifteen miles to the U.S. Army Signal Corps station manned by Sergeant Stanley R. Morgan.

"Red bird smashed," the Eskimo gasped.

Sergeant Morgan called Dr. Henry Greist, superintendent of the Presbyterian Mission Hospital at Barrow, and discussed the possibility that the expected airplane was down.

In a whaleboat with an outboard motor, the sergeant and a native crew cut through mist and fog to

the Eskimo village of Walkpi. A small group of natives huddled around a sleeping bag.

Under it was Will Rogers, his skull crushed, his legs broken. An Ingersoll pocket watch ticked three-thirty A.M. His pockets were filled with the program from the rodeo, a knife, a puzzle, and a folded news clipping about his daughter's show in Maine, in which her stage father was killed in an airplane crash. Mary's tiny face smiled on the rotogravure.

Inside the plane that lay in two feet of water, Wiley Post's body remained trapped. The sergeant instructed the natives to pry apart the twisted wreckage. Post's wristwatch was shattered at eight-eighteen.

The bodies were wrapped, and the launch chugged back toward Point Barrow—at the top of the world— where Sergeant Morgan telegraphed the terse news of the crash and the deaths.

Radio flashed the facts. Saturday morning banner headlines of newspapers worldwide carried the news. Again on Sunday, the deaths were top news, with pages of sidebars and reaction stories filling the papers. Besides the main story, one newspaper carried thirty-nine additional articles and fifteen photographs of the two victims.

Congress, racing toward adjournment, was quiet, then eulogies began to roll.

Jim Rogers had stopped over in a hotel room in New York. He was heartbroken that his father was dead. The extent of national mourning made him realize for the first time that his father was, indeed, a national figure.

Both radio networks went silent for half an hour.

Towing black banners, a squadron of airplanes flew over New York.

Joe Crosson loaded the bodies into a plane and flew them home.

Wiley Post's funeral was in Oklahoma.

Will Rogers was buried in Los Angeles. Friends in Oklahoma built a handsome sarcophagus at the regal memorial on a bucolic hillside at Claremore, a dozen miles from his Oologah birthplace. Nine years later, the bodies of Will Rogers and his son, Fred, were quietly moved home at the request of his ailing widow, Betty, who died a few short weeks later and was entombed just inches north of Will Rogers's remains.

Through the years, visitors paid quiet homage.

Will Rogers once said: "When I die, my epitaph, or whatever you call those signs on gravestones, is going to read 'I joked about every prominent man of my time but I never met a man I didn't like.' I am proud of that. I can hardly wait to die so it can be carved. And when you come around my grave, you'll probably find me sitting there proudly reading it."

ENCORE

ABOUT FIFTY-SIX YEARS AFTER WILL ROGERS DIED AT nearly age fifty-six, a musical play called *The Will Rogers Follies, A Life in Revue* opened at the Palace

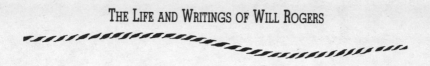

Theatre on Broadway. Keith Carradine, born fifteen years after the crash in Alaska, played Will Rogers. Dee Hoty was Betty. The show was well received by theater critics and general public alike and went on to win several major awards, including the 1991 Tony Award for Best Musical. Through the years, two major movies and several television specials had been made on Will Rogers's life. Books were written about Will Rogers and his own writing was collected into bound volumes. The 1991 Broadway show was nominated for eleven Tony awards and won six. It was directed and choreographed by Tommy Tune, a Texas-born part-Indian who had spent happy summers on his grandmother's farm at Muskogee, Oklahoma, not far from Oologah. The playwright, Peter Stone, as a boy had met Will Rogers. The show brought knowing nods of approval from those who had loved and admired Will Rogers, including Jim, his seventy-five-year-old son, who beamed through opening night alongside his own three children and ten grandchildren. Mary, the ingenue who quit the theater the day her father died, newly had joined her parents at the Oklahoma sarcophagus, a place Will Rogers's lone daughter only rarely had visited. Will Rogers Jr., an octogenarian, had undergone surgery and stayed at home in Arizona, where he eagerly read both praise and scathing reviews in the *New York Times*. Audiences laughed, applauded, and cheered. Some eyes grew misty. Leaving the Palace Theatre where Will Rogers once played, they smiled. The next day, many recounted the words they had heard.

PART TWO

THE MAN AND
HIS WORDS –
SELECTED
WRITINGS

Of Chewing Gum and New Industry

Will Rogers was best as Will Rogers. He wrote his own best material. In his book *Illiterate Digest*, a memorable treatise was:

PROSPECTUS FOR
"THE REMODELED CHEWING GUM CORPORATION"

Last week I made, on account of my Movie work, a trip to Catalina Island and along with the Glass bottom Boat I had pointed out to me the home of Mr. William Wrigley on the top of the highest mountain. He also owns the Island. We were not allowed to go nearer than the gate as the Guide said some other Tourist had carried away a Grand Piano, and he had gotten dis-

couraged at having them around. Another
tourist was caught right on the Lawn Chewing
an opposition Brand of Gum. That is really the
thing that gummed up the Tourist Parade.

Then I remembered having seen his wonder-
ful building in Chicago, all, mind you, accumu-
lated on Chewing Gum at a Cent a Chew. Now I
felt rather hurt at not being allowed to at least
walk through maybe the Kitchen, or the Cellar,
because I know that I have contributed more to
the Building of that Home than any one living.
I have not only made Chewing Gum a pastime
but I have made it an Art. I have brought it
right out in Public and Chewed before some of
the oldest Political Families of Massachusetts.

I have had Senator Lodge (who can take the
poorest arguments in the World and dress them
up in perfect English and sell them) after hear-
ing my Act on the Stage, say: "William" (that's
English for Will), "William, I could not compre-
hend a word of the Language you speak, but
you do Masticate uncompromisingly excellent."

This reception which I received at the Wrigley
Home was so in contrast to the one which I
received at Mr. Adolphus Busch's in St. Louis.
When he heard that one of his best Customers
was at the outer Gate, Mr. Busch not only wel-
comed me, but sent me a fine German Police Dog
to California, the stock of which had come direct
from the Kaiser's Kennels in Pottsdam. The Dog
did wonderful until some one here by mistake
gave him a drink of Half of One Percent Beer. He
would have been six years old next May.

After looking on Mr. Wrigley's home with

much admiration and no little envy, the thought struck me: A man to succeed nowadays must have an Idea. Here I am, struggling along and wasting my time on trying to find something nice to say of our Public Men, when I should be doing Something with Dividends connected with it. So then the thought struck me: WHAT BECOMES OF ALL THE CHEWING GUM THAT IS USED IN THIS COUNTRY?

I just thought to myself, if Bill Wrigley can amass this colossal fortune, and pay the Manufacturing charges, why can't I do something with Second Hand Gum. I will have no expense, only the accumulation of the Gum after it is thoroughly masticated. Who would be the most beneficial to mankind, the man who invented Chewing Gum, or me who can find a use for it? Why, say, if I can take a wad of old Gum and graft it onto some other substance, I will be the modern Burbank. (With the ideas I have got for used Gum I may be honored by my Native State of Oklahoma by being made Governor, with the impeachment clause scratched out of the Contract.)

All Wrigley had was an Idea. He was the first man to discover that the American Jaws must wag. So why not give them something to wag against? That is, put in a kind of Shock Absorber.

If it wasn't for Chewing Gum, Americans would wear their teeth off just hitting them against each other. Every Scientist has been figuring out who the different races descend from. I don't know about the other Tribes, but I do

Classic Will Rogers.

know that the American Race descended from
the Cow. And Wrigley was smart enough to fur-
nish the Cud. He has made the whole World
chew for Democracy.

That's why this subject touches me so deeply.
I have chewed more Gum than any living Man.
My Act on the Stage depended on the grade of
Gum I chewed. Lots of my readers have seen me
and perhaps noted the poor quality of my jokes
on that particular night. Now I was not person-
ally responsible for that. I just happened to hit
on a poor piece of Gum. One can't always go by
the brand. There just may be a poor stick of
Gum in what otherwise may be a perfect pack-
age. It may look like the others on the outside
but after you get warmed up on it, why, you
will find that it has a flaw in it. And hence my
act would suffer. I have always maintained that
big Manufacturers of America's greatest neces-
sity should have a Taster—a man who person-
ally tries every Piece of Gum put out.

Now lots of People don't figure the lasting
quality of Gum. Why, I have had Gum that
wouldn't last you over half a day, while there
are others which are like Wine—they improve
with Age.

I hit on a certain piece of Gum once, which I
used to park on the Mirror of my dressing room
after each show. Why, you don't know what a
pleasure it was to chew that Gum. It had a kick,
or spring to it, that you don't find once in a
thousand Packages. I have always thought it
must have been made for Wrigley himself.

And say, what jokes I thought of while chew-

ing that Gum! Ziegfeld himself couldn't understand what had put such life and Humor into my Work.

Then one night it was stolen, and another piece was substituted in its place, but the minute I started in to work on this other Piece I knew that someone had made a switch. I knew this was a Fake. I hadn't been out on the Stage 3 minutes until half of the audience were asleep and the other half were hissing me. So I just want to say you can't exercise too much care and judgment in the selection of your Gum, because if it acts that way with me in my work, it must do the same with others, only they have not made the study of it that I have.

Now you take Bryan. I lay his downfall to Gum. You put that man on good Gum and he will be parking it right under the White House Dinner Table.

Now, some Gum won't stick easy. It's hard to transfer from your hand to the Chair. Other kinds are heavy and pull hard. It's almost impossible to remove them from Wood or Varnish without losing a certain amount of the Body of the Gum.

There is lots to be said for Gum. This pet Piece of mine I afterwards learned had been stolen by a Follies Show Girl, who two weeks later married an Oil Millionaire.

Gum is the only ingredient of our National Life of which no one knows how or of what it is made. We know that Sawdust makes our Breakfast food. We know that Tomato Cans constitute Ford Bodies. We know that old Second-hand

Newspapers make our 15 dollar Shoes. We know that Cotton makes our All-Wool Suits. But no one knows yet what constitutes a mouthful of Chewing Gum.

But I claim if you can make it out of old Rubber Boots and Tires and every form of old junk, why can't I, after reassembling it, put it back into these same Commodities? No one has found a substitute for Concrete. Why not Gum? Harden the surface so the Pedestrians would not vacate with your street. What could be better for a Dam for a River than old Chewing Gum? Put one Female College on the banks of the Grand Canyon, and they will Dam it up in 2 years, provided they use discretion in their parking.

Now, as for my plans of accumulation, put a Man at every Gum selling place. The minute a Customer buys, he follows him. He don't have to watch where he throws it when through; all he has to do is to follow. He will step on it sooner or later no matter where they throw it.

When he feels it, he immediately cuts off the part of the shoe where it is stuck on, so he can save the entire piece. Then he goes back and awaits another buyer.

I have gone into the matter so thoroughly that I made a week's test at a friend of mine's Theatre. At one of Mr. Sid Grauman's Movie Theatres here, I gathered gum for one week and kept account of the intake every day. My statistics have proven that every Seat in every Movie Theatre will yield a half Pint of Gum every 2 days, some only just slightly used.

Now that gives us an average of a Pint and a

Half every six days, not counting Sunday where the Pro Rata really increases. Now figure the seating capacity of the Theatre and you arrive at just what our Proposition will yield in a good solid commodity.

Of course, this thing is too big for me to handle personally. I can, myself, disrobe, after every Show, one Theatre and perhaps a Church on Sunday. But to make it National I have to form it into a Trust. We will call it the "Remodeled Chewing Gum Corporation."

Don't call it Second Hand; there is no Dignity in that name. If we say "remodeled" why every Bird in America falls for that.

Of course, it is my idea ultimately after we have assembled more than we can use for Concrete and Tires and Rubber Boots to get a Press of some kind and mash it up in different and odd shapes.

(You know there is nothing that takes at a Dinner like some Popular Juice Flavor to our Remodeled and overhauled Product. I would suggest Wood Alcohol. That would combine two Industries into one.)

I want to put flavors in there where we can take some of this colossal trade away from these Plutocratic Top Booted Gentlemen. If we can get just enough of this Wood Alcohol into our reassembled Gum to make them feel it and still not totally destroy our Customer we will have improved on the Modern Bootlegger as he can only sell to the same man once.

Now, Gentlemen and Ladies, you have my proposition. Get in early on, "Old Gum made as

good as New." Think of the different brands that would be popular, "Peruna Flavor Gum," "Jamaica Ginger Gum," "Glover's Mange Gum," "Lysol Gum."

It looks like a great proposition to me. It will be the only Industry in the World where all we have to do is to just pick it up, already made, and flavor it.

I am going to put this thing up to my friend, Henry Ford. Think, with no overhead, how he could keep the Cost down. It's a better proposition than being President.

Of Politics and Applesauce

In some order following his family, his horses, roping, his ranches, movies, the *Ziegfeld Follies*, vaudeville, writing newspaper columns, traveling, making speeches, friends and even strangers, Will Rogers embraced politics.

"Politics is the best show in America," he said. "I am going to keep on enjoying it.

"You never heard me on a mother-in-law joke. I have written on nothing but politics for years. I was always about national and international affairs.

"I read politics, talk politics, know personally almost every prominent politician; like 'em and they are my friends, but I can't help it if I have

156

seen enough of it to know there is some baloney in it."

"Politics is applesauce.
"I hope I never get so old that I can't peep behind the scenes and see the amount of politics that is mixed in this medicine before it's dished out to the public as pure statesmanship."

"Slogan: be a politician; no training necessary."

It was 1924, and Will Rogers was the *Ziegfeld Follies* headliner, a star of silent pictures, and soaring in popularity as a newspaper columnist.

He earned $157,428 in 1924, including $83,000 from the *Follies*, $47,000 from movies, and $26,000 from newspaper columns. It was the year that he began delivering after-dinner speeches for $1,000 each.

As a columnist and political junkie, he was covering the Democratic National Convention in New York when John W. Davis of West Virginia was nominated to run against popular Republican Calvin Coolidge.

Coolidge won by a two-to-one margin, and Will Rogers reported that "the difference in corruption in the two parties was 7,000,000 votes."

Mocking the Democrats' search for Davis's running mate in the suicidal election, Will Rogers used his newspaper column to nominate himself as the

"**S**logan: be a politician; no training neces-
sary."

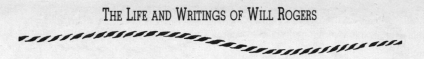

vice president "to save some other man from being humiliated by having to put me in nomination.

"*I think any fair-minded man will give me serious consideration.*

"*They have got to nominate a farmer who understands the farmers' condition. I got two farms in Oklahoma, both mortgaged, so no man knows their condition more than I do.*

"*He has to be a man of the West. Well, if a man came from 25 feet further West than I lived last year [he owned a stretch of the beach at Santa Monica], he would have to be a fish in the Pacific Ocean.*"

Charles G. Dawes was nominated as vice president on the Republican ticket "on account of his profanity," Will Rogers said. "Now I never tried cussin' in public, but I guess I could learn to get used to it before a crowd.

"*Another big reason why I should be nominated is I am not a Democrat.*

"*Another still bigger reason why I should be nominated is I am not a Republican. I am just progressive enough to suit the dissatisfied. And lazy enough to be a Stand Patter.*

"*When the President has to go anywhere, the Vice President has to go and speak or eat for him. Now I could take in all the dinners for I am a fair eater.*

"*I could say, 'I am sorry the President can't come, but he had pressing business.' Of course,*

I wouldn't tell the real reason why he didn't come, so I am just good enough a liar to be a good Vice President.

"I am not much of an after-dinner speaker, but I could learn two stories, one for dinners where ladies were present, and one for where they were not.

"I have no dress suit. The government would have to furnish me a dress suit. If I went to a dinner in a rented one, they would mistake me for a Congressman.

"I know I can hear a lot of you say, 'Yes, Will, you would make a good vice president, but suppose something happened to the President?'

"I would do just like Mr. Coolidge. I would go in there and keep still and say nothing. He is the first President to discover what the American people want is to be let alone.

"P.S. I was born in a log cabin."

During the tumult of the Democratic convention while Will Rogers was on the New Amsterdam Theater stage in the *Follies*, a *New York Times* reporter appeared in the wings.

Two Arizona delegates, each with one-half vote, had cast their ballots for Will Rogers as the Democratic nominee for president. The reporter wanted a reaction quote.

"I never heard of the delegates," he stammered, then grinned. "But I've heard of Arizona."

Quickly he noted that he was still in costume and said: "I cannot talk statesmanship clothed in the

habiliments of the art of Thespis." He quickly pulled
on a necktie and continued:

*"In the spirit in which Spartacus left his plow
in a furrow, I leave my Ford in a ditch to go lead
the movement.*

*"The hour demands a leader. The voice of
the people calls. Who am I that I should
hesitate?*

*"This is a very serious moment in the
destinies of the nation. The Democratic Party is
locked in a stranglehold and can make no
progress. My candidacy represents nothing
more than the effort of the plain people—of
which I am one—to remedy this disastrous
condition of affairs.*

*"It is my duty to go directly to the scene of
the conflict and marshal the forces of right and
justice. I do not seek this office, but respond to
public demand.*

*"My plan of campaign is to go along until all
the other candidates have begun to show signs
of weakening—about Labor Day—then throw in
my reserve.*

*"We shall make a brief whirlwind campaign.
That is the way we have started. I have
already explained how my vote has practically
doubled without me turning a hand.*

*"When we throw in the reserve, that will
make three of us.*

"We will be as obstinate as the rest of them."

Hunting for laughs four years later, the national
humor magazine *Life* launched a 1928 "Will Rogers

"*I'm not a member of any organized party. I'm a Democrat.*"

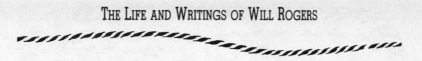

for President" campaign. While Herbert Hoover was being groomed as the Republican nominee and Al Smith was campaigning to lead the Democratic ticket, Will Rogers became the Anti-Bunk party candidate.

"In a quiet way, we have been searching for a bunkless candidate who would run for the Presidency on an honest, courageous and reasonably intelligent platform," stated an editorial entitled "For President: Will Rogers."

"We have been conducting a private straw poll to ascertain whether anyone believed such a candidate was possible. The question which we asked was this: If you could cast aside all party prejudice, who would be your ideal choice for President?

"The answer, from a large group of representative Americans, took the form of an overwhelming majority for Will Rogers.

"And why not?

"Will Rogers, to begin with, is an American. Equipped as he is with a generous supply of genuine Indian blood, he's a lot closer to 100% American than are most of the people who brag about it.

"In the second place, Will Rogers is a humorist. If elected, he would be the first President in sixty-two years who was funny intentionally.

"In the third place, Will Rogers has had wider experience as a public servant than any man that has ever run for any office. Not only has he been mixed up in politics (he has served as Mayor of Beverly Hills, Cal., he has been designated 'Congressman at large,' and he holds the commission of Colonel in Kentucky); he is also a veteran of thirteen

campaigns in the *Ziegfeld Follies*, which is a lot more than can be said for Calvin Coolidge, Herbert Hoover, or even Al Smith.

"In the fourth place, Will Rogers has seen something of the world. He knows more about our foreign relations than do all the eighteen august members of the Senatorial Foreign Relations Committee. He was famous as an Ambassador of Good Will when Lindbergh was still toting mail between St. Louis and Chicago.

"In the fifth place, Will Rogers is a good scout—and it's just about time that the people of the United States of America elected a president for no other reason than that.

"There will be objections to Will Rogers' candidacy. Indeed, most of the qualifications mentioned above would be enough to disqualify him under the rules which usually obtain in politics.

"For instance: the fact that he has set foot on foreign soil, and has made friends with Englishmen, Russians, Mexicans and similar undesirables, will be used by many as a serious argument in his disfavor.

"The fact that he is a comedian will also hurt him, beyond all questions of doubt. The American voters like to laugh at their politicians, not with them.

"Will Rogers accordingly was offered the nomination for the Presidency, as representative of a party which has no name, no emblem, no slogan and which is dedicated to only one supreme purpose:

"To fight Bunk in all its forms.

"If Rogers wants more of a platform than that, he can write it himself," the magazine said on May 24, 1928.

One week later, in blazing full color, was a half life-

sized caricature of Will Rogers on the glossy paper cover of *Life* and a headline in red, black and blue type:

"Will Rogers Accepts the Nomination."

In a byline story, Rogers wrote: "Your offer struck me like what the better fed English authors call 'a bolt from the blue.'

"*It leaves me dazed and if I can stay dazed I ought to make a splendid candidate.*"

"*Every candidate always says 'why there is dozens of men that is more competent to fill this office than I am.'*

"*Well I don't feel that way about it at all. It looks like you boys was inspired when you made your choice. For after all it's only the office of Candidate that I am accepting. You know it don't take near as good a man to be Candidate as it does to hold the office. That's why we wisely defeat more than we elect.*"

"*I think I can accept defeat in as poor English, and with as well hidden 'sour grapes' as anyone you could have chosen.*

"*I have already got in my mind the message of congratulation to the winner, and am really anxious to hurry up and lose, just to see how it will look in print.*"

"*When I was thrown out as Mayor of a certain alleged Town on account of being called a Puritan when I came out against polygamy, I*

took defeat without an alibi, which proved I had none of the earmarks of a Politician. I was immediately made President of the Ex-Mayors Association of America. There is an organization that will grow as long as there is an honest election."

"*I* admit I can make a living outside politics. Now when you admit that you can live without depending on politics, you lose right there the support of all politicians."

"*H*otels will be against us for not furnishing the back room for the nomination."

"*O*ne thing that won't be in our party and that's party leaders. No party is as bad as its state and national leaders."

"*W*e are going to try and eliminate slogans. Slogans have been more harmful to the country than Bo-Weevil, Luncheon Clubs, Sand Fleas, Detours, Conventions and Golf Pants."

"*W*e may alienate the entire female vote, but there will be no effort for sex appeal. Of course, if it unconsciously manifests itself, we can't help it."

"*O*ur platform will be, WHATEVER THE OTHER FELLOW DON'T DO, WE WILL.

"No man would want a broader, or more numerous planked platform than that.

"There will also be no promise of jobs, for no defeated candidate has ever been able to give anyone a job. Our support will have to come from those who want nothing, and have the assurance of getting it."

"Now this whole acceptance is based on one thing: IF ELECTED I ABSOLUTELY AND POSITIVELY AGREE TO RESIGN. That's my only campaign pledge or slogan, ELECT ROGERS AND HE WILL RESIGN.

"That's offering the country more than any candidate ever offered it in the entire history of its existence."

On June 7, the *Life* magazine cover headlines read: "WILL ROGERS announces his platform in this issue," "Prohibition and Farm Relief," and "Preliminary Planks in My Platform."

The bylined article started out with Will Rogers saying he was "laying low with my platform until I see what the Bunko Boys offer" at the Republican convention in Kansas City and Democratic convention in Houston.

"No matter what's on our Platform, on November 5 we will have a bonfire and burn the platform. We are only drafting it for election purposes."

On Prohibition, he speculated the GOP would "try and get by on the old gag, 'we are for law enforce-

ment.'" Democrats would nominate a wet president on a dry platform. Will Rogers's plank was:

*"**W**ine for the rich. Beer for the poor. Moonshine liquor for the prohibitionists."*

The two major parties, he said, would propose "relief" for farmers, "but I will cure him."

The magazine continued its satirical coverage of the race under the headlines "Analyzing the Political Hooch," "Our Candidate Knee-Deep in Applesauce," and "Our Candidate Makes Good His Only Promise."

"He Chews to Run," a pun on Will Rogers's gum chewing reputation, became the slogan for lapel buttons.

Other slogans were floated: "We want the wet vote. We want the dry vote."

As a running mate, Will Rogers contemplated the famous aviator Charles A. Lindbergh but rejected him on grounds that a hero should not be "rewarded with a sentence of four years" of presiding over in the United States Senate.

In the June 21, 1928, issue of *Life*, a letter from automobile magnate Henry Ford was published: "The joke of Will Rogers' candidacy for President is that it is no joke. It is a serious attempt to restore American common sense to American politics."

While he was flying to Kansas City for the GOP convention, the airplane broke a wheel upon landing and flipped. Will Rogers quipped that he had landed upside down, but "being a candidate, it didn't hurt the head."

Will Rogers (center) with draught victims, 1931.

It was media hype wrapped in good humor and satire. Yet Will Rogers reacted nervously when his name was seriously floated as a candidate and forcefully denied any intention of running.

In a syndicated column he wrote:

"There was a piece in the paper this morning where somebody back home was seriously proposing me for President. Now when that is done as a joke it is alright. But when it's done seriously it's just pathetic.

"We are used to having everybody named as Presidential candidates, but the country hasn't quite got to the professional comedian stage. There is no inducement that would make me foolish enough to run for any political office. I

*want to be on the outside where I can be
friends and joke with all of them, even the
President.''*

In 1931, George Creel, who wrote the ''Keynote''
column for *Collier's* magazine, said Will Rogers was
a serious candidate for the national ticket. Will Rog-
ers stormed back in his column:

*''Will you do me one favor? If you see or hear of
anybody proposing my name either humorously
or semihumorously for any political office, will
you maim said party and send me the bill?*

*''Life magazine and I had a lot of fun by
running me for office, but I am certainly not
going to try and impose the same comedy
twice.*

*''My friend on Collier's says that I am taking
this running serious. George, that is the worst
slam you ever took against my sense of humor.*

*''I certainly know that a comedian can only
last until he either takes himself serious or his
audience takes him serious, and I don't want
either of those to happen to me until I am dead
(if then).*

*''So let's stop all this damned foolishness
right now. I hereby and hereon want to go on
record as being the first Presidential, Vice
Presidential, Senator or Justice of Peace
candidate to withdraw.*

*''I not only 'don't choose to run,' but I don't
ever want to leave a loophole in case I am
drafted and I would use 'choose.' ''*

Unable to resist a chance for levity, he added: "I will say 'won't run' no matter how bad the country needs a comedian at that time."

"Oh, yes," he continued in his rebuttal, "*Collier's* also said 'that I could get a very liberal campaign fund.' Well, none has shown up to now, so that's really the reason for this early withdrawal. Politics has got so expensive that it takes lots of money to even get beat nowadays."

 "Congress and Hollywood are a great deal alike in lots of respects. We make in Hollywood what we think will be two kinds of pictures: Comedy and Drama or sad ones. We call ours 'pictures' when they are turned out. Now the Capitol at Washington, that's the biggest studio in the World. They call theirs 'laws.'
 "What we think is drama sometimes is received by the audience as comedy.
 "The uncertainty is about equal both places.
 "The way to judge a good comedy is by how long it will last and have people talk about it. Congress has turned out some that have lived for years and people are still laughing about them."

Will Rogers really could not leave the tumult of politics. He said Democrats could have saved forty-two pages of the forty-five-page 1924 Democratic platform and "perhaps their election if they had come out in the open on every question and told just where they stood. When you straddle a thing, it takes a long time to explain it."

171

"The Congressional Record, dictionary and political platforms are the three least-used things in existence today."

Starting with columns in 1920 about both the Republican and Democratic Conventions written from a movie set in Hollywood, Will Rogers seemed to develop an increasing interest in the process. As a pundit, he personally covered the next three national conventions of both parties.

After listening to the "Star Spangled Banner," which he said the "Republican don't know any better than the plain people," Will Rogers said "it will take America two more wars to learn the words of our national anthem."

Noting that former Presidential hopeful William Jennings Bryan also was a columnist covering the convention, Will Rogers said Bryan asked: "You write a humorous column, don't you?"

"Yes, sir,"

"Well I write a serious article and if I think of anything of a comical or funny nature, I will give it to you," Bryan said.

"If I happen to think of anything of a serious nature, I will give it to you," Will Rogers replied.

"I thought afterwards, we both may be wrong."

To shorten speeches so delegates could be out by lunchtime, Will Rogers proposed that every speaker sit down "as soon as he tells all he knows." Or the convention should "not allow one man to repeat what some other man had already said."

"One delegate told me yesterday that they either had to move to more modest quarters or to a more liberal candidate."

"In the Republican platform at Cleveland they promised to do better. I don't think they have done so bad. Everybody's broke but them."

Will Rogers's morning newspaper articles dealt with topics of the day. Presidents and others in high office took his advice seriously at the time.

Even after his death, for decades his quips were quoted and his insight was timeless:

"The Democrats take the whole thing as a joke. Republicans take it serious, but run it like a joke."

"That we have carried as much political bunk as we have and still survived shows we are a super-nation. When is this terrible ruin that the politicians have been predicting going to happen?"

"I will admit it has rained more under Republican administrations, that was partially because they have had more administrations than Democrats.

"There is no less sickness, no less earthquakes, no less progress, no less inventions, no less morality, no less Christianity under one than the other.

"They are all the same. It won't make 50 cents difference to a one of you. Unless you're foolish enough to bet on it."

"The trouble with a politician's life: somebody is always interrupting it with an election."

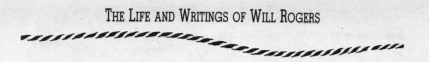

"*Politics is a great character builder. You have to take a referendum to see what your convictions are for that day.*"

"*A candidate would go over Niagara Falls if he was sure the wind was with him.*"

"*If by some divine act of providence we could get rid of both these parties and hire some good men, like any other good business does, that would be sitting pretty.*"

"*I have not aligned myself with any party. Sitting tight waiting for an attractive offer.*"

"*I hope some of the men who get the most votes will be elected.*"

"*No mathematician in this country has ever been able to figure out how many hundred straw votes it takes to equal one legitimate vote.*"

"*You could keep politics clean if you could figure out some way so your government never hired anyone.*"

"*Republicans want a man that can lend dignity to the office. Democrats want a man that will lend some money.*"

"**O**hio claims they are due a president as they haven't had one since Taft. Look at the United States, they have not had one since Lincoln."

"**I** generally give the party in power, whether Republican or Democrat, the more digs because they are generally doing the country more damage. I don't think it is fair to jump too much on the fellow who is down.

"He is not working. He is only living in hopes of getting back in on the graft in another four years. The party in power drawing a salary is to be knocked."

"**I**f we didn't have two parties, we would all settle on the best men in the country and things would run fine. But as it is, we settle on the worst ones and then fight over 'em."

"**I**f a man could tell the difference between the two parties, he would make a sucker of Solomon for wisdom. The country runs in spite of parties; in fact parties are the biggest handicaps we have to contend with."

After listening to a keynote address at a Republican convention, Will Rogers's column reported "a few things you don't know:

"**R**epublicans were responsible for radio, telephones, baths, automobiles, savings accounts, enforcement, workmen living in houses and a living wage for senators.

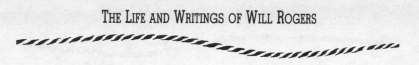

"Democrats brought on war, pestilence, debts, disease, boll weevil, gold teeth, need of farm relief, suspenders, floods, famine . . .

"The Republican says, 'Things could have been worse.'

"The Democrats say, 'How?'

"Democrats are attacking and the Republicans are defending. All the Democrats have to do is promise what they would do if they got in. But the Republicans have to promise what they would do and then explain why they haven't already done it."

"The Republican have always been the party of big business. The Democrats of small business. So you just take your pick. The Democrats have their eye on a dime and the Republicans on a dollar."

"Give a Democrat a high hat and a frock coat and put him on the speakers list and he would turn down the chairmanship of a big corporation. Give him a horse in the parade every year and that was about all the glory he wanted.

"Democrats always were a cheap lot. They never had much money to operate on. They were always kinder doing business on a shoe string basis. The type of man they had with them went in more for oratory than he did for stocks and bonds.

"They would rather make a speech than a dollar.

"They cultivate their voice instead of their finances."

"**D**emocratic graft was mostly confined to sorter rounding the saloon keepers in line with a campaign collection every year. They thought that was just about the height of big business. I guess it was because they didn't know there was any other business.

"They didn't know that a man that was owner of some mines, or lumber or coal, might also dig up something for the pot—if promised a little break in the tariff, or railroad rates or suppressed opposition.

"Their mind was on a saloon and that's as high as they could elevate.

"Republicans just were wise enough to see that the same principle applied to one business as the other. If it was good for the saloons to stand in with the government, it was good for all business. They commenced working out the ideas in a big way."

"**I**t's going to be hard to make an issue of corruption. It's like the poor, it's always been with us."

"**I**f you promise a man he will be made judge if you are made senator—you have sold him something."

"**B**oth parties have their good and bad times at different times. Good when they are out. Bad when they are in."

178

"**A**s a young boy, I didn't know a Republican from a Democrat, only in one way: If some man or bunch of men rode up to the ranch to sit or stay all night, and my Father set me to watching 'em all the time they was there—what they did and what they carried off—I learned they were Republicans."

"**T**here ain't any finer folks living than a Republican that votes the Democratic ticket."

"**T**here must be something the matter with a Southerner that would be a Republican as they are naturally in the observation ward at all times."

"**T**alk about putting a quota on immigration. Why the Yankees are swarming into the South like locusts. Only one drawback. The rascals bring their Republican politics with 'em. They ought to be met at the line and deloused."

"**O**ne thing the Republicans won't forgive. They can excuse you for being against them, for in their heart they know that you are right, but when you go and throw that support to the Democrats, that's the last straw."

"**T**he Republicans always looked bad three years out of four. But the year they look good is election year. A voter don't expect much. If you give him one good year he is satisfied."

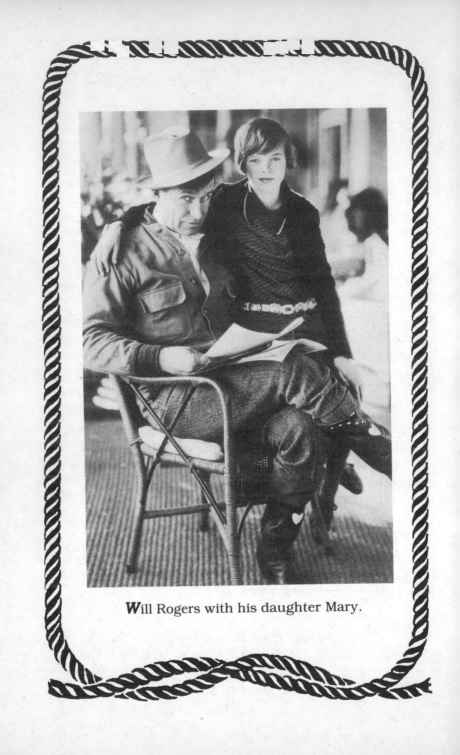

Will Rogers with his daughter Mary.

"Lots of people won't speak or associate with a Republican. I have met several of them and you take one, when he is out of office, and he's as nice a fellow as you would want to meet.

"You keep a Republican broke and out of office and pretty near everybody can get along with them.

"You keep both a Democrat and Republican out of office and I bet you they will turn out to be good friends and maybe make useful citizens. Devote their time to work instead of 'lectioneering."

"I have been trying to read the papers and see just what it is in this election that one party wants that the other one don't. To save my soul, I can't find any difference. The only thing that I can see where they differ is that the Democrats want the Republicans out and let them in, and the Republicans don't want to get out. That, right there, is the issue."

"Imagine a man in public office that everybody knew where he stood. We wouldn't call him a statesman, we would call him a curiosity."

"A man's thoughts are naturally on his next term more than his country."

"Ain't it funny how many hundreds of thousands of soldiers we can recruit with nerve. But we can't find one politician in a million with backbone."

"*The* trouble with a politician's life: somebody is always interrupting it with an election."

"*It's* always the fellow that is out of office and wants in that is discontented. But if he knew there was no chance, he might turn to some essential employment—maybe writing jokes for the newspapers or any of those WORTHWHILE industries."

"*With* every public man we have elected doing comedy, I tell you I don't see much chance for the comedian to make a living. I am just on the verge of going to work."

"*Politicians* can do more funny things naturally than I can think of to do purposely."

"*Once* a man holds public office, he is absolutely no good for honest work."

"*I* could never understand the exact connection between the flag and a bunch of politicians. Why a political speaker's platform should be draped in flags any more than a factory where men work or an office building is beyond me."

"*I* wish Americans could get some of the political bandits that live off this country to come in and give up. Then we would know just what we were paying them to live on, instead of the

present system of letting them grab what they can."

"*I* have always maintained that no President can be as bad as the men that advise him."

"*B*ut take it all in all, we got more honesty in government than any of 'em. What's keeping us going so long is that our public men in high office are honest. You never saw one getting out of Washington with a load that he made while there. It would be wonderful if we could say as much for our public men's ability as we can for their honesty."

"*S*hrewdness in public life all over the world is always honored. Honesty in public men is generally attributed to dumbness and is seldom rewarded."

"*Y*ou are a politician just in proportion to the loot you have pilfered while there for the old home state. If you can come home with a couple of Boulder dams, a few government hospitals and jails and an appropriation to build a road somewhere where nobody lives or wants to—why if you do all those things you will be putting yourself in line with becoming a statesman."

"*W*ell, cuss the politicians. But I notice we're always perfectly willing to share in any of the sums of money that they might distribute."

"It's awfully hard to get people interested in corruption unless they can get some of it."

"Another trouble with politics, it breeds politics. So that makes it pretty hard to stamp out. The only way to do it is at the source. We got to get birth control among politicians."

"Democratic women want birth control of Republicans and Republican women want equal corruption for both sexes."

"We've got to have initials for everything. This period is TYFOH: Tough Year for the Office Holders. People that were elected are not right sure yet whether they were the winner or not. They kind of think that maybe the fellow they defeated was really the winner."

"All there is to politics is trading. That's why politics is not as good as it was years ago. They don't have as many old-time horse traders in there. These we got are just amateurs. They're crude with their trades. There is really no 'finesse.' You might not get that—'finesse' is a French word and it means sneaking it over."

"You can get any bill you want passed if you don't brand it Republican or Democratic. Politics is one thing they absolutely won't stand for."

"They are awful nice old fellows, they don't do any particular harm to anyone. 'Course they don't do any real good. Been in there on a pension for years."

"What this country needs is more working men and fewer politicians."

"I don't suppose in the whole history of either party the man that went there with the most delegates ever got the nomination."

In 1931, when Treasury Secretary Andrew Mellon made headlines by borrowing $1.1 billion, Will Rogers said: "This means they are going to finance by borrowing instead of increased taxes on those able to pay. It's too close to election to antagonize the big boys."

Republicans, he once quipped, "are what we call conservatives. A conservative is a man who has plenty of money and doesn't see any reason why he shouldn't always have plenty of money.

"A Democrat is a fellow who never had any money but doesn't see why he shouldn't."

"There is no more independence in politics than there is in jail. They are always yapping about 'public service.' It's public jobs that they are looking for."

"The election will be breaking out pretty soon and a flock of Democrats will replace a mess of Republicans in quite a few districts. It won't

mean a thing. They will go in like all the rest of 'em: go in on promises and come out on alibis."

"Nobody wants his cause near as bad as he wants to talk about his cause."

"Common sense is not an issue in politics, it's an affliction."

"It takes more humor to be a Democrat than a Republican."

"I'm not a member of any organized party. I'm a Democrat."

"A Democrat would rather have applause than a salary. He would rather be told that he is right, even if he knew the guy is a liar, then he would know he is wrong but belongs to the Republican party."

"Every day brings new conditions, new ideas, new alignments. Politicians don't make up people's minds like they used to. Pretty near every old Bird you meet is thinking for himself. This radio, more newspapers, movie weeklies and all that have made one fellow think he is just as smart as the other one. He don't want anybody coming along telling him what he ought to think."

"**A** Democrat is just like a baby. If it's hollering and making a lot of noise, there is nothing serious the matter with it. When it's quiet and doesn't pay much attention to anything, that's when it's really dangerous."

"**A** Democrat never adjourns. He is born, comes of voting age and starts right in arguing over something. His first political adjournment is his date with the undertaker."

"**D**emocrats—you can't shame them into even dying. They would keep on living just to spite the Republicans."

"**A**ll of 'em will claim they are running on the real Democratic ticket. I expect Thomas Jefferson was about the very last real Democrat.

"When hungry and can't manage to get anything to eat, a Democrat can always satisfy his hunger by dreaming and harking back to 'Old Jeffersonian principles.' Nobody knows what they were, but they have furnished a topic for poor Democrats to rave about for a couple of generations."

"**I** love animals and I love politicians. I like to watch both of 'em play either back home in their native state or after they have been captured and sent to a zoo or to Washington."

Cartoon portraying Will Rogers's 1927 hospitalization.

"They say that hot air rises and I guess it does. An airplane flying over the Capitol caught fire from outside sources."

"If we could send the same bunch of men to Washington for the good of the nation, and not for political reasons, we could have the most perfect government in the world."

"The Ways and Means Committee is supposed to find ways to divide up the means."

"The United States Senate opens with a prayer and closes with an investigation."

"**N**ever blame a legislative body for not doing something. When they do nothing, they don't hurt anybody. When they do something is when they become dangerous."

"**A** lobbyist is a person that is supposed to help a politician to make up his mind—not only help him but pay him."

"**I**t's not really intent on the government's part that they don't do better, it's ignorance."

"**I** like to make little jokes and kid about the Senators. They are a never-ending source of amusement, amazement and discouragement. But the rascals, when you meet 'em they are mighty nice fellows. It must be something in the office that makes 'em so ornery sometimes. When you see what they do official, you want to shoot 'em. But when one looks at you and grins so innocently, you kinder want to kiss him."

"**A** congressman friend of mine wants a copy of some fool thing I have written that pertains to the bill they are kidding about in Congress. He wanted to read it into the Congressional Record. I feel pretty good about that. That's the biggest praise that a humorist can have is to get your stuff into the Congressional Record. Just think, my name will be right alongside all those other big humorists."

"*When* a gentleman quoted me on the floor the other day, another member took exception and said he objected to the remarks of a professional joke maker going into the Congressional Record.

"*Now can you beat that for jealousy among people in the same line?*

"*Calling me a 'professional joke maker!' He is right about everything but the professional. They are the professional joke makers.*

"*I could study all my life and not think up half the amount of funny things they can think of in one session of Congress.*

"*My little jokes don't do anybody any harm. You don't have to pay any attention to them. Every time they make a joke, it's a law. And, every time they make a law, it's a joke.*"

"*There* is no race of people in the world that can compete with a Senator for talking. If I went to the Senate, I couldn't talk fast enough to answer roll call.*"

"*A* senator learns to swap his vote at the same age a calf learns which end of its mother is the dining room.*"

"*They* say they were surprised and dumbfounded that vote trading existed. Just about as surprising to everyone that knows politics as it would be to discover the president was born in the United States, was over 35 years old and white.*"

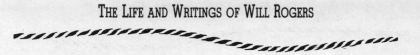

"Diary of the Senate trying to find $2 billion that it already had spent, but didn't have:

"Monday—Soak the rich.

"Tuesday—Begin hearing from the rich.

"Tuesday afternoon—Decide to give the rich a chance to get richer.

"Wednesday—Tax Wall Street sales.

"Thursday—Get word from Wall Street: lay off us or you will get no campaign contributions.

"Thursday afternoon—Decide we are wrong on Wall Street.

"Friday—Soak the little fellow.

"Saturday—Find out there is no little fellow. He has been soaked until he drowned.

"Sunday—Meditate.

"Next week—Same procedure, only more talk and less results."

"About being a U.S. Senator, the only thing the law says you have to be is 30 years old. Not another single requirement. They just figure that a man that old got nobody to blame but himself if he gets caught there."

"Legislatures are like animals in a zoo. You can't do anything about 'em. All you can do is just stand and watch 'em."

"Most all new Senators are earnest and mean well. Then the air of Washington gets into their bones and they are just as bad as the rest."

"It won't be no time until some woman will become so desperate politically and lose all prospectus of right and wrong and maybe go from bad to worse and finally wind up in the Senate.

"Men gave 'em the vote and never meant for them to take it seriously. But being women they took the wrong meaning and did.

"Up to now there has been no need for anything resembling a woman in actions in the Senate, especially an Old Woman, for there are more old women in there already than there is in the old ladies' home." ·

"There is nothing in the world as alike as two Senators. No matter how different their politics, how different the parts of the country they come from, they all look alike, think alike and want alike. They are all looking for an appointment for some guy who helped them get theirs."

"It must be nice to belong to some legislative body and just pick money out of the air."

"All Senators travel a lot. They all try to keep away from home as much as they can."

"A politician is not as narrow-minded as he forces himself to be."

"One thing you have got to say for an administration that tries out a lot of plans—some of 'em are apt to be pretty good."

Will Rogers meets Eleanor Roosevelt after her cross-country flight, Los Angeles, California.

"No element, no party, not even Congress or
the Senate can hurt this country now; it's too big.
That's why I can never take a politician
seriously.

"Congress can pass a bad law and as soon
as the old Normal Majority find it out they have
it scratched off the books.

"Even when our next war comes, we will
through our shortsightedness not be prepared,
but that won't be anything fatal.

"The real energy and minds of the Normal
Majority will step in and handle it and fight it
through to a successful conclusion.

"This country is not where it is today on
account of any man. It is here on account of
the real common sense of the big Normal
Majority."

Will Rogers saw the 1928 general election as
another victory for Republicans, who were in power
during a period of a pumping, powerful economy.

"You can't lick this prosperity thing," he wrote,
"even the fellow that hasn't got any is all excited
over the idea."

With a golfing analogy, Will Rogers advised Dem-
ocrats to look farther ahead: "You always got a
putter in your hands when you ought to have a
driver." He urged Governor Al Smith of New York to
skip the nomination in 1928 and "in '32 they will
nominate you by radio; they can't help it, and you
will have a united party."

Al Smith, ignoring Rogers's advice, was nomi-
nated in Houston and defeated in November.

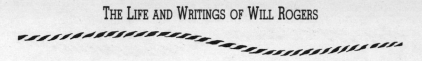

"I learned that you must never advise a man in politics to do anything but run," Will Rogers wrote, "you just lose his friendship. So it's always best to advise him the way he wanted to be advised.

"From now on I am advising EVERYBODY to run. In that way, I will be friends with the world."

Herbert Hoover won the GOP nomination in Kansas City, where the "dog fight for vice president" was "down now to just 96 senators, 435 congressmen and 47 governors" before Will Rogers left town.

> *"This convention would have been over a week ago if they had taken four words out of the dictionary: 'The Great Republican Party.'*
>
> *"If you eliminated the names of Lincoln, Washington, Roosevelt, Jackson, and Wilson, both conventions would get out three days earlier."*

After the GOP nominated Charles Curtis as vice president in 1928, Will Rogers said: "The Republican party owed Curtis something, but I didn't think they would be so low down as to pay him that way. He used to be a floor walker for the Republican Party on the senate floor. Now he will be timekeeper.

> *"Another preacher prayed this morning and he wanted us 'to look to the hills for wisdom' and here we were nominating Charley Curtis from the plains of Kansas where a five-foot ash heap would constitute a precipice. This preacher prayed for Plymouth Rock, but it's Boulder Dam*

we are after now. There is no appropriation goes with Plymouth Rock."

"I hate to say it, but the women that spoke were all terrible. They were pretty near as bad as the men. That will give you an idea how bad they were."

"Did you ever see a town after they had just finished sweeping out a convention? The Republicans had all gone back home to collect. They don't pay off until after you have voted."

During the campaign, Will Rogers wrote: "I hope the Democrats win this election just for one thing. I have heard 5,000 hours of speeches on 'return to Jeffersonian principles' and I want to see what 'Jeffersonian principles' are."

"I have been studying the two parties and here is the difference: Hoover wants all the drys and as many wets as possible. Smith wants all the wets and as many drys as he can get.

"Hoover says he will relieve the farmer even if he has to call Congress; Smith says he will relieve the farmer even if he has to appoint a commission.

"Hoover says the tariff will be kept up. Smith says the tariff will not be lowered.

"Hoover is strongly in favor of prosperity. Smith highly endorses prosperity.

"Hoover wants no votes merely on account of

religion. Smith wants no votes solely on religious grounds. Both would accept Mohammaden votes if offered.

"Hoover would like to live in the White House. Smith is not adverse to living in the White House. In order to get in there, either one will promise the voters anything from perpetual motion to eternal salvation."

On November 6, 1928, Will Rogers said that "the election ain't over until 6 o'clock tonight, but it's been over since last June."

"The politicians, you know, they have all been against Hoover. That is really what elected him," Rogers rambled in a radio broadcast. "The minute the people found out the politicians didn't want him, the whole nation said 'he is the kind of fellow we want.'"

After Hoover was inaugurated, Will Rogers addressed a new open letter to Al Smith, saying: "With you and this fellow [New York Governor Franklin D.] Roosevelt as kind of a nucleus, I think we can with the help of some progressive young Democratic governors and senators and congressmen make this thing into a party instead of a memory."

"We don't need a financier," Will Rogers said of the Democratic party, "we need a magician."

"What's wrong with the Democratic party? The law killed it. It won't let a man vote but once, and there just ain't enough voters at one vote each to get it anywhere."

By July 1929, Will Rogers was claiming: "You won't find anything wrong with Franklin D. Roosevelt outside of being a Democrat."

Less than a year after Hoover's 1928 victory, Will Rogers was saying the new President was "becoming a typical American President by becoming disgusted with the Senate."

"Distrust of the Senate by presidents started with Washington who wanted to have 'em court martialed. Jefferson proposed life imprisonment for 'em, old Andy Jackson said 'to hell with 'em' and got his wish. Lincoln said the Lord must have hated 'em for he made so few of 'em. Teddy Roosevelt whittled a big stick and beat on 'em for six years. Taft just laughed at 'em and grew fat. Coolidge never let 'em know what he wanted so they never knew how to vote against him, and Mr. Hoover took 'em serious, thereby making his only political mistake."

A few days later came the historic crash of 1929, when Republican prosperity proved to be on paper; stock values plunged and Hoover's actions to "restore confidence" were inept.

"Give me some idea where 'confidence' is, and just what you want it restored to," Will Rogers wrote. "Rich men who never had a mission in life outside of watching a stock ticker are working day and night 'restoring confidence.'"

"Restore confidence, and that's what I've been doing for weeks in my writing and talking. Of course I haven't been buying anything myself.

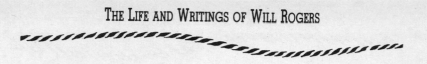

"I wanted to give all the other folks a chance to have confidence first.

"There is none of the greedy pig about me.

"I discovered confidence hasn't left this country. Confidence just got wise and the guys it got wise to are wondering where it has gone."

"I don't want to lay the blame on the Republicans for the depression. They're not smart enough to think up all those things that have happened.

"We are getting back to earth and it don't look good to us after being away so long."

"Half our people starving and the other half standing around a roulette wheel.

"They are going to get some easy money if they have to go broke to do it."

"If Russia succeeds it will be because they got no stock market."

By the following February, with Hoover in growing disrepute, Will Rogers wrote: "On account of us being a democracy and run by the people, we are the only nation in the world that has to keep a government for four years, no matter what it does."

On March 17, he wrote: "We used to think 'prosperity' was a 'condition.' Now we find that it is a 'commodity.' Mr. Hoover has ordered it delivered to us in 60 days, same as you would a sack of flour or

a side of bacon. If 'good times' is not laying on our doorsteps May 15, 1930, we can sue the Republican Party."

"The United States Senate passed the Tariff Bill. Everlasting life and perpetual motion are the only other two things now that we have to look forward to."

"Tariff has been to a politician what a bone is to a dog and a fixed jury to a Los Angeles culprit. It's not only his bread and butter, but it's his dessert and toothpick."

With the new tariff law in place and after strong Democratic gains in the November 1930 off-year congressional elections, Will Rogers projected the outcome to 1932 with the statement: "Looks like the Democrats nominated their president yesterday, Franklin D. Roosevelt. He is the first Harvard man to know enough to drop three syllables when he has something to say. Compared to me he is almost illiterate."

In the winter of 1931, Treasury Secretary Andrew Mellon's "carefully balanced budget" was called to task by Will Rogers, who said: "You let this country get hungry and they are going to eat, no matter what happens to budgets, income taxes and Wall Street values.

"The difference between our rich and poor grows greater every year. Our distribution of wealth is getting more uneven all the time. A

A tender moment between husband and wife.

*man can make a million and he is on every page
in the morning. But it never tells who give up the
million that he got. You can't get money without
taking it from somebody.*

*"Washington must not forget who rules when
it comes to a showdown."*

Shortly after Congress "turned down the $15 mil-
lion food bill and passed $15 million to 'improve
entrances to national parks,'" Will Rogers reported:
"You can get a road anywhere you want to out of
the government, but you can't get a sandwich."

In May 1931, Will Rogers reported that President
Hoover had found somebody that was "worse off
than we are but he had to go back 150 years in his-
tory to do it."

"Ten men in our country could buy the world,"
Will Rogers said during the heat of summer in 1931,
"and ten million can't buy enough to eat."

*"**W**e used to be told that depression was just a
state of mind but starvation has changed that
impression. Depression is a state of health. And it
ain't really depression either; it just a return to
normalcy. We are just getting back to earth. We
are back to two-bit meals and cotton underwear
and off $1.50 steaks and silk under rompers. The
trouble is that America is muscle-bound from
holding a steering wheel. The only place we are
calloused from work is the bottom of our driving
toe."*

"Never was there as much money in the hands of the few as now."

In October 1931, in a legendary coast-to-coast radio broadcast that was shared with President Hoover, Will Rogers sized up the Depression. The ad-libbed talk became known as his "bacon and beans and limousines" speech:

"There's not really but one problem before the whole country. It's not the balancing of Mr. Mellon's budget. That's his worry that ain't ours. It's not the League of Nations that we read so much about. It's not the silver question.

"The only problem that confronts this country today is at least seven million people are out of work. That's our only problem.

"It's to see that every man that wants to, who is able to work, is allowed to find a place to go to work, and also to arrange some way of getting more equal distribution of wealth in the country.

"Some of our big men will perhaps get some way of fixing a different distribution of things. If they don't they are certainly not big men and won't be with us long.

"Prohibition is nothing to compare to your neighbor's children that are hungry. It's food, it ain't drink, that we are worried about today. We were so afraid the poor people was liable to take a drink that now we fixed it so they can't even get something to eat.

"Here we are in a country with more wheat, more corn, more money in the bank, more cotton, more everything in the world than any other country ever had on the face of the earth—and yet we've got people starving.

"We'll hold the distinction of being the only nation in the history of the world that ever went to the poor house in an automobile.

"Our potter's fields are surrounded by granaries full of grain. Now if there ain't something cockeyed in an arrangement like that, then this microphone in front of me is—well, it's a cuspidor, that's all.

"Now a miracle can't happen and all these people get a job overnight. It's going to take time. So they must be fed and cared for perhaps all winter.

"Everyone of us that have anything got it by the aid of these very people.

"The most unemployed or the hungriest man in America has contributed in some way to the wealth of every millionaire in America.

"The working classes didn't bring this on.

"It was the big boys themselves who thought the financial drunk was going to last forever. They over merged and over capitalized and over everything else. That's the fix that we're in now.

"These people are not asking for charity. They are asking for a job. But if you can't give them a job, you can see they have food and the necessities of life.

"There's as much money in the country as

there ever was. Only fewer people have it. But it's there.

"Last winter, we didn't realize the need. But this winter we got no excuse. It's been shown to us all summer.

"Now don't wait for the government to feed these people. I have seen lots of audiences and heard lots of appeals, but I have yet to see one where the people knew the need, and the cause was there, that they didn't come through.

"Europe don't like us and think we are arrogant, bad-mannered and have a million faults, but every one of them will give us credit for being liberal.

"Dog-gone it, our folks are liberal. I don't know about America being 'fundamentally sound' and all that after-dinner hooey, but I know that America is 'fundamentally liberal.'

"I know that this subject is very dear to Mr. Hoover's heart and know that he would rather see the problem of unemployment solved than all the other problems he has before him combined."

A few weeks later, Rogers said "if people in '32 are still as hungry as they are now, and from the looks of things they will be 'hungrier,' the Democrats have a fine chance.

"They only vote for our gang when they are starved out, we fatten 'em up and then they turn Republican again."

In January 1932, Will Rogers reported: "See where Congress passed a $2 billion bill to relieve bankers' mistakes and loan to new industries. You can always count on us helping those who have lost part of their fortunes but our whole history records nary a case where the loan was for the man who had absolutely nothing. Our theory is to help those who can get along even if they don't need it."

As election neared, Will Rogers said the Republican platform "will be the same one they have read for 40 years but never used. Speeches will be the same ones delivered for 40 years but never listened to." He said both parties had a plan to relieve unemployment, adding that the unemployed "have been unemployed for three years and nobody paid attention to 'em."

As the nominating conventions of 1932 approached, Will Rogers's advice was: "No matter what the other side promises, see their promise and raise 'em two more."

"Conventions are on us now. They are like the locusts. They come every few years. Will meet you all there, at one or the other of 'em. It will be good Conventions this year for both sides are in doubt."

The Democrats met in Chicago in 1932: "Chicago is going to do herself proud just like she did with the Republicans. The last day of the Republican show they killed four gangsters for the amusement of the delegates and I know, being a Democratic city at heart, she will do as much for the Democrats."

"The plan is to stop Roosevelt. Al Smith said 'I am not only trying to stop Roosevelt, I am like the rest of 'em trying to stop everybody but myself.'"

"They are trying to change the two-thirds rule. It takes two-thirds to do it. If two-thirds of the Democrats agreed, they wouldn't be Democrats."

"They fought, they split and adjourned in a dandy wave of dissension," he said in one day's dispatch, "that's the old Democratic spirit."

In the heat of the 1932 Democratic convention, Will Rogers again was nominated for President—this time by his home state of Oklahoma as a favorite son. The delegation then switched to Franklin D. Roosevelt. Will Rogers feigned pain, but treated the salute with levity.

"Politics ain't on the level. I was only asleep a short space of time when somebody stole 22 votes from me. I was sitting there in the press stand sound asleep and wasn't bothering a soul when they woke me up and said Oklahoma had started me on my way to the White House with 22 votes.

"I don't want you to think that I am belittling the importance of 22 votes. They were worth something. Not in money, mind you, for there is not $2.80 in the whole convention. They buy 'em with promises of office.

"I expect at that time Roosevelt's bunch would have given me Secretary of State for that 22. I could have sold to Al Smith for maybe

Mayor of New York. I could have gotten the embassy in England with only ten of the votes.

"What do I do? I go to sleep and wake up without even the support of the Virgin Islands.

"Now what am I? Just another ex-Democratic Presidential candidate. There's thousands of 'em. The whole thing has been a terrible lesson. Nothing to do but start in and live it down.

"I have one thing to be thankful for. I am the only defeated candidate that didn't have a band left on my hands to ship back home."

With Franklin D. Roosevelt nominated, Will Rogers went to the ranch near Claremore to recuperate: "Heard a mule braying and for a minute I couldn't tell who he was nominating."

Incumbent Herbert Hoover, who originally pledged not to campaign, swung into a rough-and-tumble acrimonious campaign with Roosevelt. The rhetoric became so inflamed that Will Rogers called for a moratorium on candidates' speeches.

"They have both called each other everything in the world they can think of. From now on they are just talking themselves out of votes.

"The high office of President has degenerated into two ordinarily fine men being goaded by political leeches into saying things that if they were in their right minds they wouldn't think of saying."

Will Rogers introduces presidential candidate Franklin Roosevelt (far left) in Los Angeles, October 1932.

"Mr. Hoover says that in case of Democratic victory 'grass will grow in the streets of American cities.' But look at the fun it will be to see every traffic cop pushing a lawn mower."

On the Republican claim that losing would "bring gloom to a hundred thousand firesides," Will Rogers quipped: "But look at the hundred thousand Democratic postmasters whose gloom won't be so noticeable."

The aching Depression underscored the campaign, and Will Rogers said: "The calamity was brought on by the actions of the people of the whole world and its weight will be lifted off by the actions of the people of the whole world and not by a Republican or Democrat.

"*S*o you two boys just get the weight of the world off your shoulders and go fishing. Both of you claim you like to fish, now instead of calling each other names do everybody a big favor by going fishing. You will be surprised but the old U.S. will keep on running while you boys are sitting on the bank. Then come back next Wednesday and we will let you know which one is the lesser of the two evils."

"*T*here is very little dignity, very little sportsmanship, or very little anything in politics only get the job and hold it."

On the eve of the election, Will Rogers said: "Neither one of 'em is going to save us. Neither one is going to ruin us. Should Mr. Hoover lose, I don't think there is a person that wouldn't feel downright sorry for him for he certainly has meant well and did all he could.

"*I* expect it won't be long until we will be feeling just as sorry for Roosevelt. This President business is a pretty thankless job.

"Washington and Lincoln didn't get a statue until everybody was sure they were dead.

"If this depression stays with us, the loser Tuesday is going to be a winner."

"*I*t takes a great country to stand a thing like an election hitting it every four years."

"Don't you wish that the President of our country wouldn't have to run all over the land getting upon a soap box to shout his merits like a backwoods Congressman running for re-election?"

"When you figure that you have a system where you make business stand still and people go nutty for three months every four years, whoever concocted the idea of a election certainly figured out a devastating scheme."

"It all comes under the heading of democracy. As bad as it is, it's the best scheme we can think of."

Two days following the election, Will Rogers said: "The returns are pretty much all in. All but Kentucky. They got a law they can't count their votes until everybody sobers up."

Franklin D. Roosevelt had pulled together Democrats and won by seven million votes. Will Rogers commented: "If you think this Democratic victory brought on harmony, you just wait until they start to hand out those post offices down South."

Rogers analyzed the 1932 GOP loss:

"Under Coolidge and Hoover, there had grown the old original idea of the Republican Party was the party of the rich. I think that was the biggest contributing part of their defeat.

"Big business sure got big. But it got big by

selling its stocks and not by selling its products. No scheme was halted by the government as long as somebody would buy the stock.

"This election was lost four, five or six years ago, not just this year. They didn't start thinking of the old common fellow until just as they started out on the election tour.

"The money was all appropriated for the top in the hopes that it would trickle down to the needy.

"Mr. Hoover didn't know that money trickled up. Give it to the people at the bottom and the people at the top will have it before night anyhow. But it will at least have passed through the poor fellow's hands.

"They saved the big banks but the little ones went up the flue.

"Ten million people have gone without work for three years just listening to 'big men' solve their problems."

In March 1933, when President Roosevelt declared a banking holiday, Will Rogers wrote:

"America hasn't been as happy in three years as they are today. No money, no banks, no work, no nothing, but they know they got a man in there who is wise to Congress, wise to our so-called big men. The whole country is with him."

"You would never get a Republican Administration to voluntarily close a bank. Their theory is to leave 'em open until they shut."

*"**F**or three years we have had nothing but 'America is fundamentally sound.' It should have been 'America is fundamentally cuckoo.' The worse off we get the louder we laugh.*

"Every banker ought to have printed on his office door: 'Alive today by the grace of a nation that has a sense of humor.'"

Roosevelt, in seven weeks, had "done more for us than we've done for ourselves in seven years. We elected him because he was a Democrat and now we honor him because he is a magician."

*"**I** have got to start in pretty soon making a living out of the fool things that he and other Democrats do. I'm not worried, I know they will do plenty of 'em."*

*"**E**very party and everybody must have some platform even if it's in their minds.*

"Mine is that a president should hold office six years with no re-election. Stop this thing of a President having to lower his dignity and go trooping around asking for votes to keep him there another term. A six-year term with no re-election will be the remedy. Six years gives him time to do something. It takes a new President four years to find out who are his friends in the Senate and House.

"Then pay the man when he goes out one-half of his salary for life. The country should keep an ex-President from bankruptcy if it can keep a railroad or a badly managed bank. 'Course the

cabinet wouldn't have much to do on their last summer in office like they do now, but they could hang around their office and kill time."

The New Deal spawned a rash of "confidential letters" with supposed insider information or the "real low down" on what Roosevelt was doing and planning to do.

Will Rogers parodied the reports:

"The Republican Party is secretly talking about entering politics again.

"Taxes will be relieved . . . but not until after your death.

"Industry showed a slight gain . . . but the expense of keeping tab overshadowed the amount of gain.

"Labor is not laboring . . . because labor hasn't got a job.

"Weather? The weather in Washington has been . . . yes and no."

Of Taxes, Debt, and the Economy

Will Rogers had a surefire formula to become wealthy: "Don't gamble. Take all your savings and buy some good stock and hold it until it goes up, then sell it. If it don't go up, don't buy it."

He wrote extensively about economic matters, sometimes humorously and sometimes heatedly. "There is one rule that works in every calamity. Be it pestilence, war or famine, the rich get richer and the poor get poorer. The poor even help arrange it."

"Saving taxes don't help the unemployed. They got nothing, are earning nothing, hence they pay nothing."

"Tax exempt securities will drive us to the Poor House, not soldiers' bonuses."

". . . *The* rich get richer and the poor get poorer. The poor even help arrange it."

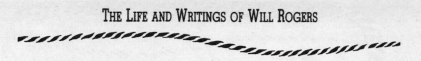

"If I was running the government, there would be no lowering of taxes."

The records show that Rogers not only paid all his tax liabilities, but often overpaid and got refunds.

During thirteen years as a nationally syndicated newspaper columnist, Will Rogers punctuated his writings with support of progressive income taxes and retirement of the national debt and pleas for economic literacy.

As a stage performer before he started writing his views, Will Rogers found that stating bold public positions kept the theater full of paying customers, which could have been his motive for an unusual posturing.

Tempering his ideas with humor, Will Rogers was able to ferment the international forum with successful and progressive—if not radical—ideas and practices that succeeded among Indian tribes before "civilization" arrived.

"What's changed our lives? Buying on credit, waiting for relief, Ford cars, too many Republicans, Notre Dame coaching methods and two-thirds of Americans, both old and young, thinking they possessed 'it.'"

Taxes, the national debt and the economy were favorite subjects.

"We are living in an age of 'what can we get some taxes out of' for the maintenance of our town and state government that shouldn't be costing us any more than it's worth."

217

*"**W**hen is the time to pay off a debt if it is not when you are doing well?"*

Interest on the national debt rose from $190 million a year in 1918 to $678 million in 1929, which triggered much of his concern.

*"**D**epression ain't nothing but old man interest just gnawing away at us.*

"All government statistics say that 60 per cent of every dollar paid in the way of taxes goes to just the keeping up our interest and a little dab of amortization of our national debts.

"Sixty per cent of all our taxes go toward interest on all our various debts, national, state, town and county. But they will take the little dab of surplus and try to buy some party votes with it in the way of lower taxes.

"If two-thirds of what you pay goes to keeping up just interest, why don't we do our best to try and cut down the principal so it will lower that tremendous interest?

"We howl and holler about 'why don't Europe pay?'

"Why don't we pay ourselves?

"There is no debt in the World too big for this country to pay.

"America has been getting away pretty soft up to now. Every time we needed anything, it was growing right under our nose. Every natural resource in the world, we had it.

"But with resources getting less and debts getting more, there is going to be some work going on in this country some day."

Three years before the stock market crash of 1929, Will Rogers wrote:

"We will have prosperity and get along fine now for a couple of years then something will happen and we won't be doing so well."

"When a political party can't think of anything else, they always fall back on lower taxes. It has a magic sound to a voter. Just like fairyland is spoken of and dreamed of by all children. But no child has ever seen it; neither has any voter ever lived to see the day when his taxes were lowered."

"Every morning some state court declares 'so and so tax declared illegal.' If this keeps on, everybody will get back everything they paid in."

"In other words, the way the courts are going now," he wrote in 1935, "they may declare this whole depression and everything connected with it illegal and that it all has to be done over again."

With America in deep recession in 1932, Will Rogers called for a "big overhauling on this tax thing. Different conditions make different taxes."

"All taxes should be on income.

"Where there is no income—either personally or from your property—you shouldn't pay anything.

"You should pay taxes on the things you buy—outside of the bare necessities.

219

"There should never be any holler about that.

"But there should be a distinction between earned and unearned income. For instance, one man earns every dollar by his work or effort and one earns the same by having enough money invested to bring him that much.

"One has his principal to fall back on. The other has nothing to fall back on when his earning capacity has diminished.

"A movie star getting $300,000 a year would be taxed over half of it (less their exemptions) while a financier receiving $300,000 a year in interest from that many tax exempt government bonds wouldn't pay a cent to the upkeep of his government from which he not only received protection for his family and himself, but also his government guarantees him his original investment.

"Tax exempt bonds is the biggest things the matter with the country. Put bonds out with no interest, people will buy 'em for it's not interest they are looking for today, it's security.

"There is a way for a rich man to draw millions from our government and never pay a cent of it out in taxes. Nothing in our country should be tax exempt."

Then, as Will Rogers pushed his cause, he closed by saying: "Write to your Congressman, even if he can't read, write to him."

"For a man to give up three million out of four is tough; but on the other hand, 90 per cent of the people would be willing to give up 99 per cent of a million if allowed to make one."

"The crime of taxation is not in the taking it, it's in the way that it's spent."

"We've got a long-sighted government," Will Rogers said facetiously. "When everybody has got money, they cut taxes. When they're broke, they raise 'em."

"The reason there wasn't much unemployed in the last ten years preceding '29 was every man that was out of a job went to work for the government, state or city.

"It costs ten times more to govern us than it used to—and we are not governed one-tenth as good."

He reported in May 1934 that "Congress has passed the big inheritance tax. That gets you when you're gone.

"I think it's a good law. You had had the use of the money during your lifetime, so turn it over to the government and they can do some darn fool thing with it. Maybe just as foolish as the children of the deceased would.

"What is it they say: 'it's only one generation

221

from a pick handle to a putter and one more from a tuxedo to a tramp.'

"They got such a high inheritance tax on 'em that you won't catch those old rich boys dying promiscuously like they did. This bill makes patriots out of everybody. You sure do die for your country if you die from now on."

"When did taxes get started? Who started 'em? Noah must have taken into the Ark two taxes, one male and one female. And did they multiply bountifully. Next to guinea pigs, taxes have been the most prolific animal."

He pointed to their necessity, however, in comments about ways to finance unemployment and disabled veterans' benefits:

"There is certainly enough wealth to do it. But getting it away from the ones that have it is another thing. When you rely on just voluntary giving, you put quite a hardship on the free giver. He will give until it hurts while a man of perhaps much larger resources will give very little. So it looks like they got to get at this relief thing through taxation on large incomes."

Rather than outlawing so-called social evils, Will Rogers seemed to prefer taxing them.

"Put a good tax on beer and that would take care of the unemployment fund."

He wrote in 1927 that "Kentucky decided it was all right for the State to have some of the money bet

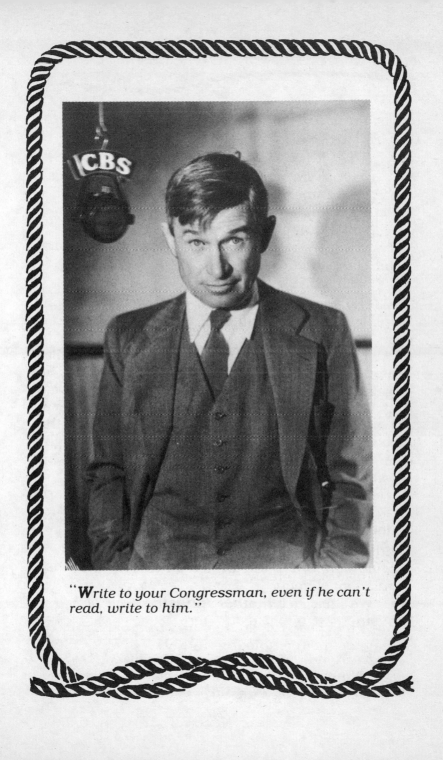

"**W**rite to your Congressman, even if he can't read, write to him."

on horse races, that the profit should not all go to the bookmakers.

"Every state gambles as much as Nevada but they were smart enough to pass a law and get some tax money out of it.

"If Wall Street paid a tax on every 'game' they run, we would get enough revenue to run the government on."

Will Rogers observed, however, that "people don't mind spending their money if they know it's not going for taxes.

"Monaco," he said after visiting the principality, "has the right idea. Fix a game where you're going to get it but the fellow don't know that you are getting it. A fellow can always get over losing money in a game of chance, but he seems so constituted that he can never get over money thrown away to a government in taxes. He will bet you on anything but he won't pay it in taxes."

"We don't seem to be able to even check crime. Why not legalize it and put a heavy tax on it. Make the tax for robbery so high that a bandit couldn't afford to rob anyone unless he knew he had a lot of dough.

"We have taxed other industries out of business, it might work here."

"Every nation must have its legalized form of gambling.

"We have our Wall Street."

"Mexico gives you a more even break. They have 'roulette.' A percentage of your losings go to the government. They are a primitive race. They put government above broker."

In 1935, he commented that "Mexico's President stopped gambling in Tijuana and the whole town is left unemployed. It's just like if they stopped lobbying in Washington—thousands would be thrown out of employment."

"We have some confidential word for you on taxes. We have it on the best of our information that taxes will be relieved, but not until after your death."

"We can always manage to dig up our taxes." It's old man interest that hurts.
"It's not supply and demand, it's old man interest that's got the world by the ears."

"I have heard every kind of reason given for our hard times and as causes of our slow recovery. But I have never heard the real one, that is that interest is too high."

"The world and about everybody in it are broke from paying too high interest."

"No man should receive more for the 'hire' of his money than he could earn with it himself."

"For the last three years," Will Rogers wrote in December 1932, "there has been nothing that he

could have made with even 2 per cent on it, outside of loaning it."

"*C*redit means interest and I will attack interest because interest attacks me and you. Not only attacks us, but has what you might call a constant attack."

Explaining how many people borrow money "to either pay off another loan or to expand," Will Rogers said: "It would have been better if we had let the first guy foreclose on us and shrunk instead of trying to expand."

"*E*very nation and every individual, their principal worry is 'debt.'
"What would be the matter with this for relieving practically everybody's depression: just call all debts off.
"There can't be over a dozen men in the world that are owed more than they owe, so you wouldn't be hurting very many and besides if you give them some worry, that's what they had everybody else doing for years.
"This would give great temporary relief to 99 per cent and wouldn't hurt the others long for they would soon have it back again."

"*T*he government floated an $800 million loan the other day and Al Capone took most of it himself. There is the guy that should be

Secretary of the Treasury. Just turn the country over to him and split the profits."

"There ought to be a law against making an ocean this wide," Will Rogers cabled from a ship in 1931. "That's something Congress can take up at the next session as they won't have anything to settle much, outside of unemployment, two billion deficit, arrange extra taxes where they will do least harm next November, relieve Wall Street and think up something new to promise farmers. Narrowing an ocean will be just a chore for this Congress."

"The only relief you can give the farmer is through his taxes. Work it like the income tax. If he makes it, he pays on it. If he don't make it, he don't pay."

"A thousand shares of stock or bonds make nothing, you pay nothing. But on a thousand acres of land, you pay enough to support half the community who own no land, pay no taxes."

"When will they quit taxing farmers' land regardless if it made anything? Or selling people's homes for taxes. Not until they get a sales tax on small necessities and on large luxuries. Then a stiff inheritance tax on the fellow that saves and don't spend. That will get him either way."

"**A** tax paid on the day you buy is not as tough as asking you for it the next year when you are broke. It's worked on gasoline. It ought to work on Rolls Royces, cigarettes, lipstick, rouge and Coca-Cola."

"**If** anything should prove that a sales tax was a fair tax, it is the uncertainty of income tax. No expert living knows exactly what exemptions are allowed and what ain't allowed."

"**R**epublicans can't tax big incomes for they haven't got last year's campaign budget yet. Democrats still owe for their last three elections."

"**R**epublicans' theory is that if you tax big incomes too much you will discourage a man from making so much for himself. Didn't discourage him during the war when income tax ran as high as 70 per cent. Some of the biggest fortunes were made at that rate of income tax."

"**P**assed the Potter's Field yesterday and they was burying two staunch old Republicans, both of whom died of starvation, and the man in charge told me their last words were, 'I still think America is fundamentally sound.'"

"**A**bolish salaries and you will abolish politics and taxes."

Of Education and Philosophy

While formal education on the western frontier during the late nineteenth and early twentieth centuries was measured by standards far different than criteria set in later times, Will Rogers attended fine schools and often excelled. He sat in classrooms for about ten years, but spent a lifetime learning.

Horses, roping, and a cowboy's life on the open plains were his preference. He developed his own style of learning through travel, reading, and personal inquiry. As with most subjects, he commented freely on education.

"Everybody is ignorant," he said, "only on different subjects."

"When ignorance gets started, it knows no bounds."

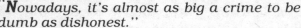

"*Nowadays, it's almost as big a crime to be dumb as dishonest.*"

"*V*illains are getting as thick as college degrees and sometimes on the same fellow."

"*T*he Lord split knowledge up among his subjects about equal. The so-called ignorant is happy. You think he is happy because he don't know any better. Maybe he is happy because he knows enough to be happy. The smart one knows he knows a lot. That makes him unhappy because he can't impart it to his friends. Discontent comes in proportion to knowledge."

"*I*'m scratching around trying to tell enough jokes to pay my taxes and interest on what I owe. But I can eat anything and have no ambition to catch fish and just crazy enough to be happy. When we figure it all up, the breaks are about even."

"*T*he more you know, the more you think somebody owes you a living."

"*T*here is nothing as stupid as an educated man if you get him off the thing he was educated in."

"*I* got a dictionary one time. It didn't last long. It was like looking in the telephone book. I never called up anybody in my life if I had to look up their number."

231

"**A** man learns by two things. One is reading.
The other is association with smarter people."

"**T**he State of Louisiana without any blare of
trumpets is doing the biggest thing being done in
our land. They stood highest in illiteracy. They
opened up moonlight schools and are teaching
over a hundred thousand to read and write,
mostly older people. They are going to wipe out
illiteracy. That beats all your luncheon clubs and
your good roads and your advertising campaigns.
That is like learning the cripple to walk and the
blind to see. One hundred thousand happy
citizens will bring your state more dividends
than one hundred thousand miles of bonded
concrete road."

"**I**nstead of these men giving money to found
colleges, why don't they pass a Constitutional
Amendment prohibiting anybody from learning
anything. If it works as good as Prohibition did,
in five years we will have the smartest people on
earth."

"**A**ll due regards to Nicholas Murray Butler
[Columbia University President from 1902 to
1945, and winner of the Nobel Peace Prize]. He
has taken a college that didn't amount to much,
right in the heart of New York City (a place where
you would think would be the very last place to
get anybody interested in education) and he has
built it up just by making rich men think that by

232

leaving something to the school it would help the rest of America forget how some of them got the money. It is just surprising the men that he has sandbagged out of jack. He is a business man if there ever was one and a mighty nice fellow. I bet he could take the Democratic Party and make it pay. The remarkable thing about Butler with Columbia, he has done all this without a football team."

"**A**way back when . . . things were educationally queer.

"Boys wanted an education whether they got a fraternity pin or not.

"They even had reading and writing and arithmetic instead of football. Didn't even have as much as a golf course. They built a library before a swimming pool. Stadium was foreign to them. Boys had gone there for their head and not for their shoulders."

"**T**he football season is about over. Education never had a more financial year. School will commence now. Successful colleges will start laying plans for new stadiums; unsuccessful ones will start hunting a new coach; cheerleaders will join the Rotary luncheons for hog-calling contests. Heroes have been cheered that will never do anything to be cheered again. We are trying to arrange a post-season game between Harvard and the motion picture leading men."

"I think you can learn the same in all schools, outside of football. Harvard has really never taken that seriously. They are talking of putting in a chair of football next year."

"Give me four years at the old college and I will have a diploma and that will be a big comfort to me in my old age. When things are bad and jobs are scarce, I can always come and commune with my diploma."

Will Rogers rejected honorary degrees, wondering "what in the world I would do with a degree. A lot of guys that earned 'em don't know what to do with 'em, much less me that wouldn't know what one was.

"Degrees have lost prestige enough without handing 'em around to second-hand comedians. Handing 'em out too promiscuously helped to cheapen 'em. Let a guy get in there and battle four years if he wants one. Don't give him one just because he happens to hold a good job in Washington or manufactures more monkey wrenches than anybody else or because he might be fool enough to make people laugh.

"Keep 'em for the kids that have worked hard for 'em. Keep 'em believing in 'em. They are stepping out in the world with nothing but that sheet of paper. That's all they got. Our civilization don't offer 'em anything else. We offer him nothing. He steps into a world not of

his making, so let's at least don't belittle his badge."

"**W**alked around a secluded corner unexpected and there was a bunch matriculating in algebra. They had two little square looking things and they were trying to figure out the cube root of seven and eleven. They were even so interested in it that they seemed to be making wagers on which was the most proficient."

"**N**obody teaches reading, or writing, or arithmetic, or some of the old-fashioned things that Lincoln struggled along with to the Presidency.

"We are trying to cram Latin and Greek down youth that would never in all their lives have any use for it."

"**E**verybody is trying to go to college and come out a bond salesman."

"**W**hen you start informing or educating this country on anything you got some job. There are millions more in this country interested in a drink than in political knowledge."

"**W**e assemble our education at a college just like they do a car. You start through and each teacher sticks a little something onto you as you go by their department. The same things on each one. When you get to the end, you get a diploma

like a car does a license. You all go out and start acting alike."

"*T*he smarter a nation gets, the more wars it has. The dumb ones are too smart to fight."

"*N*obody has ever figured out just why we thought everything could be learned in four years. It just seemed a good even number I guess and we used it."

"*J*esuit is the highest educated of all religious orders. Had to study 15 years to complete his college course after high school. Imagine a four-year college man's embarrassment if he had to tangle intellect with a Jesuit. What an ignorant bird. Then our gang gets what they call a master's degree in five years (or one extra)."

"*M*ost of our work is skilled and requires practice, and not education."

"*H*enry Ford has always had more common sense than anybody. The minute a boy comes out of college he is going to take him and educate him so he can make a living. If he can do that it will make him our greatest living American."

"*N*one of these big professors will come out and tell you what our education might be lacking. They know that it's a 'racket' and they are in on it. You couldn't get me to admit that making

movies was the bunk either. None of us will talk against our own graft. We all got us our 'rackets' nowadays."

"Does education 'pay?'
"Yes, it does, if you got a sense of humor.
"You got to pay for your laughs at a show, so why not at school?"

"They say children in kindergarten must play in order to learn. What do you mean children? Crossword puzzles learned grown folks more words than school teachers. What arithmetic the women folks know they got at a bridge table. Our splendid English comes from attending the movies. My geography comes from an airplane window. Yes sir, there are 120 million in the American kindergarten."

"Education never helped morals. The most savage people we have are the most moral. The smarter the guy the bigger the rascal."

"The more education he gets the less apt he is to be a Democrat and if he is very highly educated he will see the apple sauce in both parties."

"The higher the education the higher priced drinks they become accustomed to. Prohibition will never catch up with education."

"*E*vents are like fingerprints: no two alike. History doesn't teach us that, somebody was smart enough to find it out. What's the use of studying one event when you know it will never happen again? Napoleon moved his army on its belly. What does that prove? Only that soldiers were all belly and no head in those days. If Henry Ford had studied the past instead of the future he would have invented the cheapest suit of armor in the market."

"*I* doubt if there is a thing in the world as wrong or unreliable as history. History ain't what it is. It's what some writer wanted it to be. I bet ours is as cockeyed as the rest. I bet we have started just as much devilment as was ever started against us—maybe more. History never has to explain anything. It just gives you bare facts and there's no way of cross-examining them to find out. As far as facts are concerned, the better educated you are the less you know."

"*E*verybody is offering suggestions as to how to improve education. We have courses in business administration, salesmanship, public speaking, etiquette, banking, dairying, fertilizing, everything a person can think of—we have a course you can take at some college. I want to propose a course in 'public testifying.'"

"*M*ost of our public men spend over half their time testifying on the stand, especially the Republicans. Now what has brought forth this

"Live your life so that whenever you lose it, you are ahead."

idea of mine is the testimony that has been delivered on the stand. Did you ever see men get as frustrated and tangled up? The smarter the man the bigger the sucker when he is being questioned. The greatest testimony is some child's or old ignorant farmer or laborer. They make the hit on the stand. They answer every question without flinching in a simple, direct way. They have only one story and the prosecuting lawyer knows it so there is no chance of tying them up."

"*T*he minute a witness has had education, or thinks he knows something, the less convincing he is on the stand."

"*I* am going to start the school of public testimony laid out like a court. Instead of teachers we will have 'em made up as sheriffs, bailiffs, jurymen and judges.

"The minute a person is elected to office like a Senator or Congressman, we will have him come and spend a few weeks and when he goes on to his public office, he will be all set for investigations.

"We will teach 'em not to be nervous, not to let the other fellow get 'em rattled and have 'em all trained to tell where they got every dollar they used in their campaign and how much paid for each vote.

"In other words, it will persuade our big men to turn honest after election and trust the mercy of the jury. We will coach 'em to tell

240

everything the first time. That will save having to spend your life on the stand. Even if it takes longer the first time you testify, it will save time in the long run.

"If it takes a whole day to tell the thing, my school will instruct you to go through with it.

"In other words, we are going to try to instill honesty into our pupils and get them used to telling nothing but what happened and all of what happened.

"When some of my early pupils first start testifying, they won't be believed. Such a radical change for the unusual will make the committee think it is a clever fake. As they grow used to my pupils, they will begin to realize they can depend on them. It's really patriotic reasons that make me want to do this.

"I am afraid that foreign nations will read some of our papers and find the testimony of some of our men who are in the cabinet and high in public office and they will judge them by that testimony. They will think they are smarter than their testimony.

"If I can change that and get them to make their testimonies as smart as the men are, then I will have performed a public service."

"Our country holds the record for dumbness. The Pope spoke to the world in three languages and we didn't understand a one of them. The minute he finished and the local stations got back to selling corn salve and tooth paste we were right up to our intellectual alley again."

"*There* never was a nation founded and maintained without some kind of belief in something. Nobody knows what the outcome in Russia will be or how long this government will last. But if they do get by for quite a while on everything else, they picked the one thing I know of to suppress that is absolutely necessary to run a country on, and that is religion. Never mind what kind. But it's got to be something or you will fail at the finish."

"*What* all of us know put together don't mean anything. Nothing don't mean anything. We are just here for a spell and pass on. Anyone who thinks that civilization has advanced is an egotist. Fords and bathtubs have moved you and cleaned you. But you were just as ignorant when you got there. We know lots of things we used to didn't know but we don't know any way to prevent 'em happening. Confucius perspired out more knowledge than the U.S. Senate has vocalized out in the last 50 years."

"*We* have got more tooth paste on the market and more misery in our courts than at any time in our existence."

"*There* ain't nothing to life but satisfaction. If you want to ship off fat beef cattle at the end of their existence, you got to have 'em satisfied on the range. Indians and primitive races were the highest civilized because they were more

242

satisfied and they depended less on each other and took less from each other.''

"*L*ive your life so that whenever you lose, you are ahead.''

Of War, Disarmament, and Diplomacy

Will Rogers trotted around the world three times, and sat through peace conferences and lectures. He listened and reflected. Then he talked and wrote on world affairs.

In 1930 Will Rogers said, "America has a very unique record. We never lost a war or won a conference in our lives.

"We can lick any nation in the world single-handed, yet we can't confer with Costa Rica and come home with our shirts on.

"I have often said it is cheaper for America to go to war than it is for us to confer with anybody. We can talk our heads off until it comes a time when it means something then we are as dumb as an oyster."

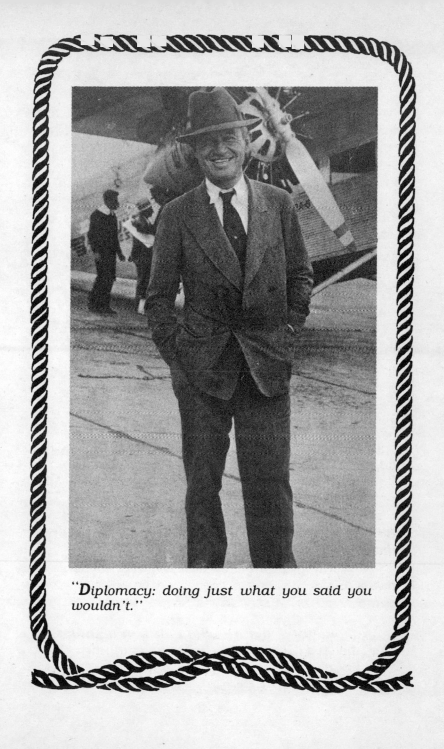

"Diplomacy: doing just what you said you wouldn't."

In 1926 when Calvin Coolidge was President and Frank Kellogg was secretary of state, Will Rogers returned from a trip to Russia and Europe and said: "Our gunboats are all in the Chinese war, our marines have all landed in Nicaragua, Kellogg is sending daily ultimatums to Mexico and Coolidge is dedicating memorials to eternal peace. Who is the next country wants their affairs regulated?"

Will Rogers wrote on the issues of diplomacy, war, and conferences with inspiration:

*"**I** really was not sent here to instruct America grammatically—only diplomatically. But a little intelligentsia now and then is relished by the best of men, even politicians."*

*"**A** diplomat has a hundred ways of saying nothing, but no way of saying something, because he has never had anything to say. That's why they call 'em diplomats."*

*"**D**iplomacy was invented by a man named Webster to use up all the words in his dictionary that didn't mean anything.*

"Diplomacy: doing just what you said you wouldn't."

*"**A** diplomat is a man who tells you what he don't believe himself. The man he is telling it to doesn't believe it any more than he does. So diplomacy is always equal. It's like good*

bookkeeping. He don't believe you and you don't believe him, so it always balances."

"*T*ake diplomacy out of war and the thing would fall flat in a minute."

"*T*hese so-called peace treaties are a funny thing. The Democrats had one years ago, but nobody wanted peace just because the Democrats suggested it. We have had ten years of peace without any treaty but now the Republicans want to make it even more peaceful. You ask 'em:
"'Does it prevent war?'
"'No.'
"'Does it prevent peace?'
"'No.'
"'Is it for anything?'
"'No.'
"'Is it against anything?'
"'No.'
"I think the whole thing is just to find out if we can write."

"*A* diplomat is one that says something that is equally misunderstood by both sides and never clear to either."

"*D*iplomats are just as essential to starting a war as soldiers are for finishing it."

"*I* have always said that a conference was held for one reason only, to give everybody a chance to get sore at everyone else. Sometimes it takes two or three conferences to scare up a war, but generally one will do it. I'll bet there was never a war between two nations that never conferred first."

"*M*ost of us had the impression that the late big war was started all at once by Germany deciding it would be a good time to go through Belgium. According to all the dope, this fellow had quite a time arranging the war. It looked for a while that he wasn't going to be able to put it on."

"*I*t's awfully hard to get into a war without a diplomat."

"*W*hy does every peace envoy go on a battleship?"

"*D*iplomacy is a great thing if it wasn't transparent."

"*N*ow we gather to disarm. Less diplomats is what you want, not less arms."

"*R*ussia has called home her diplomats from China. China has called home hers from Russia. If they had both done that before the argument started there would have been no argument.

That's why diplomats don't mind starting a war because it's a custom that they are to be brought safely home before the trouble starts. There should be a new rule saying 'if you start a war while you are your country's official handicap to some other country, you have to stay with any war you start.' Then diplomats would begin to 'dip.'"

"*T*he only real diplomacy ever performed by a diplomat is in deceiving their own people after their dumbness got them into a war."

"*I*f Armistice Day had stopped speeches, it would have done more good than to have stopped war. Speeches is what starts the next wars. It's not armament, it's oratory, that's wrong with this country."

"*A*mericans are wired for sound. Before they go abroad, they ought to detach the wiring."

"*P*eople talk peace but men give their life's work to war. It won't stop until there is as much brains and scientific study put to aid peace as there is to promote war."

"*I*f you want to know when a war is coming, just watch the United States. When they start cutting down on their defense it's the surest barometer in the world."

"*T*wo things can disrupt business in this country. One is war and the other is a meeting of the federal reserve board."

"*T*he funny part of the disarmament treaty says there is to be no more war so we must sink our boats. Sinking our own boats is a military strategy that will always remain in the sole possession of America. But we are allowed to practice shooting at them as they go down in case there is another war and we need the marksmanship."

"*A*ll we got to show for the Washington disarmament conference was the desk and we will perhaps lose it at the next one."

"*O*ne mighty satisfying thing about our country. Our young men can get us ready for wars faster than our diplomats can talk us into them."

"*I*f they are trying to outlaw war, why don't they quit practicing shooting?

"A gun has put every nation in the world where it is today. It all depends on which end of it you were on—sending or receiving."

"*O*ur boys went after a treaty [the London Treaty, May 1930] and Japan's gang went after ships. They both got 'em. In case of trouble, for

every ship they send out to attack us, we shoot 'em down with a treaty.''

"**W**e are at peace with the world because the world is waiting to get another gun and get it loaded.''

"**Y**ou can't say civilization don't advance. In every war they kill you in a new way.''

"**T**hey are talking of having another naval disarmament conference. We can only stand one more. If they ever have a second one we will have to borrow a boat to go on.''

"**W**ars don't diminish our navy. It's peace that's so devastating. When we were attacked by the disarmament conference we had even our lifeboats shot out from under us.''

"**M**y advice to Mr. Coolidge on preparedness is slowly bearing fruit. Here are his exact words: 'what we need and that we do need for national protection is adequate protection.' Couldn't ask for a clearer statement. What a hungry man needs and all he needs for personal sustenance is adequate food and shelter. All a Democrat needs for self-preservation is adequate votes.''

"**S**ome of the senators are not for building cruisers until we get a war booked. We have to figure out some kind of guarantee to those fellows that we will scare 'em up a war.''

"**A** senator wants a conference to decide 'your rights on the seas during a war which you haven't been able to get into.' That's like holding a convention to discuss the 'rights of innocent bystanders during a fight between police and bandits.'

"He only has one right and that's the right of a decent burial."

In May 1930, he said: "America never lost a boat in a battle, but we have had many-a-one shot from under us at a conference."

"**N**ations want to protect themselves according to their own needs. They don't want war. Neither do they want to be left entirely defenseless. You can't blame 'em.

"Nothing makes a nation or an individual as mad as to have somebody say 'now it's really none of my business, but I am just advising you.'

"They will never get anywhere with this disarmament for no nation can tell another nation what they need to defend themselves. That's a personal affair.

"If my neighbor don't want me in his yard, you don't see me making an effort to get in. So all this honor that nations speak don't seem to be working."

"*I* don't care how little your country is, you got a right to run it like you want. When the big nations quit meddling, then the world will have peace."

"*W*hen one nation is big and one is little, the little nation's port is just like a public regatta. Everybody can come in that's got a boat.

"The whole thing as I see it all over the world today is that the little nations have got no business being little."

"*T*here ain't anything that you find in one country that you don't find is being done just about as bad in our own.

"They want peace. But they want a gun to get it with."

"*T*he one thing these old boys with a big navy are scared of is submarines. They are always claiming they are inhuman and not a civilized mode of warfare. It would be rather interesting to see published the names of the weapons that are considered a pleasure to be shot by."

"*E*ngland tries to stop war, we try to stop disarmament. One fellow tries to stop the actual fight, we try to regulate the number of bullets he shall have after the fight starts. Take your pick as to who is the humanitarian."

"*E*ngland and America may make a big to-do about cutting down until it's a parity on battleships and cruisers. That don't mean a thing. Evenly matched don't mean that we won't fight. It really means we are more liable to fight for each will naturally think they have the edge on the other.

"The whole thing will lead to something. It sets people thinking in the right direction. As far as doing anything to prevent war it's not liable to happen."

"*T*here has been war since the beginning of time and we are no smarter than the people that have gone before us. There is apt to be some more war."

"*A*ny man is a bandit if he is fighting opposite you and licking you most of the time. If you are fighting against him, that's patriotism. The difference between a bandit and a patriot is a good press agent."

"*W*ith all our diplomacy, advancement and education, nations have never become civilized enough to sell another nation a piece of ground when they absolutely need it for their overflow. They don't mind losing it in a war, but they don't want to sell it. That would be too commercial."

"*W*e would never understand why Mexico wasn't crazy about us. We have always had their goodwill, oil, coffee and minerals at heart. Woe

be to a weak nation if they live by a strong one. They either got to play with them or join them.

"Can you imagine the nerve of some little upstart nation telling an American oil millionaire that he could dig oil only fifty years more before taking out another lease?

"Or some other little pup tent nation electing a president without our permission. Here they are taking themselves serious. That wasn't so bad but it was interfering with our trade, oil and bananas."

"**W**e are heartily against all wars, unless, of course, we should see fit to do a little fighting ourselves. Then, of course, this agreement would be null and void. But we certainly join you in preventing others from having the pleasure of fighting."

"**W**e only have one or two wars in a lifetime. But we have three meals a day. When you have helped raise the standard of cooking then you would have raised the only thing in the world that matters."

"**I** would like to stay in Europe long enough to find some country that don't blame America for everything in the world that's happening to them—debts, depression, disarmament, disease, fog, famine or frostbite.

"European nations can't hate you so bad they wouldn't use you. There just ain't no

animal such as international good will. It just lasts until the loan runs out.

"We have loaned more money to foreign nations than anyone. But we never was smart enough to make 'em sign that they would help us out in case Mexico or Canada or some other bully jumped on us. I guess we are the dumbest Nation in the world in that respect."

"One thing no nation can ever accuse us of is secret diplomacy. Our dealings are an open book. Generally a check book."

"American people like to have you repent, then they are generous."

"Charity is the only way to help all these different kinds of people. If you are going to do anything at all for them, feed 'em, even if they don't become Christians."

"If the president does nothing else but keep our Army and Navy at home, we can forgive him for not giving us rain, lower taxes and an inflated stock market."

"Won't it be wonderful if we can live to see the day when any country can have its own revolution and even a private and congenial war with a neighboring nation without uninvited guests."

"If I was a little Nation, I would find the poorest land and county in the world then settle on it. I might not make a living, but I would at least be let alone."

"Now that brings us to Russia. Russia just thrives on propaganda. She does love propaganda. Instead of taking the money and improving her country, she sends it out to try and buy propaganda. So Russia just remains poor to show the world they are right. They call each other comrades, but they don't call each other to dinner very regular."

"Russia and China are arranging the details for a war. According to the communists, all are equal. So they will all be generals.

"When American diplomacy gets through messing us around over in China, I can tell them what has caused this hate for us. It's our missionaries who have been trying to introduce 'chop suey' into China. China didn't mind them eating it there, but when they tried to call it a Chinese dish that's what made them start shooting at us."

During the September 1931 London conference, Will Rogers made this observation about India's Mahatma Gandhi: ". . . a skinny little fellow with nothing but a breechcloth, a spinning wheel and an old she-goat goes there representing more humanity and with more authority than all the high hats in the world. It's sincerity versus diplomacy."

"*Even* experts don't know what the weather will do. Even millionaires don't know what Wall Street will do. There are millions of things that nobody knows about in advance.

"But the dumbest guy in the world knows that the minute a Latin American country has a revolution that is just the opening of a series of 'em. You know we got the wrong impression of a revolution. They was raised on 'em down there. They love 'em. It's their only relaxation. Sure people get killed sometimes. If it's a first-class, grade A revolution, they may lose about as many as we lose over a weekend by trying to pass somebody on a turn."

"*There* is one thing about a Latin American country. No matter who is running it, they are always run the same."

"*One* good thing about wars, it takes smarter men to figure out who loses 'em than it does to start 'em."

"*When* China and Russia didn't start this late uprising that led me to believe that China, as ignorant as they are, and Russia, as dumb as they are, are the two most highly civilized nations on the face of the globe. The more ignorant you are the quicker you fight."

"*Lincoln* didn't have a foreign policy. That's why he is still Lincoln."

Of Presidents,
Bad and Good

From Republican Teddy Roosevelt to Democrat Franklin Roosevelt, Will Rogers never met a president he didn't like either. His influence interfaced the administrations of Roosevelt, Taft, Wilson, Harding, Coolidge, Hoover, and Roosevelt.

Absent rancor, Will Rogers would roast politicians' foibles and failures on stage and in his newspaper columns, then join his targets for supper without apology.

"You shouldn't elect a President; we should elect a magician. We elect our Presidents, be they Republican or Democrat, then go home and start daring them to make good."

259

"You can joke about a big man. That's why he's big."

"*B*eing serious or being a good fellow has got nothing to do with running this country. If the breaks are with you, you could be a laughing hyena and still have a great administration."

Mostly as humorous ploy, Will Rogers's name was tossed into the candidate arena, but he said:

"I would rather tell them what I think and retire with satisfaction than to be President and be hampered.

"*W*hen you are in politics and depending on somebody to keep you in, you really ain't able to act like real life. Politicians will use any means to get their cause launched; a funeral, a commemoration, a christening, any occasion that looks important, they will decide to launch along with the chaplain's benediction some of the promises the future holds for you."

Will Rogers was comfortable with men in power from his birthplace at the White House on the Verdigris to the White House on the Potomac.

"Teddy Roosevelt was my best bet for a laugh during those [vaudeville] days," Will Rogers wrote.

Will Rogers's presidential bantering and political commentary were restricted to the vaudeville and *Follies* stages for a dozen years, but the impact expanded widely when he began writing for newspapers during the Warren G. Harding administration.

Will Rogers watched the White House for years, saw the indignity and disarray of campaigns for re-

election, and spoke out strongly for a single six-year term for presidents. Will Rogers was a benign critic or an equal champion of leadership efforts.

Will Rogers said:

"They do love to be President. It's the toughest job in the world but there is always 120 million applicants."

"*P*residents become great. But they have to be made presidents first. If we told the truth about 'em, maybe some of 'em was pretty punk. But we drug along in spite of 'em.

"None of 'em from any party are going to purposely ruin the country. They will all do the best they can."

"*S*ometimes we don't need a different man as bad as we need different advisors for the same man."

"*W*e never get anywhere by switching around. A man don't any more learn where the ice box is in the White House than he has to be back to being a lawyer again.

"No matter what man is in an office, the one that you put in his place is worse. We had no business ever letting Washington (George, not D.C., I mean) go. We ought to have kept him until we got hold of Lincoln. Then been more careful of the protection of his life and preserved him to a ripe old age down to where Roosevelt was about 15 years old. Then we could have turned it over

to him. He could have run it as good at that age as most men could at 50."

*"**T**eddy [Roosevelt] was a man who wouldn't waste even hatred on nothing."*

Will Rogers wrote of the twenty-seventh president, who also served nearly a decade as chief justice: "William Howard Taft always seemed like he was one of us.

*"**I**t's great to be great but it's greater to be human.*

"He was our great human fellow because there was more of him to be human.

"We are parting with 300 pounds of solid charity to everybody and love and affection for all his fellow men."

While Warren G. Harding's administration became known as one with either competent men who were corrupt or inept honest servants, Will Rogers said Harding "was the most human of any of our late presidents. If he had a weakness it was in trusting friends and the man that don't do that, there is something the matter with him.

*"**B**etrayal by friendship is not a bad memorial to leave."*

When Coolidge Dam was to be dedicated by Calvin Coolidge, Will Rogers wrote:

"*The Apache Indians are going to make Mr. Coolidge chief of their tribe to replace Geronimo. They had a great deal in common. Neither one said much. Mr. Coolidge, when big chief, arrived at the same result with a veto that Geronimo did with a tomahawk.*"

"*Coolidge was the first president to discover that what the American people want is to be let alone.*"

"*You may think you can out-general old Cal, but you look at his record and you are going to have a tough time out-lucking him.*"

If Herbert Hoover had any luck, it seemed to be bad or, as Will Rogers said:

"*He reaped the benefits of the arrogance of the party when it was going strong. I always did want to see him elected. I wanted to see how far a competent man could go in politics. It has never been tried before.*"

"*He [Hoover] has no use for politicians which fact elected him by the largest majority ever recorded. If he will just continue to hate them we are liable to wake up with another Lincoln or Jefferson on our hands.*"

"*Mr. Hoover has done all in his power to try and further peace and at the same time leave us a loaded musket in the corner.*"

Franklin D. Roosevelt defeated Republican Hoover by overwhelming numbers in the depths of the Depression. Will Rogers had these kind words for him:

"He is a particular friend of mine and for many years standing, he and his whole family, but I have to start making a living out of the fool things that he and those Democrats will do. I am not worried, I know they will do plenty of them."

"There is not a man in public life today that I don't like. Most of them are my friends. But that's not going to keep me from taking a dig at him when he does something or says something foolish."

"Roosevelt is a mighty fine human being. Too nice a fellow to be mixed up in all this politics."

"Roosevelt stepped to the microphone and knocked another home run. His message was not only a great comfort to the people, but it pointed out a lesson to all radio announcers and public speakers what to do with a big vocabulary: leave it at home in the dictionary."

"Roosevelt said he would take brains anytime in preference to politics. He just as good as admitted you couldn't get both in the same body."

"Everybody that is making money has it in for Roosevelt. You will have to explain that one yourself. Folks are predicting Roosevelt's downfall, not only predicting but praying. People are willing to cooperate but they are not going to willingly pay to do it. You can bet his faith in human nature has had quite a jar."

"America is just like an insane asylum, there is not a soul in it will admit they are crazy. Roosevelt being the warden at the present time, us inmates know he is the one that's cuckoo."

Will Rogers said George Washington "was the father of our country on account of having no children. He was a surveyor and he owned half of Virginia because he surveyed his own lines. He was a general on our side because England wouldn't make him one of theirs. He was a politician and a gentleman. That is a rare combination.

"He was a farmer, civil engineer and a gentleman. He made enough at civil engineering to indulge in both the other luxuries.

"He was a surveyor. He took the exact measure of the British and surveyed himself out about the most valuable piece of land in America at the time, Mount Vernon. George could not only tell the truth but land values.

"Washington was elected the first President because he was about the only one who had enough money to give a decent inauguration party.

"Every once in a while, he would whip England. That wasn't an accomplishment. That was a habit. He took the job so he could locate the capital in Washington."

After the Revolutionary War, Will Rogers said Washington took the land from the British and "annexed most of it personally himself. What he didn't get, a Democrat named Jefferson got."

Will Rogers called Washington, D.C., "the first real estate promotion scheme; Washington and Jefferson owned practically all the land. Washington and Jefferson landed on two of the best hills in that country and the government got the swamps.

"While you didn't get much money for being president in those days, it wasn't exactly a philanthropic job. George lost no money in the transaction."

Will Rogers said that Washington "fought for his tribe against the invaders [Indians] and wound up with a flock of statutes and a title of Father-of-His-Country. The old Apache chiefs went through more and fought harder for their country than George did, but George won, that's the whole answer to history.

"It's not what you do, but what did you get away with at the finish."

On Washington crossing the Delaware, Will Rogers said "I don't remember whether he crossed it to get to or away from Philadelphia."

Will Rogers said President Thomas Jefferson was "the most far-sighted Democrat and they named the

Democratic Party after him. That is he was for the poor but was himself of the rich. Jefferson sitting up there on that hill believed in equality for all. But he didn't divide up the hill with any poor Democrats."

"Jefferson seemed to be the only Democrat in history with any kind of business ability."

President Andrew Jackson "never missed a shot or a drink while he was in the White House.

"I knew what a great man he had been, but at the same time I heard enough to know that an 'injun' didn't rate high with him. I knew he had a lot to do with running the Cherokees out and making them go west. But I knew he had unconsciously favored us in the long run, so I forgave him."

"Andy stayed two terms and was the first man who didn't choose to run again. He had to get back to his regular business which was shooting at Indians. The Indians wanted him in there so he would let us alone for a while."

"If Abe Lincoln from Illinois was resurrected and insisted he was Republican, there would be party vote against him. Every politician always talks about him but none of them ever imitate him."

268

"*Lincoln was great. He freed the slaves and put the southern whites in bondage for the duration of their lives. He furnished General Grant with cigars to smoke and poor Lee had no gas mask so he had to surrender. Lincoln did his best to prevent that war between the Democrats and the Republicans. Since then, they have been settling their difficulties at the polls with about the same results.*"

"*Lincoln made a wonderful speech one time: 'That this nation under God shall have a new birth of freedom and that Government of the People, by the People, for the People shall not perish from this earth.' Every time a politician gets in a speech, he digs up this Gettysburg quotation. He recites it every Decoration day and practices the opposite the other 364 days.*"

"*They say Lincoln wrote his speech going up on a train in a day coach on the back of an envelope. Every speaker that goes to commemorate something or other, should be locked up in a day coach and if he comes out with over 300 words he should be put in a cattle car and make it to the stock.*"

Of Religion, Death, and Life

Will Rogers made his most quoted statement at Boston's Tremont Temple Baptist Church on June 16, 1930. After the pastor, Dr. James W. Brougher, finished the sermon, the *Boston Globe* reported that Rogers was invited to speak and made these remarks:

"When I die, my epitaph, or whatever you call those signs on gravestones, is going to read 'I joked about every prominent man of my time but I never met a man I didn't like.' I am so proud of that. I can hardly wait to die so it can be carved. And when you come around my grave you'll probably find me sitting there proudly reading it."

On a grassy hillside in his hometown of Claremore, Oklahoma, Will Rogers's body rests in a sarcophagus chiseled with those very words.

Will Rogers wrote of the realities of death and fate:

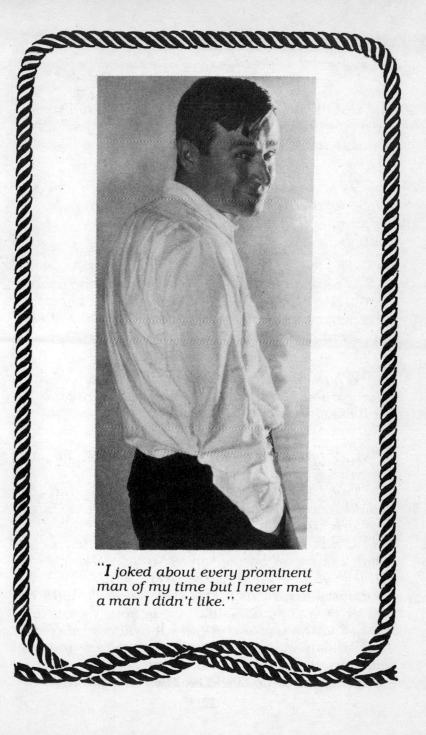

"*I joked about every prominent man of my time but I never met a man I didn't like.*"

"**D**eath knows no denomination; death draws no color line. If you live right, death is a joke as far as fear is concerned."

"**U**s ignorant laugh at spiritualists. But when they die they go mighty peaceful and happy. After all, all there is to living is to go away satisfied."

"**W**e are all just hanging on here as long as we can. I don't know why we hate to go. We know it's better there. Maybe it's because we haven't done anything that will live after we are gone."

"**W**hat constitutes a life well spent? Love and admiration from your fellow men is all anyone can ask."

"**J**udge a man's greatness by how much he will be missed.

"There is a lot of lessons in the Bible that we could learn and profit by and help us out, but we are just so busy doing nothing we haven't got time to study. In Moses' time, the rich didn't gang up on you and say 'you change that commandment or we won't play.'

"Moses just went up on the mountain with a letter of credit and some instructions from the Lord and he wrote 'em out and they applied to the steel men, the oil men, the bankers and the farmers. Even the U.S. Chamber of Commerce.

"Whoever wrote the Ten Commandments

made 'em short. They may not always be kept, but they are understood. They are the same for all."

"When Congress gets the Constitution all fixed up, they are going to start on the Ten Commandments, just as soon as they can find somebody in Washington who has read them."

"The Bible has always been the best seller. It gets hard to read for a dumb fellow for there is so much that we can't understand. I don't suppose there is two preachers in the world that would absolutely interpret a whole chapter exactly alike. But any interpretation you put on it is good."

"I was raised predominantly a Methodist, but I have traveled so much, mixed with so many people in all parts of the world, I don't know just what I am. I know I have never been a non-believer. But I can honestly tell you that I don't think that any one religion is the religion."

"I have worked for every denomination in the world because one is just as worthy as the other and I can't see any difference in them. I haven't been able to see where one has the monopoly on the right course to heaven."

"I am broad minded in a religious way. Which way you serve God will never get one word of argument or condemnation out of me. There has

been times when I wished there had been as much real religion among some of our creeds as there has been vanity, but that's not in any way a criticism."

"*If* some of those birds would spend their time following His example instead of trying to figure out his mode of arrival and departure, they would come nearer getting confidence in their church."

"*There* is no argument in the world that carries the hatred that a religious belief does. It seems the more learned a man is the less consideration he has for another's belief."

"*Speaking* of not believing, I don't believe that Noah took a pair of every kind of animal into the Ark. I don't believe Noah could round up all the animals in one herd without the skunk causing a stampede."

"*Whether* the animals came over here by ark or by subway makes no difference to me. I enjoy a zoo."

"*If* you are going to argue religion in the church instead of teaching it, no wonder you can see more people at a circus than at church."

"*The* Lord put all these millions of people all over the earth. They don't all agree on how they got here. Ninety per cent don't care. They all

agree whether Christian, Heathen or Mohammedan that the better lives you live the better you will finish."

"They are pretty bad, these big wars over commerce. They kill more people. But one over religion is the most bitter."

"When those old Boys who blueprinted the first Constitution decided that a man can believe what he likes in regard to religion, that's one line that is going to stay put."

"I don't know how I got here but I will stay ignorant and take my chances in the end."

"No great religious revival will ever be started from an argument over where we come from. The religious revival of the future, when it is started, will be people's fear of where they are going."

"If the Lord wanted us to know exactly how and where we come from, he would have let us know in the first place. He didn't leave any room for doubt when he told you how you should act when you got here. His example and the commandments are plain enough. Start from there. Never mind going back any farther."